AT FIRST SIGHT

PHOTOGRAPHY AND THE SMITHSONIAN

Merry A. Foresta
with entries by Jeana K. Foley

Smithsonian Books
Washington and London

Copy editor: Nancy Eickel
Production editor: Duke Johns
Designer: J. Abbott Miller,
Johnschen Kudos, Pentagram

Merry A. Foresta wrote the introduction to each chapter.
Jeana K. Foley provided entries on individual photographs,
unless otherwise noted.

CONTRIBUTORS

Michelle Anne Delaney

Debra Diamond

Paula Richardson Fleming

Christraud M. Geary

David E. Haberstich

Amy Henderson

Pamela Henson

Susan Jewett

Liza Kirwin

Peter Liebhold

Claire Orologas

Shannon Perich

Phyllis Rosenzweig

Joanna Cohan Scherer

Ann M. Shumard

Steven Turner

William E. Worthington Jr.

Library of Congress Cataloging-in-Publication Data
Foresta, Merry A.
At first sight : photography and the Smithsonian / Merry A. Foresta.
p. cm.
ISBN 1-58834-155-0 (alk.paper)
1. Smithsonian Institution — Photograph collections — Exhibitions.
2. Photograph collections — Washington (D.C.) — Exhibitions.
3. Photography, Artistic — Exhibitions. I. Title.
TR6.U6W19 2003
770'.74'753 — dc21 2003042410

British Library Cataloguing-in-Publication Data available

CONTENTS

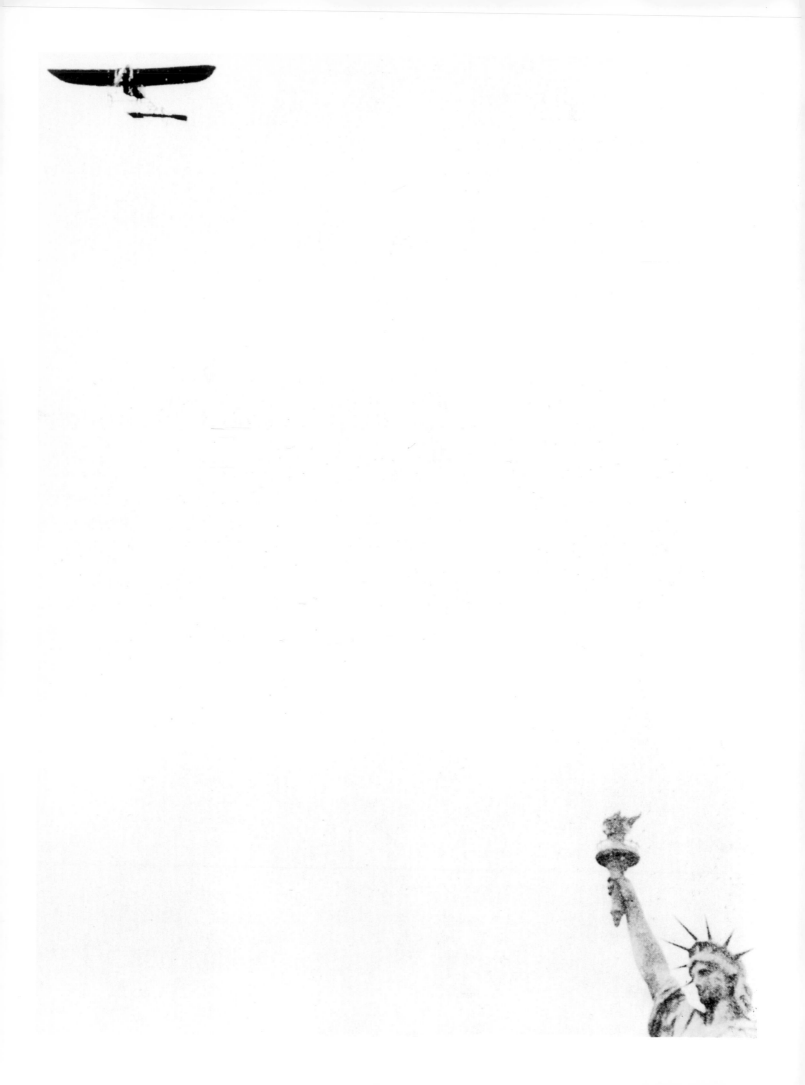

ACKNOWLEDGMENTS

This project would not have been possible without the support and encouragement of many people, including those original Smithsonian leaders who took an active interest in photography and who created an institution that has collected and exhibited photographs for more than 150 years. That engagement with photography has continued into the present through a succession of Institution directors and curators who have built the collections that provided such a rich resource for this project. The recent leaders who have helped bring this initiative from dream to reality are the current Secretary, Lawrence M. Small, who backed his support of the idea with enthusiasm and resources, and his predecessor, Michael I. Heyman, whose long-term interest in photography is abetted by his wife, and my colleague, Therese Heyman.

The book and its offshoots, including the nascent Smithsonian Center for Photography, were prepared under the sheltering wing of the Smithsonian's International Art Museums Division (IAMD) and its director, Thomas Lentz. Barbara Croissant of IAMD lent her administrative and management skills to the cause, as did Francine Woltz and Juhee Kang. My thanks go to Stephanie Comer and the Comer Foundation for their support as well.

I am most grateful for the support and advice of the Smithsonian Photography Committee, which was formed more than a decade ago to consider issues of the collecting, care, conservation, and interpretation of photographs. This committed group of curators, archivists, and conservators includes Paula Richardson Fleming, David E. Haberstich, Jessie Cohen, Michelle Anne Delaney, Liza Kirwin, Sarah Stauderman, Ann M. Shumard, Christraud M. Geary, Colleen Hennessey, Tom Soapes, Phyllis Rosenzweig, Linda Machado, Frank

Blériot XI bis Airplane in Flight during Statue of Liberty Race
in Belmont Park, Long Island, New York, Flown by John B. Moisant
Unidentified photographer
Gelatin silver print

October 1910

NATIONAL AIR AND SPACE MUSEUM ARCHIVES

Goodyear, and Lou Stancari. It was through them, and dozens of other keepers of the Smithsonian collections, that I was able to access so many archives throughout the Institution. I also am indebted to the research and writing of Helena Wright and David Haberstich, in particular, in regard to the history of collecting photographs at the Smithsonian. The arduous work of Diane Vogt O'Connor, whose discoveries were published in the four volumes of the *Guide to Photographic Collections at the Smithsonian Institution*, helped direct me through some of the more than seven hundred photography collections housed within the Smithsonian's museums. In addition, my gratitude goes to Michael Horsley of the Smithsonian Archives for providing me with open access to the early years of Smithsonian photography and to the brilliant career of Thomas Smillie, the Smithsonian's first photographer and photography curator.

Thanks go as well to my Smithsonian colleagues who contributed written entries to the book, sharing knowledge specific to their field of study and unfolding additional layers of meaning in these photographs: Michelle Anne Delaney, Debra Diamond, Paula Richardson Fleming, Christraud Geary, David Haberstich, Amy Henderson, Pamela Henson, Susan Jewett, Liza Kirwin, Peter Liebhold, Claire Orologas, Shannon Perich, Phyllis Rosenzweig, Joanna Cohan Scherer, Ann Shumard, Steven Turner, and William Worthington Jr.

Other Smithsonian colleagues from many different museums contributed time, information, and energy to the successful completion of this book. We thank Susan Carey, Wendy Hurlock, Liza Kirwin, and Judy Throm at the Archives of American Art; Liesl Dana, Christraud Geary, Julie Haifley, Franko Khoury, and Katherine Sthreshley at the National Museum of African Art; Jill Bloomer and Stephen Van Dyk at the Cooper-Hewitt; Linda Machado, David Hogge, Rebecca Barker, John Tsantos, Colleen Hennessey, Ann Yonemura, and Bruce Young at the Freer Gallery of Art and the Arthur M. Sackler Gallery; and Anne-Louise Marquis, Amy Densford, Brian Kavanagh, and Phyllis Rosenzweig at the Hirshhorn Museum and Sculpture Garden. Our gratitude extends as well to Alan Janus, Andy Johnston, Tom Soapes, Rosemary Steinat, and Kristine Kaske at the National Air and Space Museum; Jeanne Benas, Judy Chelnick, Michelle Anne Delaney, Margaret Grandine, Reuben Jackson, Paula Johnson, Shannon Perich, Kathryn Speckart, Susan Strange, Susan Tolbert, and Roger White at the National Museum of American History; Steve Bell, Ann McMullen, Erik Satrum, and Lou Stancari at the National Museum of the American Indian; James Dean, Lisa Palmer, Sandra Raredon, Susan Jewett, and Jann Thompson at the National Museum of Natural History; Jake Homiak, Paula Richardson Fleming, and Rob Leopold at the National Anthropological Archives; Frank Goodyear, Jennifer Robertson, Ann M. Shumard, and Yvette Stickell at the National Portrait

Gallery; and Jessie Cohen at the National Zoo's photographic archives. In addition, we thank Catherine Maynor, Lynn Putney, Riche Sorenson, Abbie Terrones, Ginny Treanor, and Denise Wamaling at the Smithsonian American Art Museum; David Aguilar, Kathleen Lestition, Wallace Tucker, and Megan Watzke at the Smithsonian-Harvard Astrophysical Observatory; and William Cox, Traci Robinson, Sarah Stauderman, and Kathleen Williams at the Smithsonian Institution Archives. Thanks also go to Karen Goldman of the Smithsonian Office of Contracting and Farleigh Earhart of the Smithsonian's Office of the General Counsel, who assisted us with legal matters during the course of producing this publication.

My task was shared with Jeana Foley, whose fine eye helped shape the book, whose research enlivened many of the book's captions, and whose dedication and good humor kept both me and the project in order and moving forward. I owe her more than thanks.

Joining the team was Sam Yanes, who served as a consultant throughout the book's development; intern Robert Gravitz, who conducted initial research for the book; Robert Hennessey, who created the separations for the book; Franko Khoury, who generously offered his photography services whenever needed; and Doug Robinson, who served as our photo shoot registrar. Managing Editor Duke Johns and Executive Editor Caroline Newman at Smithsonian Books, along with copy editor Nancy Eickel, brought *At First Sight* into focus. I would also like to thank Constance Sullivan for her early advice on the book's conception and planning. Designer J. Abbott Miller of Pentagram Design, Inc., gave form to many of my wilder ideas, and his staff members Jess Mackta, Jeremy Hoffman, Johnschen Kudos, and Susan Brzozowski ensured the book came together beautifully.

Finally, I want to thank my husband, Andy Grundberg, for his patience, his generosity, and his constant good spirits. He is my hero.

Merry A. Foresta

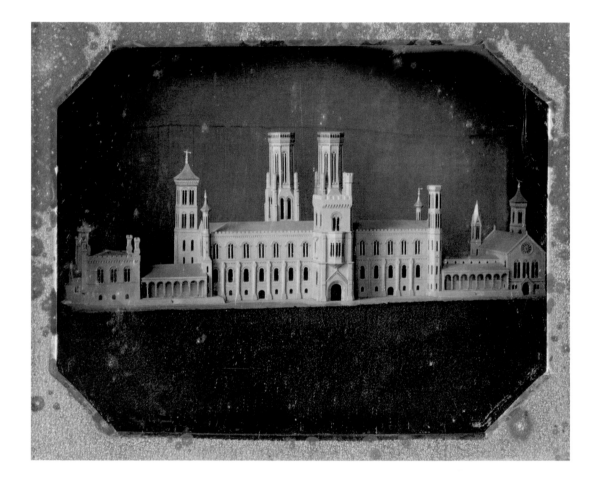

Architect's Model of the Smithsonian Institution Castle
Unidentified photographer
Daguerreotype

1846–52

AT FIRST SIGHT

PHOTOGRAPHY AND THE SMITHSONIAN

Merry A. Foresta

Images are not arguments, rarely even lead to proof, but the mind craves them, and, of late more than ever, the keenest experimenters find twenty images better than one, especially if contradictory; since the human mind has already learned to deal in contradictions. Henry Adams, *The Education of Henry Adams*, 1906.[1]

The nature of photographic images is as contradictory and confounding now as it was to historian Henry Adams a century ago. Photographs have become central to our understandings of ourselves and of the world around us, yet they remain elusive and unreliable as vessels of truth. Photographs are valuable as tools of science, history, medicine, education, and commerce, yet they are increasingly considered independent objects of art. Photographs reveal new and exciting things unperceived by the naked eye, yet they are accused of reducing experience to a lowest-common-denominator stereotype. Photographs are prized individually for their great beauty, yet much of what they have to relate is a consequence of their vast numbers. These numbers suggest that photography, as much as language, does not have one nature but many. And perhaps most confounding of all is the realization that photography, precisely because it serves a broad spectrum of purposes and intentions, has radically redefined what art is.

The Smithsonian Institution holds more than thirteen million photographs, housed in nearly seven hundred special collections and archive centers within its sixteen museums.[2] These images, and the collections in which they are found, represent nearly 160 years of collecting as well as a diverse range of impulses and intentions. Some are collections of specimens: fish skeletons, early airplane models, cast-iron bridges. Others support collections of exploration and experiment: photographs from geological surveys of the western United States territories, views of distant planets, motion studies of humans and animals. Still others, collected more recently, represent the discipline of photography itself, as both a technology and a form of art. Besides providing a unique view of the Smithsonian's sense of what at that time seemed important to document and preserve, these collections demonstrate the multifaceted significance of photography in the formation of our sense of ourselves as individuals, as a people, and as a nation.

For the most part, the Smithsonian's collections of photographs are kept in their original locations and contexts. They are, that is to say, discipline-based collections, the original purpose of which can be deduced easily from their surroundings. Each collection holds the history of that purpose, usually defined by its subject matter (peoples of Africa, flight, illustrious Americans) but sometimes based on aesthetics (the history of photography, photographs intended to be seen as art); each also tells the history of its assembly. The anthropological archive, for example, contains photographs of American Indians that were taken to document the "race" of peoples that preceded other populations on the continent. Looked at individually, some of these pictures are outstanding examples of the artistic beauty of photography. Viewed together, however, they reveal how the Smithsonian, in the name of all Americans, has used photography as a means of describing and comprehending the world.

A CHANGING WORLD

Photography was born into a changing world. In the nineteenth century the development of innovative industrial techniques and processes, including interchangeable parts, assembly-line production, and steam and electric power, altered an essentially agrarian economy and inevitably led to new political, economic, and social relations. Transportation was revolutionized by the advent of railroads, communications by the invention of the telegraph. More and more Americans were living in cities and working in factories. For many commentators of the day, it was an era of inevitable progress, of faith in the unalloyed power of rational thinking, of Manifest Destiny and a positive future.

First announced in France and England in 1839, photography emerged as part of this cultural revolution and introduced diverse ways of measuring, collecting, and illustrating the modern world. Itself a marriage of technology and the advancing sciences of chemistry and optics, photography also became nothing short of the most important record of the act of seeing. Soon after photography was announced, the surface of the moon was photographed through telescopes, microbes were captured on light-sensitive plates through the magnifying lens of microscopes, and collected plants were classified by their photogenic silhouettes. The camera's awe-inspiring realism provided what seemed to be empirical evidence, as it reinforced the nineteenth-century belief that the world could be known through precise observation. In the words of Louis Jacques Mandé Daguerre, the Frenchman who first laid claim to being photography's creator, it was nothing less than a "useful and extraordinary invention."

As with today's new technologies, photography was initially received with a combination of exhilaration about its scientific

promise and skepticism about its reliance on a machine. This debate was carried out largely in the precincts of art, where French poet Charles Baudelaire and other critics bemoaned photography's presence because it was too precise. In Baudelaire's view, it left nothing to the imagination, and imagination was the essential element of art. American writers, including Oliver Wendell Holmes, Edgar Allan Poe, and Walt Whitman, took a more benevolent and curious approach. Holmes, in an 1859 article in the *Atlantic Monthly*, called photography a "triumph of human ingenuity" and "our new art."[3] Poe deemed photography's invention the "most important, and perhaps most extraordinary triumph of modern science."[4] Such jubilant notions were well placed: within three decades photography had become an indispensable means by which Americans experienced the present, encountered the future, and made sense of the past.

Although the daguerreotype was a French invention, it proliferated in the United States more than in any other country. American photographers improved the daguerreotype process and pioneered other, less expensive means for making photographic portraits. Portrait studios — many with reception rooms and viewing salons — opened in every major city and nearly every small town. Some itinerant photographers put their equipment in the back of wagons and searched the countryside for customers. New processes and equipment led to more photographers and more and more photographs. By the time Holmes was writing in the *Atlantic*, just twenty years after photography's birth, the stereoscope had become a popular parlor entertainment.

Photography's enthusiastic adoption in the "new world" of the United States was in part a consequence of its status as an instrument of the current mechanical age. By mid-century the system of roads and canals that had been built after the War of 1812 was superseded by rail transportation. Although the first steam locomotives in America were imported from England, by the late 1830s locomotives made in the United States were being sold abroad in Austria, Prussia, and England. Charles Goodyear discovered the vulcanization process for hardening rubber in 1839. Elias Howe's first sewing machine patent dates from 1846. The next year Samuel Colt's famous revolver, with its rotating breech and interchangeable parts, was being manufactured on a production line in Hartford, Connecticut. Agriculture was mechanized as Eli Whitney's cotton gin and Cyrus McCormick's reaper came into widespread use. In 1843 Samuel F. B. Morse had secured a U.S. patent for a working telegraph, and by the end of the 1850s thousands of miles of lines had been erected throughout the United States.

Because of his invention of the telegraph, Morse played an important role in introducing photography to the United States. When he was in Paris during the winter of 1838 awaiting a French patent for the telegraph, he was introduced to Daguerre, who showed him the little

pictures he had chemically coerced to fix onto small silver-coated metal plates. Morse's amazement must have worked on several levels. For one, he himself had once experimented with light-sensitive images, but like many other early experimenters he was unable to prevent them from disappearing. He also found the detailed but ephemeral surface of the daguerreotype irresistible: it was, he wrote home to America, "one of the beauties of the age." He saw Daguerre's pictures not as representations of nature but as nearly physical traces of it. They were, he observed, "painted by Nature's self with a minuteness of detail which cannot be called copies of nature but portions of nature herself."[5] Most profoundly, he could have recognized the kinship of Daguerre's invention with his own. Both photography and the telegraph were mechanized means of communication, able to transmit messages to distant audiences and to relay distant information back home. And — perhaps this was beyond Morse's thinking at the time — both made use of codes to convey information across physical, cultural, and disciplinary boundaries.

As much as photography was born into a changing world, it also served as an agent of that change. It launched innovations in nearly every aspect of modern life, from the way criminals were tried in court to the way museums maintained visual records of artworks and the specimens of science. Photography required a recalibration of proportion, distance, and geographical difference. It changed the way people saw themselves and others. Time itself was now caught and studied, and the concept of then and now was stretched to the moment between the pictured world and the world before photography.

One example of photography's role as an agent of change is found in the modern institution we call the museum.[6] Photography was called upon to document museum collections of objects, whether paintings and sculpture or skeletons and teacups. This, of course, introduced a new collection: the repository of photographs. Photographs were especially valuable when they complemented existing displays within the institution or, better yet, could substitute for the primary objects themselves. In this way, the museum could add to its collections while it used photographs to promote and communicate information about the objects on view. Photography itself thus became collectible, able to serve the museum either by taking the place of the primary objects themselves or by preserving objects too big or too far away or too ephemeral to retain inside the museum.

Photography also redefined the fledgling field of art history. Students of art no longer had to travel from museum to museum to form opinions on great works of art, relying on memory in the process. Colleges and museums could abandon the practice of stocking plaster casts of marble sculpture and prints of oil paintings. Instead, they could gather photographs of the originals — first in the form of black-and-white lantern

slides, and later as 35-millimeter color transparencies. Journalism was similarly affected: with the introduction of halftone reproduction in the late 1880s, engravings and woodcuts no longer passed as authentic glimpses of historical events. Photography became the only acceptable witness that readers of newspapers and magazines would accept.

Our reliance on photographs undoubtedly has had consequences. In our predominately visual culture camera images have become the common coin of representation and the means by which we receive most of our information about the workings of the world. It is also the means by which we distribute and communicate much of our knowledge. Surprisingly, we know little about how the so-called power of photography works. We simply know that it does. Our modern assumption is that its allure is located in the individual image — be it striking, beautiful, poignant, unforgettable — much as we treasure certain paintings as masterpieces of their medium. Indeed, the study of photography traditionally has been rooted in a canon of images considered landmarks of their time, but this idea runs counter to the actual functioning of photographs in American life.

From the outset, photography traded in volume. Picture upon picture, thousands upon thousands — portraits, landscapes, stereo views — photographs began to form an inventory of our culture. This visual inventory deemed certain things important: the fastest horse, the tallest building, a shattered bone, our likeness in youth and old age. It preserved people we would never see again because of death or distance. We saw places we would never visit. With photographs we captured the details, if not always the meaning, of other cultures and learned to measure the distance, both physical and cultural, between the familiar and immediate and the foreign and strange. Document, art, advertisement, science, business, entertainment: the variety of purposes for which the camera is used suggests the significance of a large, multifaceted photographic archive. It also supplies the fundamental rationale for the accumulation of photographic images at the Smithsonian Institution.

PHOTOGRAPHY AND THE SMITHSONIAN

As photography was born into a changing world, the Smithsonian Institution was born into the world of photography. The Smithsonian began in 1846, when Congress accepted the generous bequest of wealthy British scientist James Smithson, and President James K. Polk signed into law the establishment of a national museum. Along with Smithson's $500,000 gift came a mandate to create a new breed of institution, the first of its kind in the United States, one devoted to the "increase and diffusion of knowledge." The Smithsonian, in joining the ranks of other newly established nineteenth-century public institutions

in England and Europe, took on a double purpose. It was conceived not only as a base for research and scientific expedition but also as a museum of preservation and display—with even an element of entertainment. In the 1850s the time was ripe to develop a uniquely American scientific and cultural tradition.

The Smithsonian set for itself a task that was as modern as its mission. Unlike seventeenth-century collectors of curiosities, who amassed specimens because they were interesting or rare, the Smithsonian set out to catalog and organize the world. The nineteenth-century natural scientists in its ranks collected specimens in hopes of linking diverse species and ultimately forging connections between the present and the origins of mankind. Since it was established as a national museum, the Smithsonian Institution's interests included the investigation of what it means to be an independent country. What would be the nation's identity? Americans in the first half of the nineteenth century had been preoccupied with separating from the cultural influence of Europe, but what would replace it? With so many different kinds of people in the United States, both native to the continent and European in origin, what was it to be an American? How big was this "new world" and what did it look like? And how did it compare to the rest of the world? Discovering the answers to these questions became a crucial subtext for collecting at the Smithsonian.

Photography, though still in its infancy, was the perfect match for this progressive mission of collecting, knowing, and showing. Not long after the camera's invention, people widely acknowledged that photographs had a particular utility as historical documents capable of preserving the past for the future. "Posterity, by the agency of photography, will view the faithful image of our times," author and photographer Lake Price wrote in 1858. Photographers would, he thought, be the scribes of permanence: "The future student, in turning the pages of history, may at the same time look on the very skin, into the very eyes, of those long since mouldered to dust, whose lives and deeds he traces in the text."[7] Oliver Wendell Holmes, writing the following year, declared that the extraordinary detail preserved in photographic images made them "absolutely inexhaustible" as a source of information.[8]

Photography, the instrument of artists as well as scientists, offered enticing pictures to viewers who increasingly delighted in seeing their world pictured, whether in splendor, with irony, or with understanding and explanation. By the 1870s photography served as an essential tool in the Smithsonian's effort to explore unknown territories and the heavens, to record the natural world, and to document significant people and events. Photographs provided powerful yet beautiful evidence of the resources and achievements of modern life.

Scientists found photography immediately useful.[9] Photographs of specimens could be closely examined with a magnifying glass and used as if they were the specimens themselves. Scientific illustrators copied directly from photographs to make engravings of natural history subjects. As early as 1856 John William Draper and other scientists were using photographs of microscopic evidence (frog's blood, for example) to teach physiology more effectively. Draper's textbook, *Human Physiology Statistical and Dynamical; or the Conditions and Course of the Life of Man,* published in New York in 1856, included woodcut copies of his original daguerreotypes and was extolled by *Harper's New Monthly Magazine* as the "first attempt on an extensive scale to illustrate a book on exact science with the aid of photography."[10] Photographs became the most effective means to further the zoologist's search for visible regularities and anomalies among animals and other organisms. Not only did they advance research through intent inspection, but they also made earlier forms of illustration nearly obsolete. The hand-drawn illustration was either a general view or a magnified view, and inevitably it was characterized by the artist's style. In a single photograph, by comparison, a zoologist possessed both types of illustration in one image: the general description of the specimen obvious to the naked eye and, when the photograph was examined under a magnifying glass, a realistic close-up view. Were it not for its lack of dimensionality and color (both problems were later addressed), a photograph, it seemed, could be a satisfactory substitute for the object itself.

Photography was useful to the Smithsonian even before its collections were assembled. A mid-nineteenth-century daguerreotype of the architectural model for the original Smithsonian building is one of the earliest photographic images at the Institution. Today we can only speculate about the reason it was made. Did the building's architect, James Renwick of Philadelphia, tire of transporting his model back and forth to his clients in Washington as they decided on one tower or two, or whether to place the windows high or low? Perhaps the daguerreotype, so much easier to carry in a pocket than even a miniature building, proved to be an excellent substitute. In the case of the proposed first building of the nation's museum, a photograph of the model could be presented at meetings, studied, or even changed. (When the building was finally completed in 1855, it lacked the model's second tower.) In the mid-nineteenth century a single photograph functioned as an extension of the thing itself, from flowers, fossils, and buildings to culture as a whole.

Photography and the natural historian's scientific catalog both emerged as new, objective fixtures of the modern era, complete with their related affiliates: the table, the index, and the archive. They

did so without critical distance, unaware of the more recent belief that photographic truth was not a given but rather something constructed, often according to institutional needs. Scientists used photography to help classify similarities and differences among species, some structural, others superficial, and they made social and scientific inferences based on photographic evidence. Natural historians came to depend upon photographic technologies to "naturalize" the field as a discipline, and they relied upon photographic mass production to disseminate their findings.

The Smithsonian's use of photography to catalog and classify nature was new but not unique. Recently created cultural institutions throughout England and Europe, such as the French Académie des sciences and London's South Kensington Museum, were immersed in ambitious initiatives aided by the new medium. In France a project called the Photographie Zoologique was announced in 1852 and was the first institutional attempt to apply the medium of photography to a systematic cataloguing effort.[11] Organized by the Muséum d'histoire naturelle and the Académie des sciences, the project proposed to assemble and publish photographs of zoological subjects. The photographic specimens included a wide range of animal subjects: shells belonging to land and sea creatures, insects, mammalian skulls and bones, and reptiles. While described in the language of pictures, the catalog was also linked to the evolving methodologies of science. The editors of the publication *Photographie Zoologique* asserted that the photographic illustrations included in the volume were "so faithful that a magnifying glass alone will render perfectly distinct all those qualities which escape the naked eye." With such professed faith in the truth of the photographic image, scientists could use photographs to define the knowledge they had so neatly collected.

In the United States, scientists adapted the idea of the Photographie Zoologique as part of an effort to record America's native populations. In 1859 Joseph Henry, the first Secretary of the Smithsonian, proposed the institution's first photographic project: making a photographic record of members of the Indian delegations that visited Washington to finalize treaties. The pictures, in Henry's words, "should be portraits of the men."

The project, however, did not begin until after 1865, when the original Smithsonian building caught fire and an exhibition of Indian portraits painted by John Mix Stanley and Charles Bird King was destroyed. In an historic, if unanticipated, turn of events, photographs served as a convenient and inexpensive substitute for the paintings. Not only were they more faithful in appearance than the paintings (and less suspect as the product of artistic imagination), but they also could be created in multiples, so any future loss could be remedied

quickly and inexpensively. As substitutes for the Indians, they could be labeled, catalogued, and studied. The photographic portraits provided a record of individuals as well as an index to tribal histories, and within them were the makings of other collections, ones based on decorative apparel, body decoration, and tribal differences.

Under the guidance of Ferdinand V. Hayden of the U.S. Geological Survey and with the financial support of William Blackmore, several photographers in Washington, D.C., were hired to photograph members of native delegations when they visited the nation's capital. (The already completed work was purchased, and Antonio Zeno Shindler, a photographer and gallery proprietor, copied it.) Eventually the list of photographers who participated included Alexander Gardner, Julian Vannerson, Charles Savage, George M. Ottinger, William Henry Jackson, and Joel E. Whitney. In 1867 more than three hundred of these pictures were hung in the newly repaired and renovated Smithsonian building in the Institution's first exhibition of photographs, *Photographic Portraits of North American Indians*, and a catalogue was printed.[12] Later these photographs formed the Smithsonian's first significant photography collection.

More photography collections, of course, were amassed over time.[13] The history of their coming into being, while connected to the Institution's establishment and growth, provides a chronology of attitudes about photography from the mid-nineteenth century to the present. Decisions about what to collect were not always conscious and specific. In some cases, groups of photographic material were accumulated informally in the course of accomplishing other tasks, such as undertaking Smithsonian expeditions or documenting scientific experiments. Other collections of photography came into being only when the value of the imagery and objects contained within them was recognized or when photographs of a particular subject were later deemed significant.[14]

Although an official Section of Photography was not established until July 1896, a collection relating to the history of photography was assembled at the Smithsonian as early as 1888. For the modest sum of $23, the Smithsonian acquired the daguerreotype camera and photographic apparatus used by Samuel Morse. Thomas W. Smillie, chief photographer at the Institution, who subsequently became custodian of its Section of Photography, called these objects "specimens."[15] Albert Moore, the owner of the equipment, offered it for sale on the strength of a rumor that Smillie was "making a museum of photography."[16] While little corroborating evidence indicates that any serious consideration was being given to such an initiative, records show that the "specimens" were immediately accepted and a photography catalog was duly begun.

Smillie's duties as the chief—and, for most of his tenure, only—photographer for the Smithsonian were many. He photographed museum installations and specimens collected by the Smithsonian. He created reproductions for use as printing illustrations, and as a consultant on inks for the U.S. Post Office Department he acquired several patents for photographic printing. He documented the construction of Smithsonian buildings, acted as a chemist and adviser for Smithsonian scientific researchers, and served as the photographer on scientific research expeditions. In 1900, when the Smithsonian Astrophysical Observatory loaded several railroad cars with scientific equipment and headed to Wadesborough, North Carolina, to observe an expected total solar eclipse, Smillie headed the team of photographers that took an unprecedented record of the event. His photography lab at the Smithsonian was state of the art and his output prodigious. During a one-year period Smillie's office produced a total of "1,328 negatives, 3,615 silver and velox prints, 6,447 blueprints (cyanotypes), 28 bromide enlargements, and 74 rolls of film taken in the field."[17]

Smillie's activity matches the interests and expansion of the Smithsonian itself. The Smithsonian annual report for 1870 recorded that Smillie "fitted up a photographic apartment ... in which photographs are taken of specimens of archaeology and of natural history for illustrating the publications of the institution, and for distribution to other museums. During the past year a large number of food-fishes and prehistoric remains have been photographed." In 1874 Smillie produced "a series of ethnological and natural history specimens for the use of the Institution, and a large amount of copy work for others, especially for the Government surveys." Other reports mention Smillie's photographic experiments and the instruction he gave to expedition scientists who desired to "acquire some knowledge of this art preparatory to their departure on various expeditions." By 1886 Smillie's list of photographs included subjects from a growing array of disciplines: ethnological and archaeological, lithological, mineralogical, ornithological, metallurgical, and perhaps the most popular category of all, miscellaneous. Even more significant to the growth of collections was the multitude of prints made for catalogues, reproduction, and enlargements for public exhibitions. The Smithsonian's accomplishments, in the form of photographs, were being advertised to the world.

By 1888 Smillie was not so much making a "museum for photography" as he was preparing an exhibition *about* photography. At almost the time he was negotiating for Morse's camera, Smillie was hard at work on a display for the 1888 Ohio Centennial Exposition. By the last decades of the nineteenth century people were most likely to see photographs at industrial fairs and international cultural expositions. These immense displays of modern progress were meant to illustrate

the newest technologies that were transforming contemporary life, from train travel to automated sewing machines to photography. As early as 1840 photographic displays were included in the wide range of commercial objects on display at industrial fairs, and they were evaluated in the awards handed out to fine art objects and technological innovation. As Julie K. Brown points out in her study of nineteenth-century visual presentations, "Photographs in publications and displays were meant to embody an idea of progress in which the application of technology served the public good. … Photography was part of, as well as essential to the work of the nation."[18]

While the Ohio exposition was by no means the first time photography was put on view, it marked a new approach to photographic display. In the words of George Brown Goode, Assistant Secretary of the Smithsonian, photography would now have a place within the larger context of artifacts illustrating "human culture and industry in all their phases."[19] In other words, examples of the art and science of photography would be presented alongside exhibits of fossils, botanical drawings, stuffed birds, mechanized sewing machines, and the world's largest steam locomotive. Smillie's exhibit for the Ohio Centennial Exposition included his own photographs, a back-lighted wall of glass transparencies of western views taken by U.S. Geological Survey photographers, examples of images made by the latest technology produced by Eastman Dry Plate and Film Company and other manufacturers, and cases of cameras, including the historically important Morse camera.

By 1913, the year of the establishment of the first Smithsonian Hall for Photography in the Arts and Industries building, Smillie had developed an additional aspiration for the medium of photography. This opening exhibition primarily told a history of photography based on technological advances. Smillie, however, was attentive to the increasing presence and significance of photography as an art form and had already acquired a small collection of early art photography, including works by Oscar Rejlander, Julia Margaret Cameron, and Henry Peach Robinson. In 1911 Smillie wrote to Alfred Stieglitz on behalf of the Smithsonian, requesting a collection of works by the esteemed photographer and his associates. Stieglitz was at the time the leading figure in photography's long battle to be recognized as a form of art equal to painting and drawing. He had founded a group of artistic photographers called the Photo-Secession, opened a gallery in New York to show their work, and published the influential journal *Camera Work*. Not surprisingly, the photographs that represented Stieglitz's ideas about what the art of photography could be were largely in the style now know as Pictorialism — softly focused, idyllic images of agrarian landscapes, muted portraits, and genre scenes that evoked pre-industrial life. The collection of twenty-six prints chosen for the

Smithsonian illustrated a range of types, from platinum prints to photogravures, and included work by Annie Brigman, Frank Eugene, Edward Steichen, and Stieglitz himself.[20] Significantly, he also included works by earlier photographers, such as Cameron and the Scottish portrait team of Hill and Adamson, thereby sketching a history that confirmed the place of his choices, and his aesthetic, in the lineage of art photography. Consciously or not, Stieglitz's selection was a rejection of Smillie's own brand of photography, which was in the service of science and technology.

IN AND OUT OF THE ARCHIVE

Even so, Smillie and Stieglitz shared what would then have been considered a vanguard consciousness about photography: they recognized it as a distinct field or discipline that was defined by its own history of practice and use. For Smillie, the history of photography was the sum of all its functions, from the most prosaic to the most aestheticized. Stieglitz, however, saw photography in the same progressive sense that framed the study of American history and the development of science and technology. Since its beginnings, he believed, the medium had developed and grown ever more sophisticated, so that by his own generation in the early 1900s its potential as a form of art had been finally achieved and recognized. Photography's scientific, vernacular, and commercial functions were for Stieglitz something that the history of photography could afford to ignore, since the important consideration was the fulfillment of its aspirations to become an art.

For most of the twentieth century Stieglitz's view of photography's historical narrative prevailed. Indeed, it continues to define the way in which most art museums present and promote photography. The most influential history of photography, first written by Beaumont Newhall in 1937 and since updated five times, essentially elaborates on Stieglitz's progressive notion, seeing "modern photography" as the fulfillment of the aesthetic potentials inherent in the medium from the start. Museum collections of photography — many of them formed since the photography boom of the 1970s — follow an outline of Newhall's canon of masters and masterpieces from 1839 to the present day that is separate from the larger, more anonymous archive of images.

There is something anomalous about such collections, however. Many of the photographers whose works are included — Felice Beato, Samuel Bourne, Timothy O'Sullivan, William Bell, Dorothea Lange, and Harold Edgerton, to name but a few — never thought of themselves purely as artists and never intended for their photographs to be viewed primarily (or at all) as art. Nineteenth-century photographers such as Cameron, who self-consciously fashioned her tableaus and portraits to

resemble paintings, share the flat files with expeditionary photographers whose pictures only in retrospect can be read as romantic landscapes in the picturesque tradition. The dominant view of photography history in the twentieth century, it can be argued, forced the medium into a Procrustean bed of art for art's sake.

Smillie's idea of the history of photography remains a promising alternative to Stieglitz's heritage. In his 1913 exhibition in the Smithsonian's Arts and Industries building, Smillie arranged the photographs in a rough chronological order in displays that highlighted their value as documents of history, as portrayers of American life, as tools of science and technology, and as artistic images. Even so, nothing about the exhibition suggested that one function of photography was elevated above any other, or that there was a progression from the realm of science to that of art. Compared to Stieglitz, Smillie was a pre-modern holdover from the previous century, but today his vision of the medium seems almost post-modern.

At heart, Smillie's view of photography presented a unified field in which art and function are inseparable. This could be said to apply not only to the enterprise of photography as a whole but also to individual images. We might think, for example, given the way in which the history of photography is now written, that there would need to be at least two distinct and different kinds of photographic images: ones useful for the fields of science, history, and cultural memory, and others that are collected as art because they are simply beautiful. Experience has shown that this is not the case. Most truly useful photographs have an innate and undeniable beauty, and most beautiful photographs either were or are also useful.

Smillie's original aspiration for an omnibus collection of photography at the Smithsonian was superseded by the rapidly expanding collections themselves and by the building of museums to house them. On the one hand, Smillie and the Institution, busy with the practical work of photography, did not create a central focus (no exhibition gallery, no *Camera Work*) to become a worthy competitor to the convictions of Stieglitz. On the other hand, because the Smithsonian did not develop a single repository for photographs, its diverse collections for the most part remain based in the disciplines that created them. The disciplinary nature of the Smithsonian's collections offers several advantages. From a historical perspective, we can more easily appraise the contexts in which the photographs were originally collected and thus ascertain the meanings they may have had when they were made. Photographs of bridges and dams are mostly found in the American History Museum's Division of the History of Technology, photographs of fishes and birds reside in Natural History's Department of Vertebrate Zoology, and portraits of famous Americans for the most part are housed in the National Portrait

Gallery. Some subjects, such as Native American culture, span many collections and meanings.

As new technologies multiply the number and kind of photographic images even further, we are again fascinated with the ability of photographs to function across many disciplines, often simultaneously and in broad ways. For instance, does Mathew Brady's 1868 portrait of a Ute delegation belong at the National Portrait Gallery, where it can be prized for the individuality of its subjects, or should it reside among the several hundred thousand photographs of American Indians in the National Anthropological Archives at the National Museum of Natural History? Does it belong in the social-history archives of the National Museum of the American Indian, or should we focus on Brady's artistry at the Smithsonian American Art Museum? Today we might covet a single example of Brady's work because it is beautiful, but we are also in danger of losing the key to its larger meaning. The fact is, Brady's portrait rightly belongs in several archives — and today, thanks to the development of digital image databases and online access, it can virtually reside in all of them.

The process of looking at photographs from a variety of disciplines and functions provides insight into the real nature of photography and furnishes a broader understanding of how these images communicate culture, and in turn how culture communicates itself. In this sense, the selection of photographs that follows complements the better-known achievements of photography. The works allow us to reconsider the ways we look at photographic images and appreciate how these photographs have the power to shape and influence our views. In a world increasingly awash with photographs and reproducible images of all kinds, we are still moved by what a photograph reveals. Why? In the dynamic and open-ended process of finding the answer, we may realize that past art histories of photographic meaning are limited and can be supplemented with additional meanings that may have more in common with science than art, or share a language that borrows from both.

These images represent an attempt to recognize photography's multidisciplinary nature. The book's four sections move across history, geography, time, and traditional disciplinary distinctions. The first, "A New World," concentrates on the marvel of photography: seeing images for the first time and what new things the camera reveals. The next, "Proofs Positive," presents photography in service to empirical science and looks at the essential role it has played in making certain scientific discoveries possible. "A Democracy of Images" examines the popularization of photography and its part in everyday life. The final section, "Seeing as Believing," reflects contemporary awareness of how photography has fashioned modern culture and how it has emerged as an intentional art. It is a consideration of the nature of representation itself and

of how, in a very purposeful way, photographers in all disciplines have used the medium to describe, inspire, influence, argue, and communicate.

For most of us, the words "at first sight" automatically summon associations of recognition and amazement. It may surprise everyone who loves both photography and the Smithsonian to realize that never before has the Institution been mined systematically as a photographic resource. The works presented here merely scratch the surface of the Smithsonian's photography collections. They were selected because they hold our attention and make us think not only about beauty but also about purpose.

1. Henry Adams, *The Education of Henry Adams* (1907; reprint, Boston and New York: Houghton Mifflin, 2000), 489.

2. While never completed, the four-volume *Guide to Photographic Collections at the Smithsonian Institution*, edited by Diane Vogt O'Connor (Washington, D.C.: Smithsonian Institution Press, 1989–95), remains the best overview of photography holdings at the Smithsonian.

3. Oliver Wendell Holmes, "The Stereoscope and the Stereograph," *Atlantic Monthly* (June 1859), reprinted in Vicki Goldberg, *Photography in Print* (New York: Simon and Schuster, 1981), 100–14.

4. Edgar Allan Poe, "The Daguerreotype," *Alexander's Weekly Messenger* (15 January 1840), 2, reprinted in *Literature and Photography: Interactions 1840–1990*, edited by Jane M. Rabb (Albuquerque: University of New Mexico Press, 1995), 4–5.

5. Samuel F. B. Morse, letter dated 15 March 1839, to his brothers Richard and Sidney, publishers of the *New York Observer*, who published it on 20 April 1839.

6. For a thorough discussion of the establishment and agendas of nineteenth-century institutions in Britain and Europe and the development of photography collections, see Mark Haworth-Booth and Anne McCauley, *The Museum and the Photograph: Collecting Photography at the Victoria and Albert Museum, 1853–1900* (Williamstown, Mass.: Sterling and Francine Clark Institute, 1998).

7. Lake Price, *American Journal of Photography*, n.s. 1 (1858–59), 148, cited in Robert Taft, *Photography and the American Scene, A Social History, 1839–1889* (1938; reprint, New York: Dover Publications, 1964), 137.

8. Holmes, *Atlantic Monthly* (June 1859), in Goldberg, *Photography in Print*.

9. Recent exhibitions and catalogues have begun to pay special attention to the subject of science and photography. See *Beauty of Another Order: Photography in Science* (Ottawa: National Gallery of Canada, 1997) and *In Visible Light: Photography and Classification in Art, Science and the Everyday* (Oxford, England: Museum of Modern Art, Oxford, 1997).

10. John William Draper, *Human Physiology Statistical and Dynamical; or the Conditions and Course of the Life of Man* (New York: Harper and Brothers, 1856).

11. For the institutional contexts in which early natural scientists connected scientific objectivity and photography and an examination of Photographic Zoologique, see Jeff Rosen, "Naming and Framing 'Nature' in Photographie Zoologique," *Word and Image* 13, no. 4 (October–December 1997), 377–91.

12. For a complete history of this exhibition and catalogue, see Paula Richardson Fleming, *Native American Photography at the Smithsonian: The Shindler Catalogue* (Washington, D.C.: Smithsonian Books, 2003).

13. For a chronology of collecting photography at the Smithsonian, see David E. Haberstich, "Photographs at the Smithsonian Institution: A History," *Picturescope* 32, no. 1 (summer 1985), 5.

14. See Helena E. Wright, "Developing a Photographic Collection: National Museum of American History," *History of Photography* 24, no. 1 (spring 2000), 1–6.

15. Thomas Smillie, "History of the Department of Photography," Smithsonian Institution Archives, record unit 55, box 22, file 10.

16. Haberstich, "Photographs at the Smithsonian," 7.

17. Richard Rathbun, "Report on the Progress and Condition of the U.S. National Museum for the Year Ending June 30, 1908" (Washington, D.C., 1909), 60; quoted in Haberstich, "Photographs at the Smithsonian," 6.

18. Julie K. Brown, *Making Culture Visible: The Public Display of Photography at Fairs, Expositions and Exhibitions in the United States, 1847–1900* (OPA: Harwood Academic Publishers, 2001), 3.

19. George Brown Goode, "Report upon the Progress and Condition of the U.S. National Museum for the Year Ending June 30, 1888," in *Annual Report of the Board of Regents of the Smithsonian Institution* (Washington, D.C., 1890).

20. A complete list of photographers includes J. Craig Annan, Annie Brigman, Julia Margaret Cameron, Alvin Langdon Coburn, Robert Demachy, Baron A. de Meyer, Frank Eugene, Frederick Evans, Hill and Adamson, Gertrude Käsebier, Joseph Keiley, Heinrich Kuhn, Edward Steichen, Alfred Stieglitz, and Clarence White. Stieglitz offered them for a price of $800; Smillie negotiated a final price of $200. See Smillie-Stieglitz correspondence, Office of the Registrar, National Museum of American History, Behring Center, accession file no. 55701.

Carnegie Cat

Richard Barnes

Gelatin silver print

2002

Animal Locomotion

Richard Barnes

Gelatin silver print

1993

HIRSHHORN MUSEUM AND SCULPTURE GARDEN

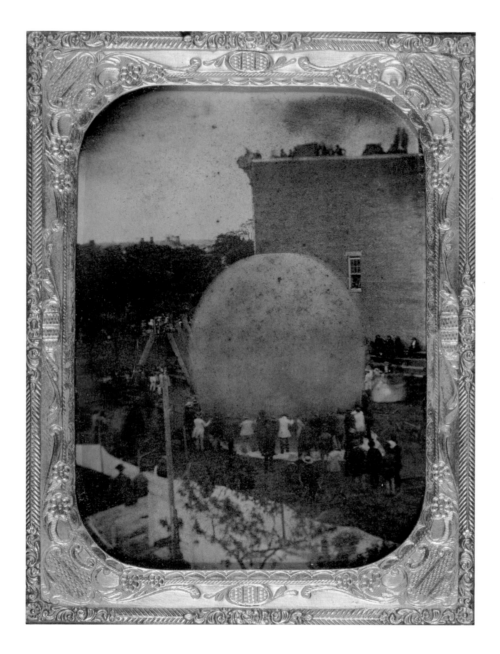

Inflation of John Steiner's Balloon

Unidentified photographer

Ambrotype

1857

A NEW WORLD

By the late 1830s, when Louis Jacques Mandé Daguerre and William Henry Fox Talbot each announced that they had independently succeeded in fixing the image produced by a camera obscura, photography seemed to indicate the culmination of a long fascination with the activity and mechanics of seeing. The camera's lens, scientists of the eighteenth century believed, was an apt metaphor for how the human eye worked. In addition, the camera's lens was the optical counterpart of a system of perspective that had served painters since the Renaissance. It depicted the world from a single fixed vantage point, and in doing so it fixed the position of the spectator as being apart from and in front of the scene. The only difference was now the picture itself was fixed, frozen in time and space by the action of light itself.

The invention of photography thus marked the birth of a new and complex paradigm for sight. Images taken directly from nature could now be imprinted on glass plates and paper, without the hand's intervention. The technology of picture making—wooden box cameras, glass lenses, and chemical formulae—occupied one part of photography's enterprise. The camera's product, photographic images themselves, was another matter. Photography, by its very nature and by design, generated exciting ways to see the world; it also came to bear witness to a world transformed by scientific advancements like itself.

Not surprisingly, the earliest announcements of photography took the form of exclamations of revelation. "Wonderful wonder of wonders!" an enthusiastic New York newspaper writer declared in 1839. Photography was, wrote another journalist, "a discovery ... that must make a revolution." And yet another writer proclaimed after seeing the first photographs that "their exquisite perfection almost transcends the bounds of sober belief." The thrill of photography was twofold: familiar things seen in new ways were joined with images of things never before seen.

Working without technical precedent, early photographers had to be inventive and imaginative. Many of the first of this new breed were scientists, telescope makers, doctors, metallurgists, and inventors— all skills useful in managing light, chemistry, and imagination. Cameras were made to fit onto the eyepieces of microscopes and telescopes; apparatus for carrying them and the requisite plates and solutions was devised for travel and exploration. Just as fascination accompanied this

new medium, questions surrounded it as well. Artists and scientists, along with a public captivated by the new invention, wondered what power this modern instrument would wield. Today we have an answer: it has changed forever the way we see the world.

For one, photographs provided a new way of looking at ourselves. Among the first images made in America was a self-portrait taken by a young telescope maker from Philadelphia, Henry Fitz Jr. (page 37). He closed his eyes to keep from blurring the picture during the required long exposure, and he dusted his face with white powder to intensify the transmitting power of the natural light. The result is a demonstration of brash American ingenuity and of photography's potential as a portrait medium. (Daguerre himself had earlier expressed doubts about the camera's ability to capture with success the details of the human face.) It also introduces another necessary photographic element: thoughtful contemplation.

Photography ushered in a period in the history of representation when portraiture was no longer restricted to the wealthy. Even those with moderate income could afford portraits of themselves, their friends, and their families. The earliest photographs required exposures of several minutes — sitting before the camera demanded patience — and a standard vocabulary of posing developed. Sometimes a brace kept the head from moving; often the sitter leaned against a table. Books suggested wisdom, flowers complemented beauty, and a classical column signaled a noble character. As self-consciousness about posing increased, so did the desire to present the best self for the camera. Second nature to us now, the photographic portrait began as an act of self-preservation. Photography provided even the most average person with a permanent record of having been.

The changing world into which photography was introduced brought with it new categories of people to describe. Perhaps the many daguerreotypes made of slaves, former slaves, and abolitionists testify to the implied freedom that a pictured identity could impart. Celebrated individuals relied on the photographic image to convey a public identity. Frederick Douglass's photograph, for example, supplied proof of person: of blackness, of self-confidence and self-awareness, and of the changing face of America.

With photography, Americans could see the world beyond their borders. One of the fledgling medium's functions became communicating information about other places, other people, and other cultures. Much like Samuel Morse's telegraph, the photograph presented one distant part of the world to another. In response to global expansion of western political and economic interests in the nineteenth century, photographers highlighted cultural differences. Grand schemes to compare and contrast races with the aid of photographs were launched

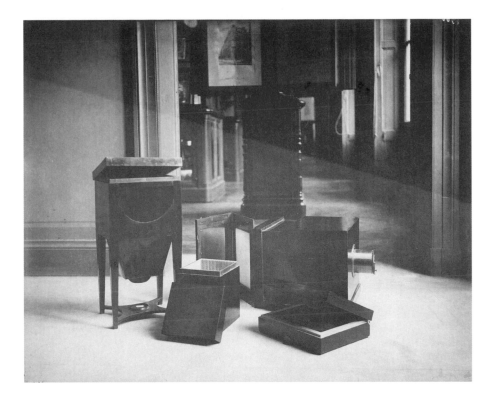

Samuel F. B. Morse's Daguerreotype Equipment
Thomas Smillie
Cyanotype

ca. 1888

in the late 1800s. With few exceptions, American Indians constituted the primary subjects of ethnographic studies in the United States, but the public appetite hungered for pictures of Japanese, Egyptian, and African subjects as well. Sadly, most of these highly embellished portraits reflect the preconceptions of western photographers and their audiences more than they describe verifiable cultural differences.

Still, photography brought the faraway near. Cameras were carried everywhere, and the resulting photographic prints often were published in handsome albums. Immediately the camera was seen as an indispensable accompaniment to any scientific expedition. It could document information. It gave people access to a world they might only be able to experience in pictures. In artistic terms, it could record a picturesque view of natural landscapes untouched by the advances of modern civilization. How these seemingly disparate capabilities coexisted is evident in the work of John B. Greene, who actively studied both photography and ancient cultures, and became one of the earliest archaeologists to use the new medium in his research (page 48). Some of his

Photographic Printing Experiments
William Henry Fox Talbot
Calotypes

ca. 1839

"Miscellanea Photogenica"
William Henry Fox Talbot
Ink inscription on paper folder

ca. 1840

NATIONAL MUSEUM OF AMERICAN HISTORY
DIVISION OF INFORMATION TECHNOLOGY AND SOCIETY
PHOTOGRAPHIC HISTORY COLLECTION

work consists of precise depictions of ancient Egyptian architecture, sculpture, and hieroglyphics; other images resemble evocative watercolors rather than systematic records.

Nineteenth-century photographers surveyed the geological monuments of the Southwest on behalf of the government, while other intrepid souls ventured on their own to Yosemite, taking large-plate images that they sold in the boom town of San Francisco. The first of these Yosemite photographers, Charles Weed, traveled on to Japan, where he took landscape pictures intended to enlighten American audiences about this mysterious land (pages 58–59). We still depend on photography's ability to give visual authenticity to places we might never see in person, even if today images of Mars and distant galaxies are beamed back to Earth in a stream of digital data.

In the early years of the industrial age, photography found one its most enduring roles in depicting other recent inventions. Among frequently photographed subjects were new means of transportation — first automobiles and airplanes, then jets and rockets — and those

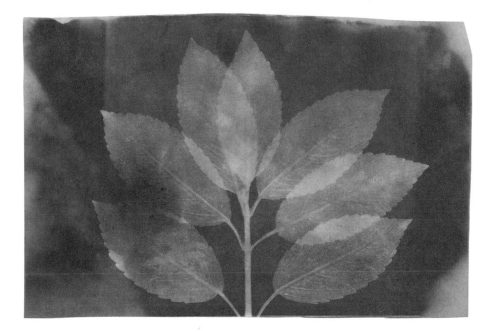

Branch of Leaves of *Mercurialis perennis*

William Henry Fox Talbot

Calotype negative

1839

NATIONAL MUSEUM OF AMERICAN HISTORY
DIVISION OF INFORMATION TECHNOLOGY AND SOCIETY
PHOTOGRAPHIC HISTORY COLLECTION

forms that never got much beyond the drawing board, such as propeller-powered bicycles. The speed and mobility of these inventions were analogous to photography itself. Compared to drawing, the camera accelerated the picture-making process to an astonishing speed, providing a new kind of free-ranging armchair travel. In short order, bicyclists rode into the countryside with cameras at their sides, and airplane pilots leaned out of cockpits to show the Earth from the vantage point of a bird. As photography itself became a standardized, assembly-line process in the late nineteenth century, photographers entered factories to record industrial advancements and their products. Scientists devised ways to use the camera to make new discoveries that would lead to still other inventions. Photography, in essence, became an indispensable instrument of the emerging technological society. Today, in an era of yet another quantum technological advance, the medium retains its significance, even as its own processes shift from film and chemistry to electronic, digital recording.

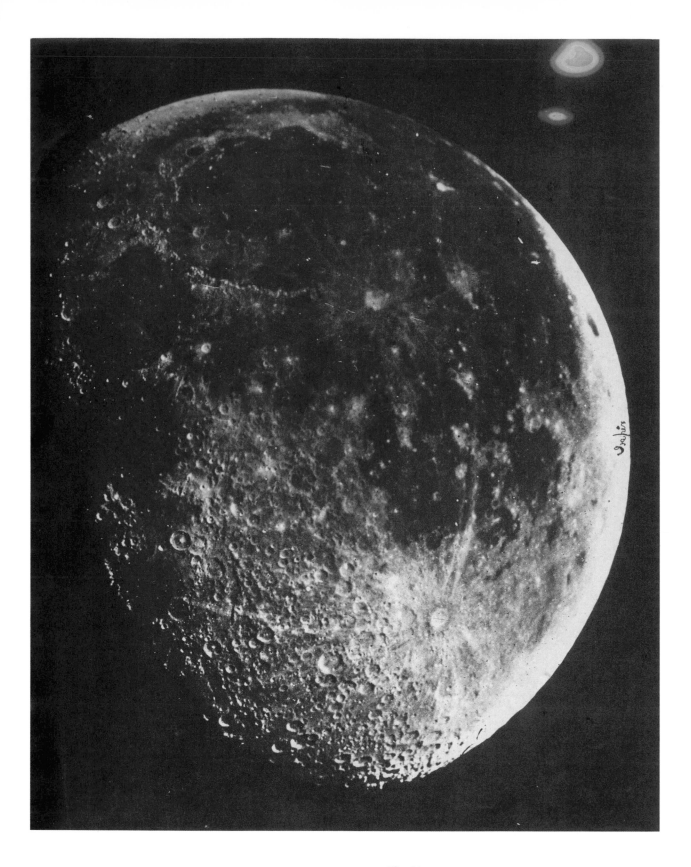

The Moon

Henry Draper

Cyanotype

1863

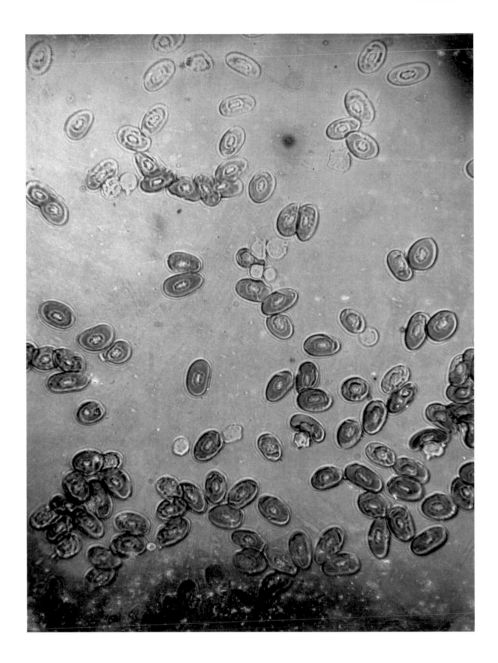

Photomicrograph of Frog Blood
John William Draper
Daguerreotype

ca. 1844

A multitalented scientist and inventor, John William Draper was a chemistry professor at the University of New York, where he conducted research in numerous fields, from medicine and philosophy to spectrum analysis and photography.

His son Henry Draper was equally talented in the sciences and used photography to pursue his interest in astronomy. Both Drapers experimented extensively with harnessing the power of photography as a tool for their scientific work. They invented cameras that fit on microscopes and telescopes, allowing each to see, and then photograph, the unseen.

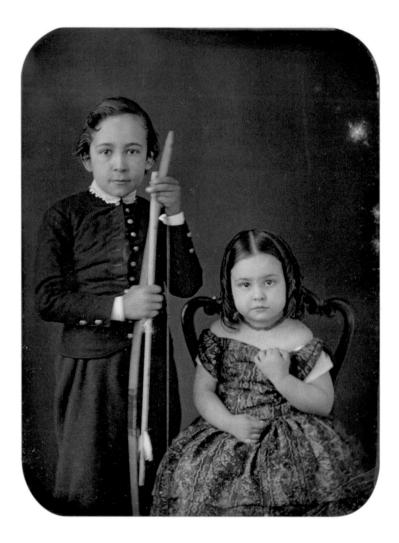

Thomas Eakins and Frances Eakins

Unidentified photographer

Daguerreotype

ca. 1851

NATIONAL PORTRAIT GALLERY

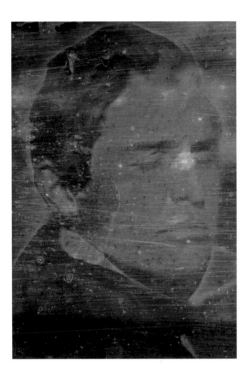

Self-Portrait
Henry Fitz Jr.
Daguerreotype

November 1839

NATIONAL MUSEUM OF AMERICAN HISTORY
DIVISION OF INFORMATION TECHNOLOGY AND SOCIETY
PHOTOGRAPHIC HISTORY COLLECTION

This daguerreotype of Henry Fitz Jr. with his eyes closed is one of the first known photographic self-portraits. Fitz, an early innovator in the new field of photography, opened a daguerreotype studio in Baltimore in 1840. Later, as an accomplished and well-respected optician in New York City, Fitz became well known for making high-quality lenses for early cameras and telescopes. The dreamy look in this self-portrait was actually the result of the long, five-minute exposure time in bright light that early daguerreotype cameras required of sitters.

A NEW IDENTITY

Ann M. Shumard
National Portrait Gallery

When the daguerreotype process was introduced in 1839, its originator, Louis Jacques Mandé Daguerre, doubted it would prove practical for portraiture because of the lengthy exposure times it required. This obstacle failed to deter the first intrepid experimenters, who reasoned that the daguerreotype's greatest value lay in its potential as a portrait medium. Initial attempts at portraiture yielded images such as the Fitz self-portrait, which were remarkable as technical achievements but fell short of capturing likenesses that were natural in pose or conveyed a sense of the subjects' vitality. Yet by the close of 1840, modifications to the daguerreotype's chemistry, coupled with the development of better lenses and lighting techniques, had dramatically reduced exposure times and paved the way for commercial portrait photography.

Offered at moderate prices that made them affordable to customers across the economic spectrum, daguerreotype portraits found a ready market with the public. Ordinary citizens whose ancestors had never posed for a likeness and whose own financial circumstances placed them beyond the reach of traditional portraiture now joined the nation's elite in having their pictures made. The majority of these portraits were intended as personal keepsakes, and demand for family images was strong. While children typically posed with a parent or sibling, some of the most intriguing portraits document extrafamilial relationships, such as those between African American caregivers, either free or enslaved, and the white children in their charge (page 43).

At first, simple representation was enough to satisfy most portrait customers. In time, however, photographers and their subjects began to take an interest in creating images that revealed something of a sitter's character or identity. Such efforts met with varying degrees of success, and the results could sometimes be extraordinary. A case in point is the riveting image of radical abolitionist John Brown by the African American daguerreotypist Augustus Washington. Made more than a decade before the ill-fated raid at Harper's Ferry, this portrait gives tangible expression to Brown's abolitionist fervor by depicting him with one hand raised, as if pledging his life to the destruction of slavery.

As daguerreotypes gradually gave way to newer, more economical, and increasingly flexible processes in the 1850s, the demand

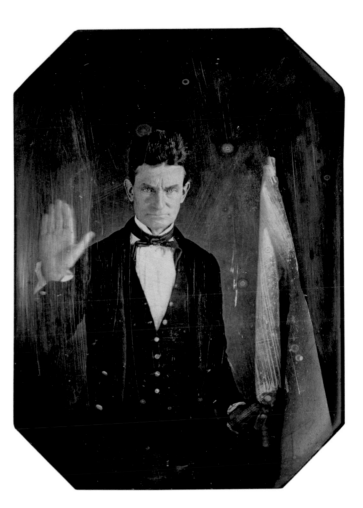

John Brown
Augustus Washington
Daguerreotype

ca. 1846–47

NATIONAL PORTRAIT GALLERY

for portraits soared. Public desire for images fueled competition among photographers, who in turn vied for the opportunity to secure likenesses of marketable subjects, from exotic Native Americans to rising politicians. Those in the public eye soon recognized the utility of photographic portraiture in projecting a popular persona. When Abraham Lincoln won the presidency in 1860, he acknowledged the role that Mathew Brady's portrait had played in his election. In October of that year a visit to Brady's newest portrait gallery prompted a writer for the *New York Times* to declare, "All our books, all our newspapers, all our private letters — though they are all to be weighed yearly by the ton, rather than counted by the dozen, — will not so betray us to our coming critics as the millions of photographs we shall leave behind us." This observation, made just twenty years after the first portrait studio opened in the United States, speaks volumes about the extent to which photographic portraiture had come to shape the way in which Americans viewed themselves and others.

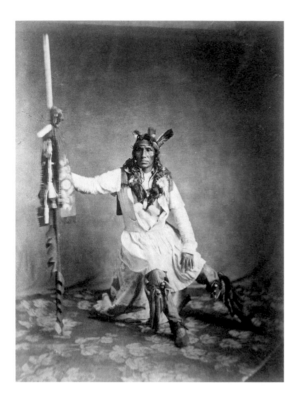

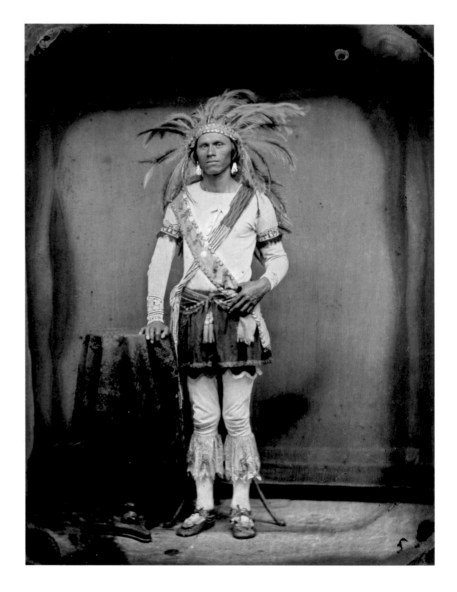

Portrait of Tshe-Tan Wa-Ku-Wa Ma-Ni
(Chief Hawk That Hunts Walking), called Little Crow
Julian Vannerson and James McClees
Albumen print

1857

Tonawanda Seneca Sachem Nishaneanent
(Chauncey Abrams)
Unidentified photographer
Ambrotype

ca. 1855

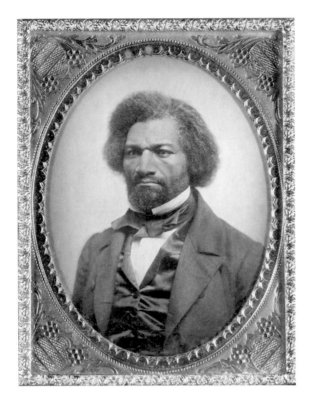

Frederick Douglass

Unidentified photographer

Ambrotype

1856

NATIONAL PORTRAIT GALLERY

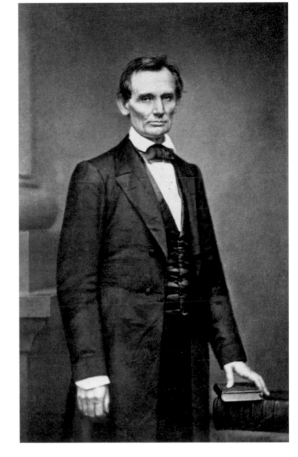

Abraham Lincoln

Mathew Brady

Salted-paper print carte-de-visite

1860

NATIONAL PORTRAIT GALLERY

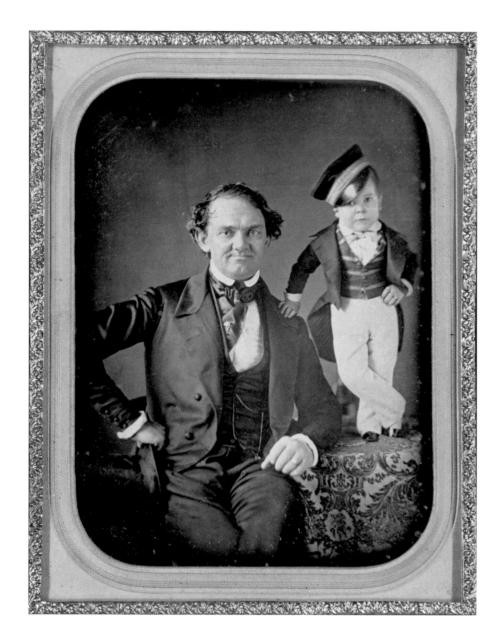

P. T. Barnum and "Tom Thumb"

Attributed to Samuel or Marcus Root

Daguerreotype

ca. 1850

NATIONAL PORTRAIT GALLERY

Showman extraordinaire P. T. Barnum had his first huge sideshow success when he discovered the diminutive Charles Stratton in 1842, who at age five weighed fifteen pounds and stood twenty-five inches tall. After teaching the child to sing, dance, and act, Barnum christened Stratton "Tom Thumb" and billed him as an eleven-year-old. They traveled around the world, performing for the public, kings, queens, and presidents. Barnum, who well understood the power of photography as a promotional tool, peddled photographs of his performers as collectible souvenirs.

Woman and Child

Jeremiah Gurney

Daguerreotype

1850

SMITHSONIAN AMERICAN ART MUSEUM

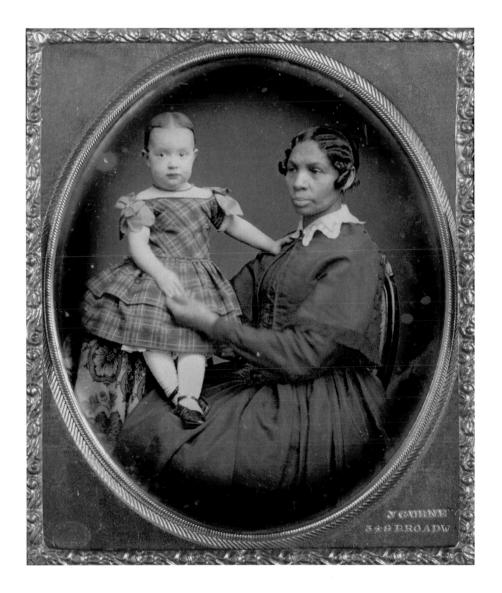

PHOTOGRAPHIC TRADE: PORTRAITS INTO POSTCARDS

Christraud Geary
National Museum of African Art

In the second half of the nineteenth century, photography spread along the African coasts. As European photographers opened studios in major coastal cities, Africans who lived in these towns became increasingly familiar with this new technology. Some entrepreneurial Africans took up photography themselves. In West Africa photographers traveled along the coast from Liberia and Sierra Leone to the Gold Coast, now Ghana, and to present-day Nigeria. They carried their equipment with them — cumbersome cameras, tripods, and backdrops — and in each location set up open-air studios. Africans also began to patronize local photographic establishments, in some instances studios run by Europeans and photographers from the Near East. Photography was modernity par excellence, and having one's portrait taken visually proclaimed one's position and status in society. Many early portraits commissioned by African sitters have survived: numerous ones are in photographic albums, others remain in European archives, and some exist in an unexpected form — as postcards.

Produced by the millions since 1898, postcards enjoyed great popularity, especially during their heyday before World War I. Mailed and collected, they were akin to illustrated magazines of today. Their imagery covered a wide spectrum of themes, ranging from peoples, cities, and landscapes to topics now considered the domain of newspapers, such as images of royalty, political events, and even natural disasters. Thus, it is not surprising that some private photographic portraits of Africans circulated as postcards. How they migrated to the postcard medium, however, is a vexing question. Photographers may have fed them into the production pipeline and shipped the negatives to publishers in Europe, who in turn produced them as postcards. Color photography, of course, did not yet exist, so the publishers relied on colorists to embellish some of these cards and make them more appealing and realistic. Since these colorists had never been to Africa, the invented combinations of colors on the cards reflect Western fantasies and misconceptions about Africa and Africans. Color schemes might change when popular postcards were reprinted.

A group of postcards in the Eliot Elisofon Photographic Archives of the National Museum of African Art, taken in the vibrant

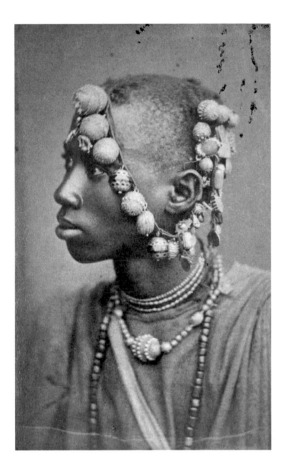

Young Wolof Man with
Gold Ornament, Senegal
Felix Bonnevide
Carte-de-visite

ca. 1880

NATIONAL MUSEUM OF AFRICAN ART
ELIOT ELISOFON PHOTOGRAPHIC ARCHIVES

Senegalese harbor town of Dakar around 1910, exemplifies how African patrons presented themselves to the camera and wanted to be seen in their photographs. The imprint on the cards, "Benyoumoff," may be the name of the photographer and/or the publisher. Expertly colored, they show the sitters in front of locally painted backdrops, which transported them into a different world. A lush tropical landscape evoked the Senegalese coast, while the grand staircase with the balustrade in another backdrop suggested the interior courtyards found in houses of rich Senegalese and French merchants of the time. The elegantly dressed patrons preferred frontal, dignified poses and often looked directly at the camera. The studio props, such as a vase with flowers and European chairs, and accessories — among them, imported umbrellas and European-made shoes — all indicate the clients' modern and sophisticated ways of life. Like millions of sitters around the globe, they could assert and express their identity through photography.

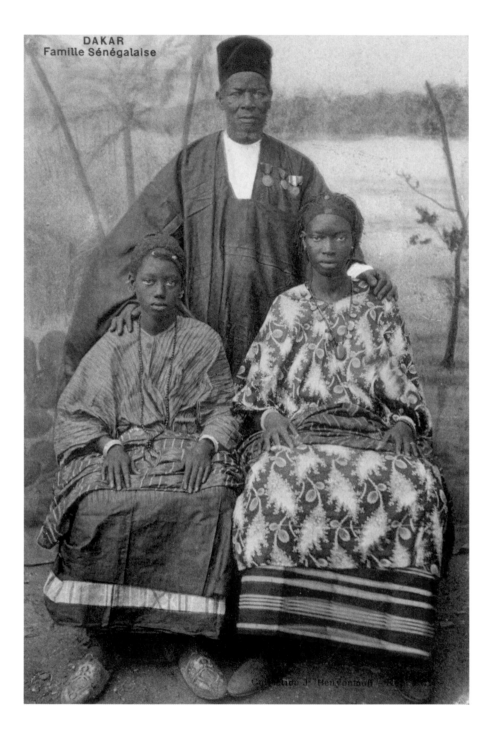

Dakar—Familie Sénégalaise

Unidentified photographer

Postcard

1912

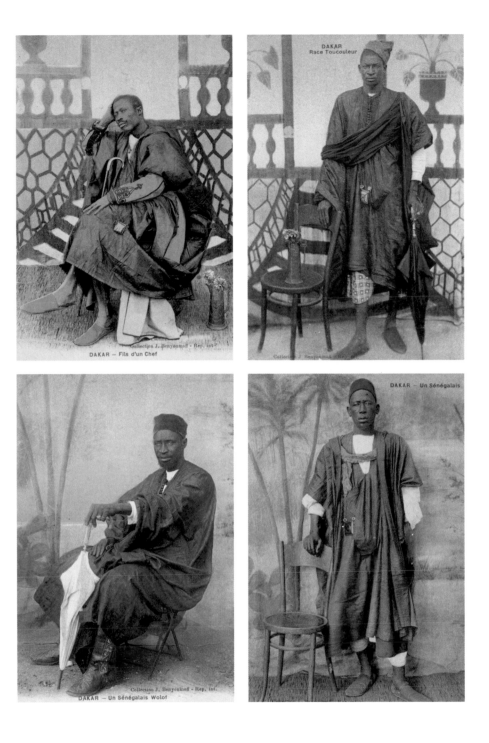

Dakar — Fils d'un Chef
Dakar — Race Toucouleur
Dakar — Un Sénégalais Wolof
Dakar — Un Sénégalais
Unidentified photographer
Postcards

1912

NATIONAL MUSEUM OF AFRICAN ART
ELIOT ELISOFON PHOTOGRAPHIC ARCHIVES

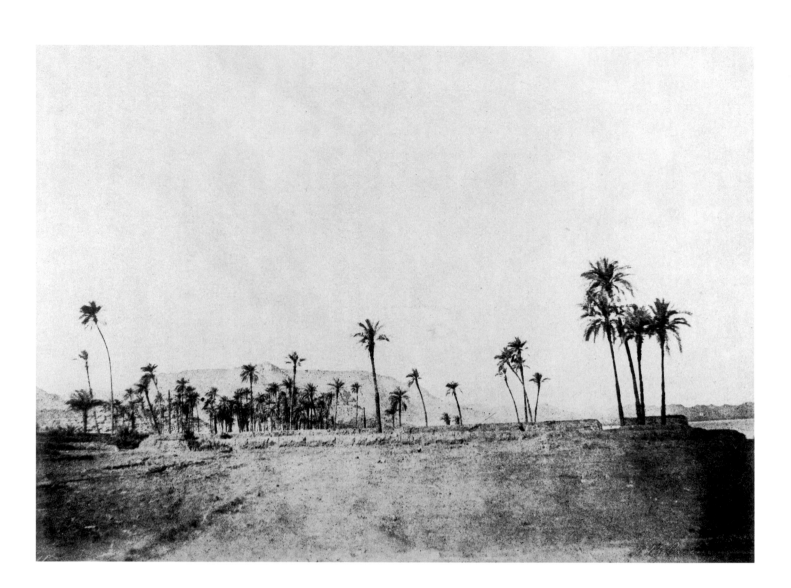

Palms along the Nile

John B. Greene

Salted-paper print

1856

SMITHSONIAN AMERICAN ART MUSEUM

Among the earliest traveling photographers were John B. Greene and Francis Frith, who photographed the sites and wonders of exotic lands about which many Europeans and Americans only dreamed.

Landscape views, such as those made by these photographers, were commonly published in large, elaborate volumes as well as in stereograph form and were avidly collected by armchair travelers. These Victorian collectors were interested in the faraway lands that were romanticized in the art, literature, and popular culture of the day. Frith capitalized on the popularity of his photography and established a successful publishing company through which he sold his photographs printed in books and as stereographs and postcards.

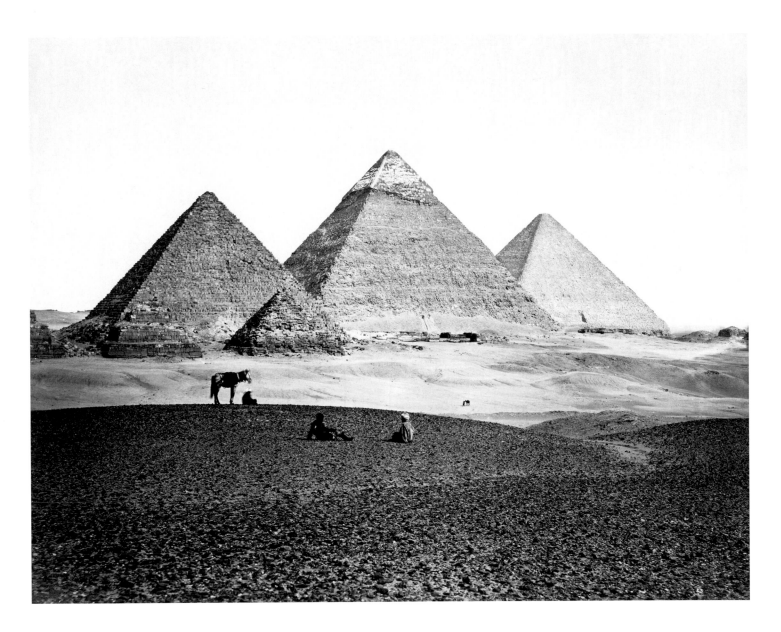

Pyramids of El-Geezeh [*sic*]

Francis Frith

Albumen print

1858

NATIONAL MUSEUM OF AMERICAN HISTORY
DIVISION OF INFORMATION TECHNOLOGY AND SOCIETY
PHOTOGRAPHIC HISTORY COLLECTION

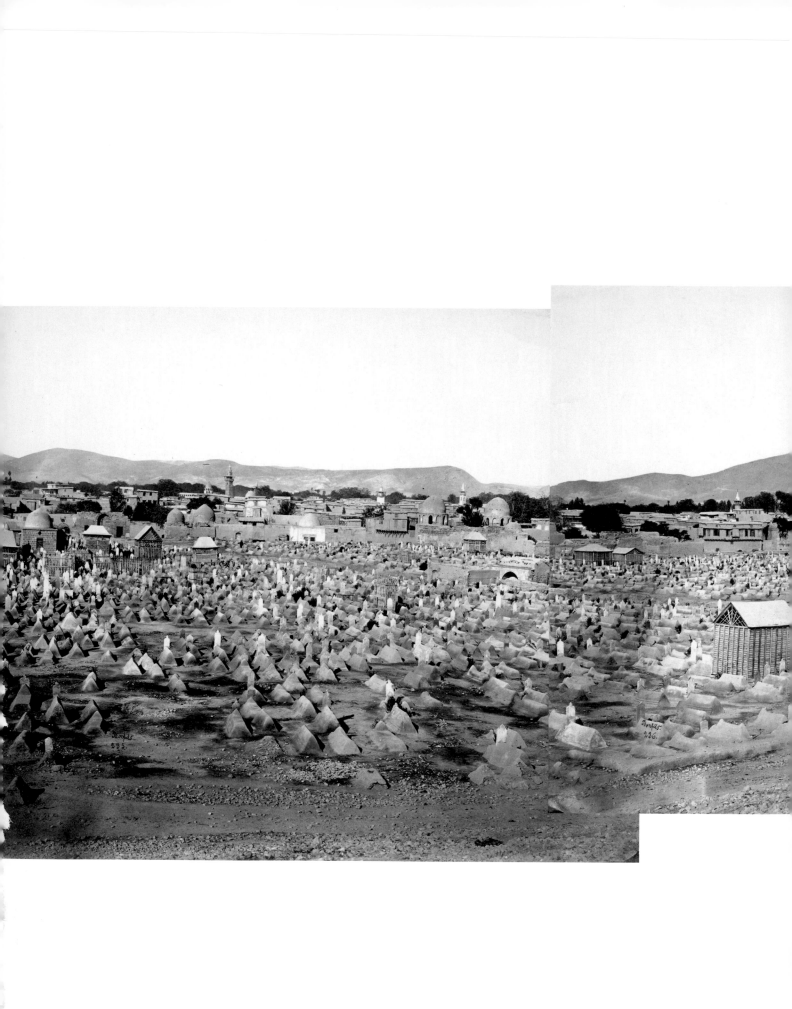

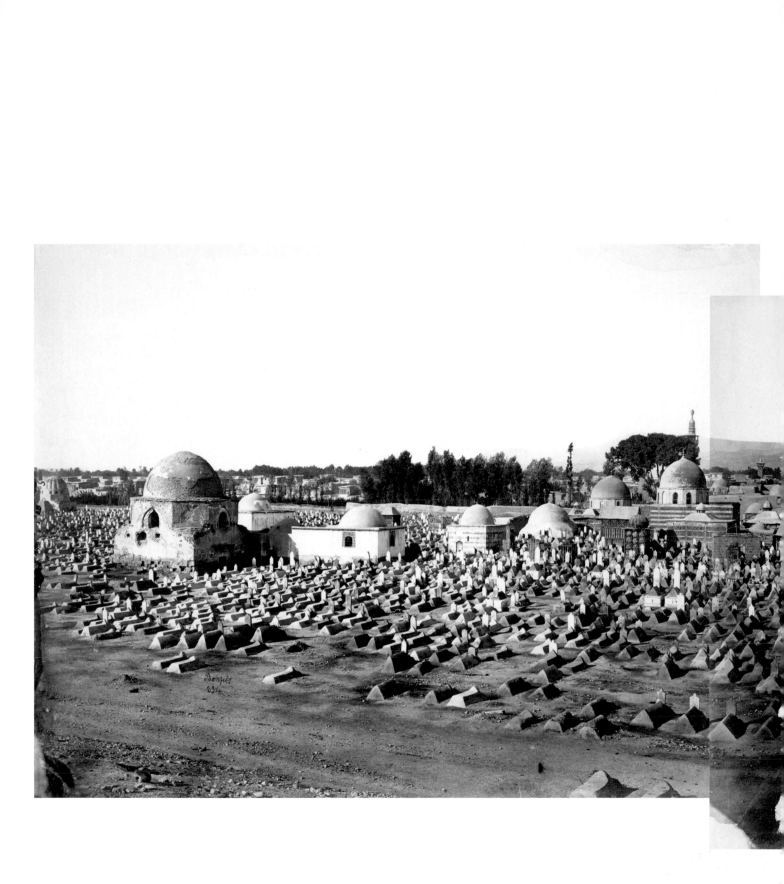

THE VISIBLE HORIZON

Claire Orologas
Freer Gallery of Art and Arthur M. Sackler Gallery

During the nineteenth century, thousands of travelers from Europe and the United States journeyed to the lands of the Bible and classical antiquity. Only months after the invention of the camera in 1839, photographers were dispatched to Egypt and the Holy Land to record their sites and monuments.

P. Felix Bonfils was among the second generation of photographers to work in the Middle East and was the first French photographer to settle there. He and his wife Lydie moved to Beirut in 1867 and established the photography studio La Maison Bonfils. Within the first four years alone, the studio produced 15,000 prints from 591 negatives taken in Egypt, Palestine, Syria, and Greece. The Bonfils created panoramic scenes in an effort to extend the narrow frame of the camera and thus convey the full expanse of the landscape. Most early panoramas were executed by piecing together separate, overlapping images, a process that accounts for the tonal variations seen from one segment to the next.

This panorama of Damascus is fascinating in that the city itself is not prominently featured. The expanse of the cemetery dominates the scene, drawing the eye across the many rows of graves, along the meandering path, and finally to the city itself. The great landmarks within Damascus, such as the citadel (in the central portion of the fourth print) and the Umayyad Mosque (in the center of the fifth print), do not stand out. Depicted instead is the Cemetery of Bab as-Saghir, located in the southwest sector of the Old City. Members of the prophet Muhammad's family as well as other important figures in the early history of Islam are believed to be buried there.

In spite of international recognition for his work and the widespread dissemination of his photographs, Felix Bonfils's death in France was apparently not announced in an official death notice or obituary. This panorama serves as a poignant reminder of Bonfils and the legacy he left through his photographs.

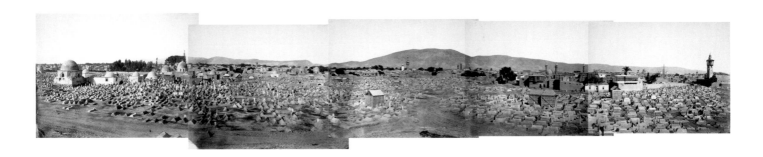

Panorama of Damascus,
View of the Cemetery of Bab as-Saghir
Felix Bonfils
Albumen print (5 sheets)

ca. 1870

FREER GALLERY OF ART AND ARTHUR M. SACKLER GALLERY ARCHIVES

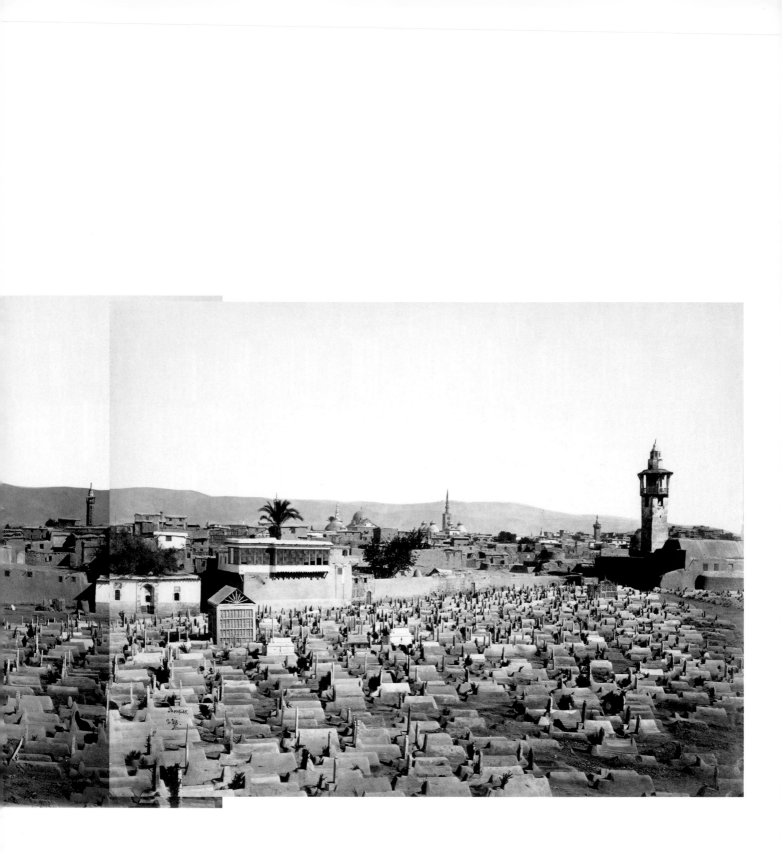

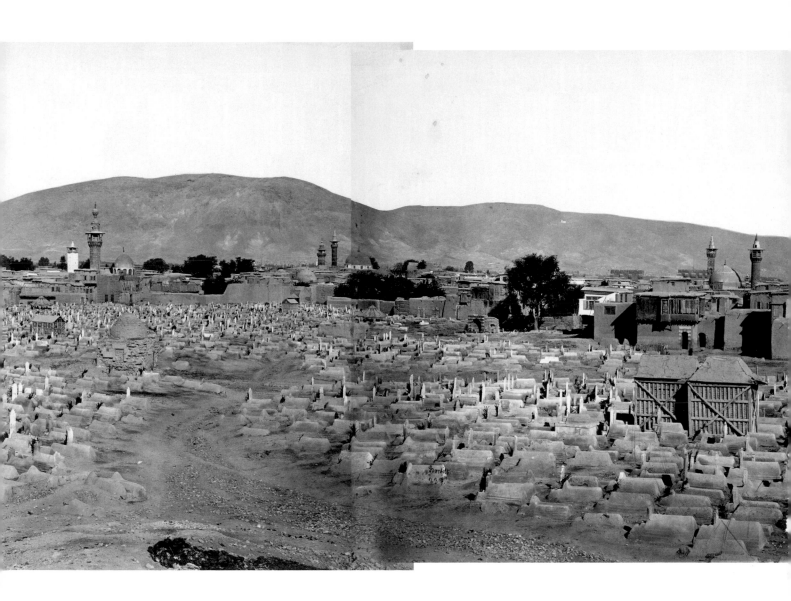

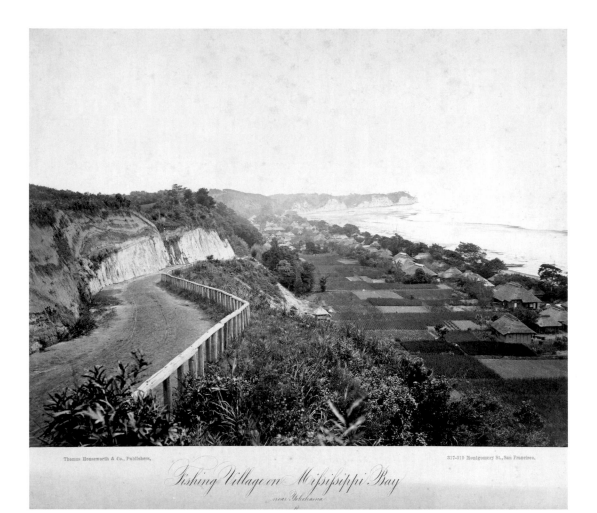

Thomas Houseworth & Co., Publishers, 317-319 Montgomery St., San Francisco.

Fishing Village on Mississippi Bay
near Yokohama

Fishing Village on Mississippi Bay near Yokohama
Charles Weed
Mammoth albumen print

ca. 1866–67

FREER GALLERY OF ART AND ARTHUR M. SACKLER GALLERY ARCHIVES

Charles Weed established his career as a daguerreotypist after moving to Sacramento, California, from his native New York in 1854. The next year he modified the wet-collodion photography method, which he used to create his first impressive views of the Yosemite Valley in 1859. Weed also made several trips to Asia during the 1860s, and he even attempted to open a studio in Hong Kong. While his work in the western United States is well known, his Asian landscapes, such as this photograph of Japan's Mississippi Bay, are quite rare. Mississipi Bay acquired its name after Commodore Matthew Calbraith Perry arrived in Japan in 1854 and opened the area to American trade. Many of the local landmarks received new American names.

Samurai in Western Hat and Others on a Road and Bridge, Japan

Felice Beato

Albumen print

undated, ca. 1863–83

FREER GALLERY OF ART AND ARTHUR M. SACKLER GALLERY ARCHIVES

Born in Greece, Felice Beato worked as a press photographer in England and achieved recognition for his coverage of British political conflicts, including the Crimean War of 1855 and the 1858 Indian Mutiny in Delhi and Lucknow. After moving to Yokohama in 1863, Beato opened the first photography studio there and worked throughout Japan for the next twenty years, taking photographs and selling them commercially to tourists. During his travels, Beato gained access to Japanese ports that were only open to diplomats by acting as an official photographer for the British navy.

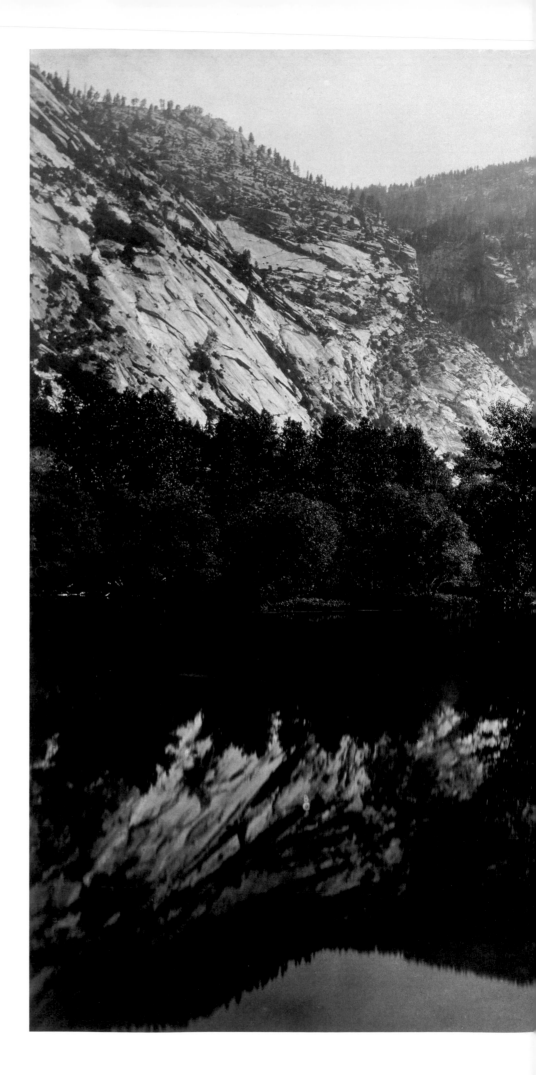

Mirror Lake and Reflections,
Yosemite Valley,
Mariposa County, California
Charles Weed
Albumen print

1865

**SMITHSONIAN AMERICAN
ART MUSEUM**

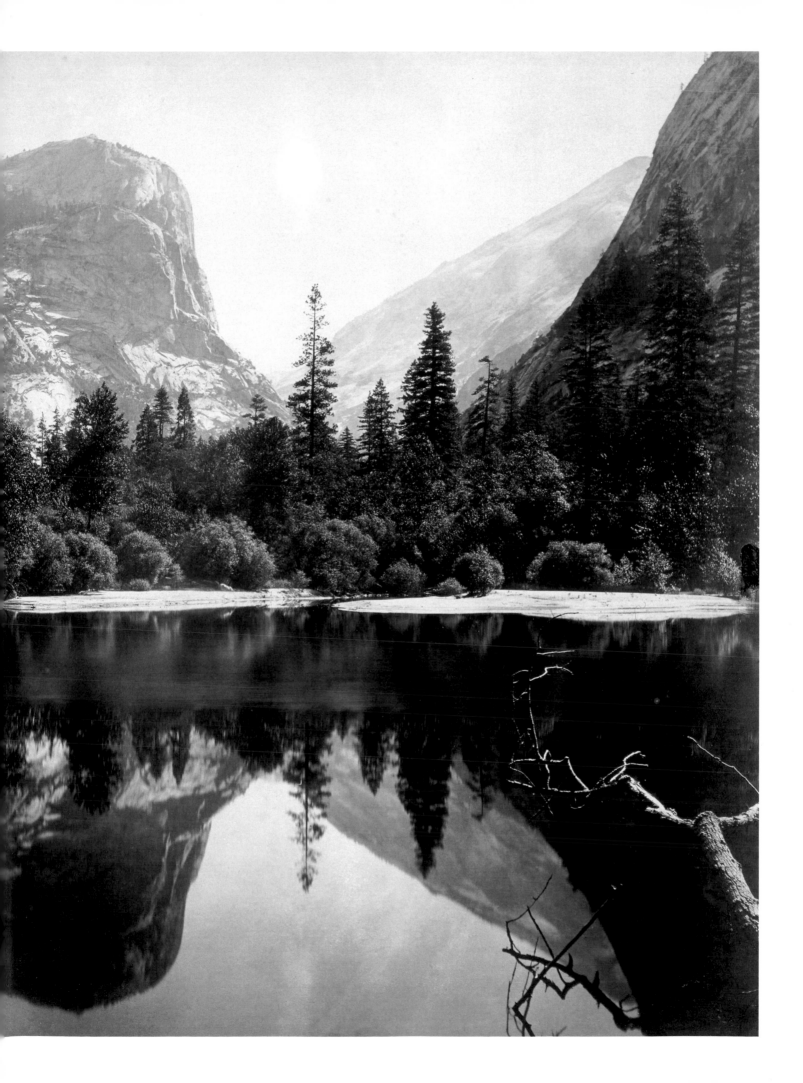

Holy Trinity Church, Bishop's Road, Paddington, London

William Henry Fox Talbot

Calotype

1845

Gateway Hussainnabad;
Group by Thatch Shelters with Food and Goods Nearby
Samuel Bourne
Albumen print

1863

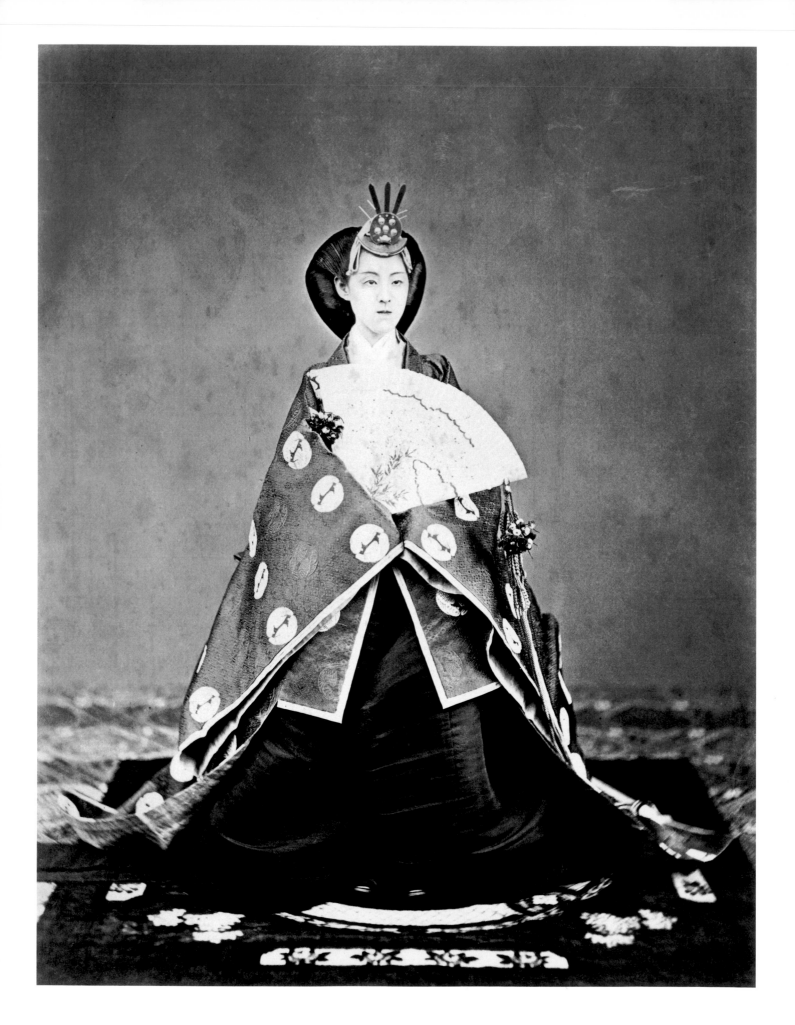

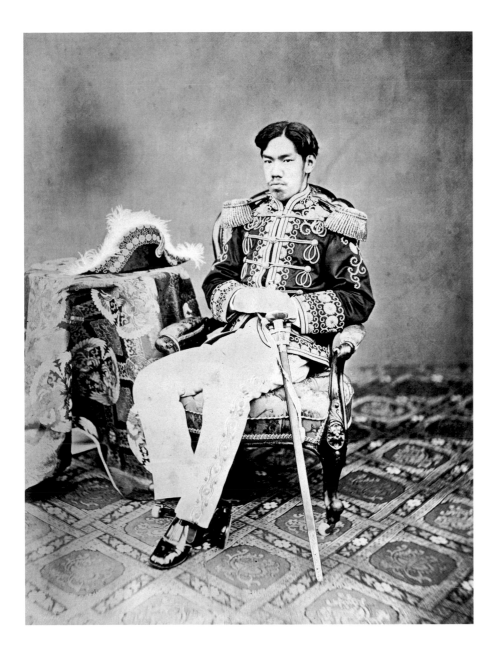

Emperor Meiji
Uchida Kyuichi
Albumen print

1873

Empress Meiji
Uchida Kyuichi
Albumen print

1872

FREER GALLERY OF ART AND
ARTHUR M. SACKLER GALLERY ARCHIVES

In 1872, and for the first time in Japanese history, the emperor and empress of Japan were photographed. Uchida Kyuichi photographed the emperor and empress again in 1873, although none of these early photographs was circulated. Japanese commoners were forbidden to see the faces of the imperial couple, who were considered deities.

This image of the emperor is easily identifiable as being from the 1873 series. In that year, he cut off his traditional topknot and adopted a Western hairstyle. Photographs of the emperor and empress were not widely available until Kyuichi's additional photo session with the royal couple in 1899. Thereafter, his photographs were frequently circulated as models to which painters and printers could refer when creating images of the imperial couple for the public. The Meiji period triggered a shift toward modern ideas in Japan, as this new freedom of commoners to look upon the face of their emperor and empress in a photograph or painting confirms.

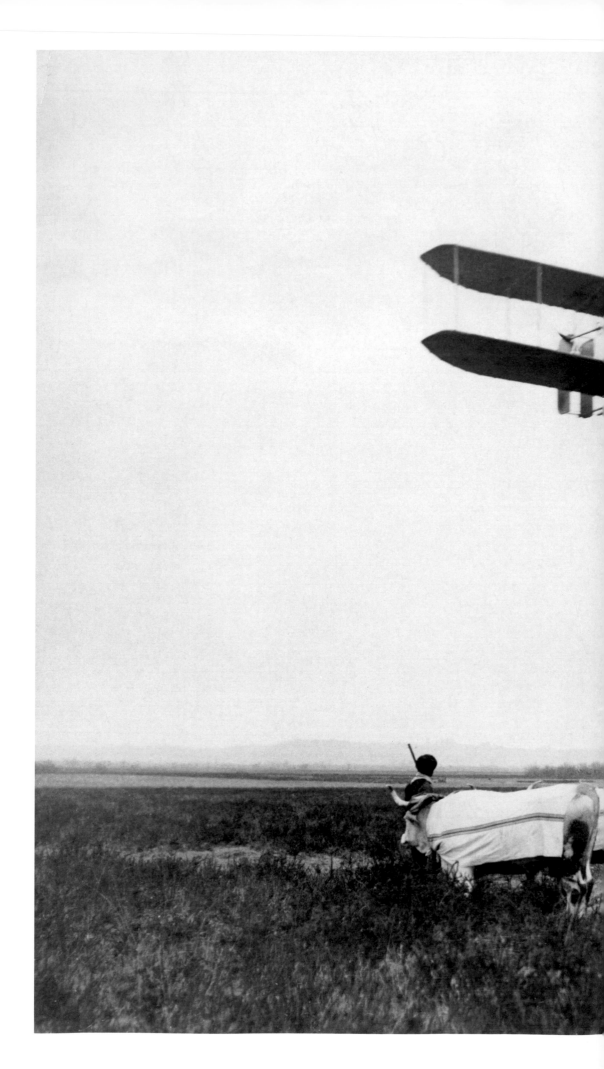

Wright Type A Flyer over
Hayfield in Le Mans, France
Unidentified photographer
Gelatin silver print

August 1908

NATIONAL AIR AND SPACE
MUSEUM ARCHIVES

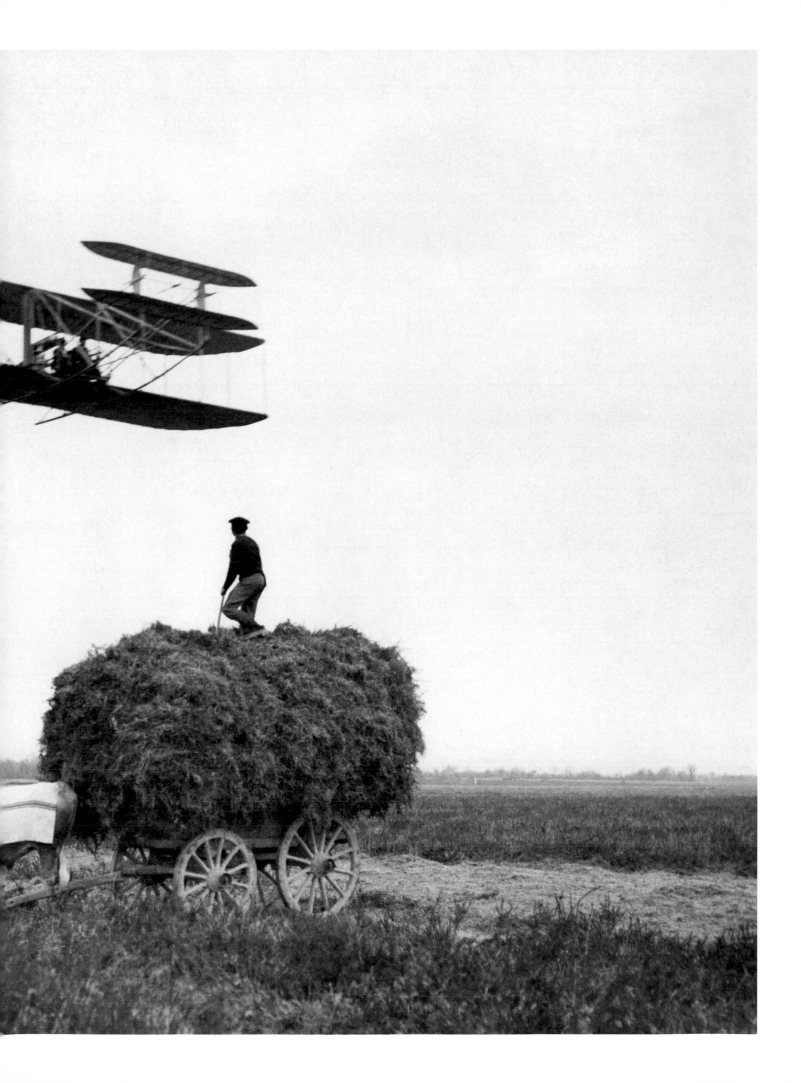

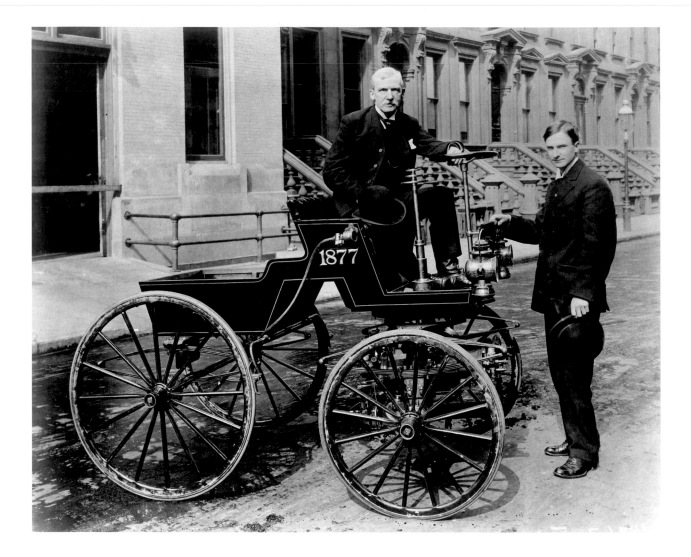

George B. Selden and Son with Early Car
Unidentified photographer
Gelatin silver print

ca. 1906

George Selden's 1879 patent for the combustion-engine automobile did not receive approval until 1895. Selden, who studied science and engineering, was an attorney who specialized in patent law. Even though he never created a fully working model of the patent, and his work did not truly influence designs by other inventors and manufacturers of the combustion-engine automobile, Selden hindered the growth of the automobile industry in America for years.

In 1903 Henry Ford, founder of the upstart Ford Motor Company, challenged Selden in a multiyear lawsuit over patent and licensing fees. Working models of Selden's original patent were manufactured as evidence during the trial. Finally, in 1912, the suit was settled in Ford's favor. While photographs were often used to register patents, this circa 1906 photograph of Selden in one of his car models (which sports an 1877 date) reveals the false proof of which photography was also capable.

Pickering Wind Tricycle
Unidentified photographer
Albumen print

ca. 1890

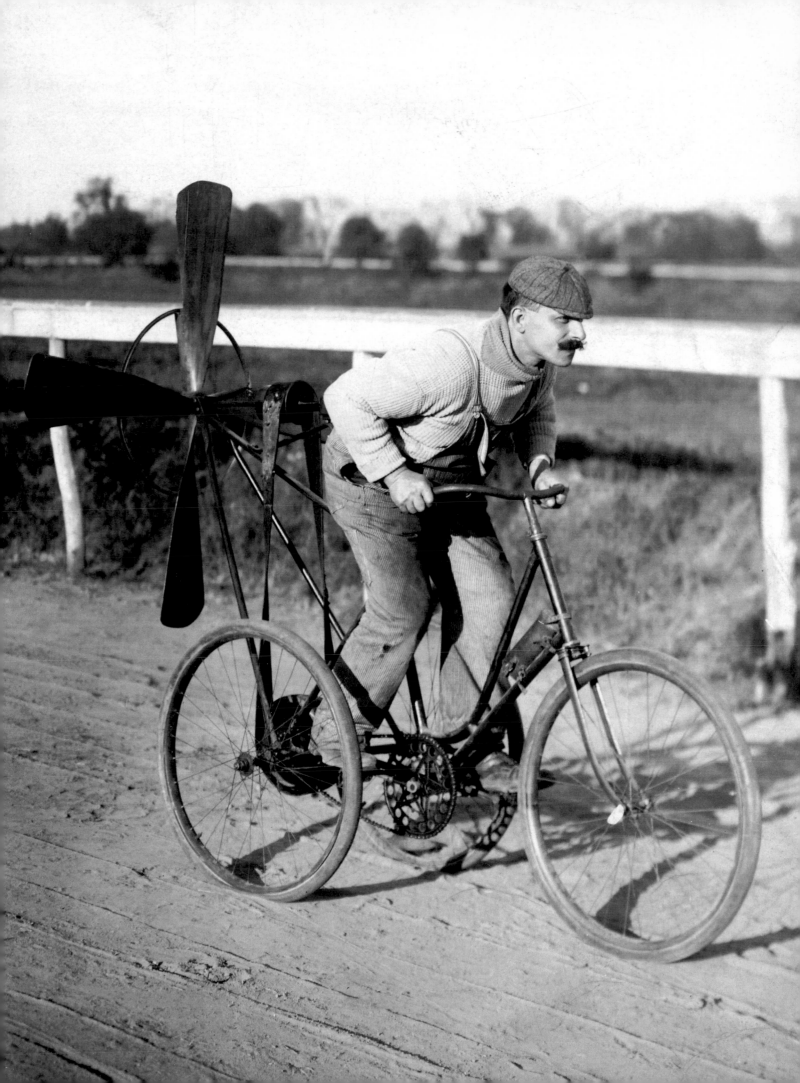

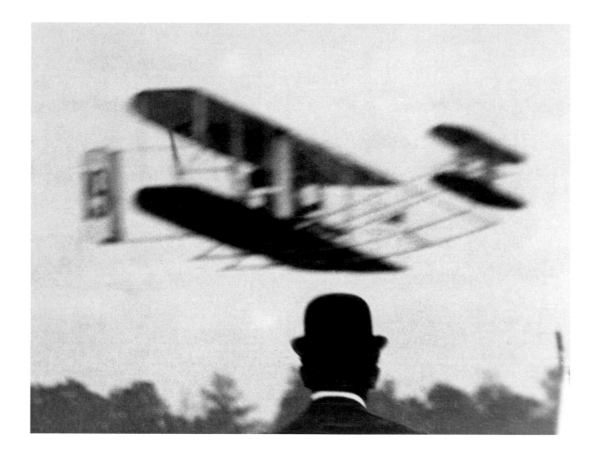

Right Side View of Wright Type A Flyer, No. 25, in Flight
Unidentified photographer

Gelatin silver print

1909

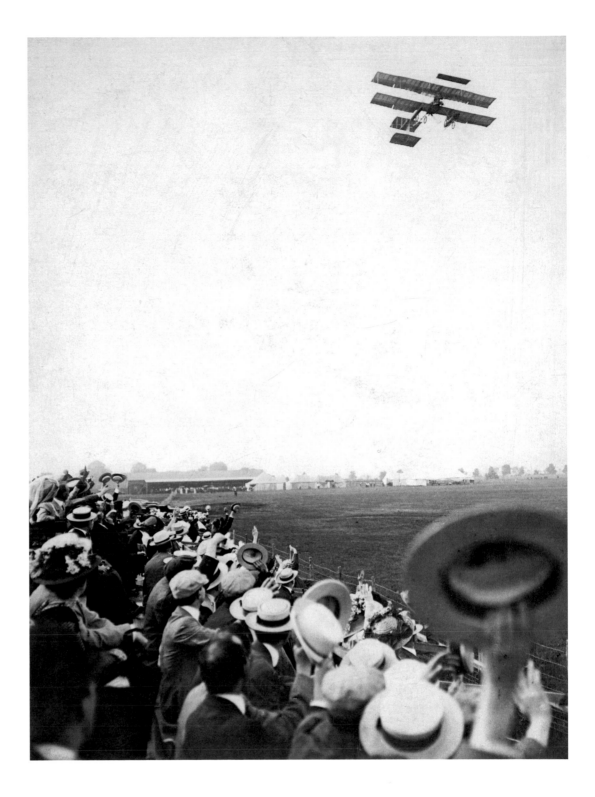

Spectators at an Air Show, 7/15/1911

C. H. Detrich

Gelatin silver print

1911

EVIDENCE FOR NEW PHYSICS

Steven Turner
National Museum of American History

Technological innovation in photography, as in other areas, depends on our understanding of what materials are and how they work. Gabriel Lippmann's photography uses essentially the same silver nitrate emulsion as black-and-white film, but he utilized the wave nature of light to produce a color image.

Like nearly every other physicist in the nineteenth century, Lippmann believed in the wave theory of light, a premise that neatly explains how light can sometimes "interfere" and produce colors. According to this theory, some of the waves that make up white light collide and cancel each other out, leaving the others to produce colors. In this way colors can sometimes be seen in soap bubbles or thin films of oil. Lippmann employed this idea to design a film that would produce color in much the same way. Instead of employing pigments, his film produced color by manipulating light waves. Although it created beautiful images, Lippmann's process was complicated and never widely used. It was, however, considered of great scientific importance because it offered an elegant verification of the wave nature of light. For that reason, Lippmann was awarded the Nobel Prize in Physics in 1908.

The process of X-ray astronomy and the images it produces depends on a series of instruments that could never have been explained by the wave theory. Even as Lippmann was receiving his award, other physicists were beginning to understand light in terms of photons and energy quanta. Ultimately, this led to the birth of modern physics and the technological revolution of the twentieth century. X-ray astronomy is firmly embedded in this new conception. As our ways of understanding the physical world change, so does our ability to make images of it.

Color Photograph of Solar Spectrum
Gabriel Lippmann
Heliochrome

ca. 1908

NATIONAL MUSEUM OF AMERICAN HISTORY
DIVISION OF SCIENCE, MEDICINE, AND SOCIETY
PHYSICAL SCIENCES COLLECTION

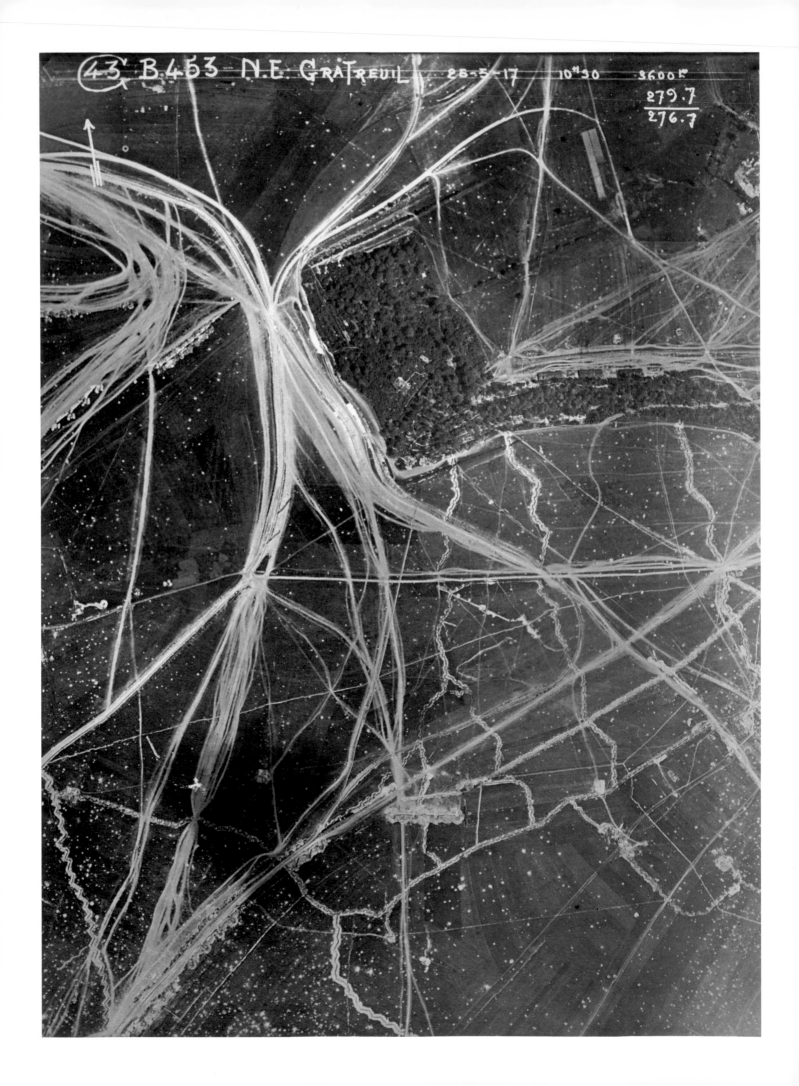

Photomicrograph of Algae

John William Draper

Daguerreotype

1856

NATIONAL MUSEUM OF AMERICAN HISTORY
DIVISION OF INFORMATION TECHNOLOGY AND SOCIETY
PHOTOGRAPHIC HISTORY COLLECTION

A passing glance at these two photographs suggests a visual match. The initial graphic similarity is surprising, but after a closer analysis, many differences become discernible. Advances achieved in scientific technology in two different centuries made it possible to photograph these repeating man-made and natural patterns. In the 1850s John Draper developed a way to attach a camera to his microscope so he could photograph the physiological characteristics of algae and other microorganisms. The invention of the airplane in the early twentieth century, along with improvements in the size and ease of use of cameras, allowed the French army to make aerial maps of territories at stake in World War I. In both instances, photography enabled the study and documentation of fleeting information.

French World War I Aerial Reconnaissance Photograph of N.E. Gratreuil Area

Unidentified photographer of the French military

Gelatin silver print

1917

NATIONAL AIR AND SPACE MUSEUM ARCHIVES

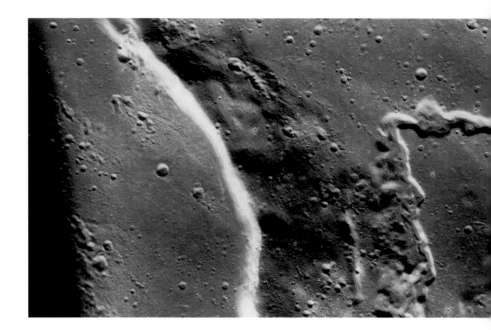

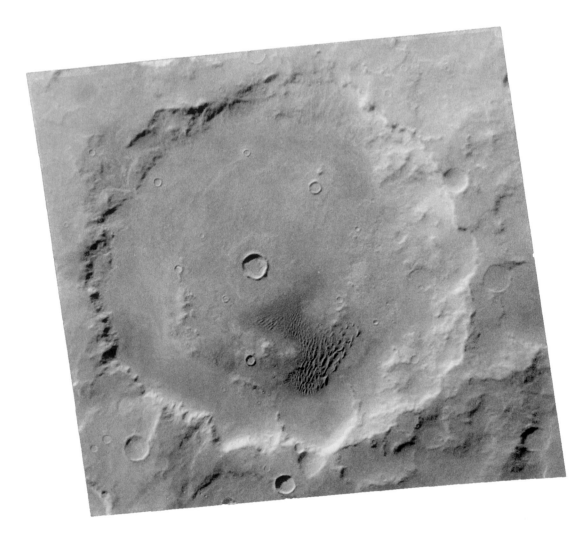

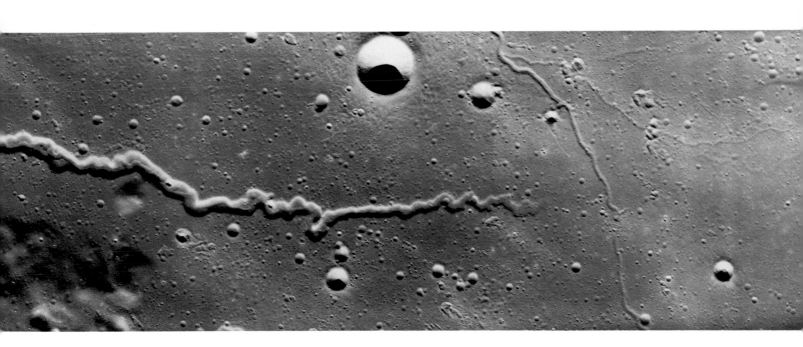

Panorama of the Moon's Surface
Apollo 15 Mission Orbiter Camera
Gelatin silver print

1971

NATIONAL AIR AND SPACE MUSEUM
CENTER FOR EARTH AND PLANETARY STUDIES

Mars Orbiting Camera Digital Transmission
of Mars's Surface
National Aeronautics and Space Administration
Digital transmission

2001

NATIONAL AIR AND SPACE MUSEUM
CENTER FOR EARTH AND PLANETARY STUDIES

Launched by NASA in November 1996, the Mars
Orbiting Camera spent six years circling Mars to
collect data on the fourth planet from the Sun in our
solar system. Advances in digital photography allowed
cameras sent into space to beam back massive
amounts of photographic data almost instantly.
This photograph—a composite of two images taken
on January 26, 2001—shows the southern hemisphere
of the planet during a Martian winter. Kaiser Crater,
the landmark seen here, has a similar latitude to
Seattle, Washington (47 degrees S, 340 degrees W).

The Apollo 15 mission, commanded by astronaut
David R. Scott, launched on July 26, 1971, and
returned to Earth on August 2. The mission's primary
scientific objective was observing the lunar surface
and surveying the Hadley-Appenine region of
the Moon. Several pieces of scientific equipment
accomplished these tasks, including a 24-inch
panoramic camera attached to the orbiting command
module. The camera's lens rotated inward to protect
it during thruster firings. This camera worked in
conjunction with a three-inch mapping camera and
a laser altimeter to produce data for a comprehensive
map of this area of the Moon's surface. A complete
set of these beautiful and informational panoramas
is housed at the National Air and Space Museum's
Center for Earth and Planetary Studies.

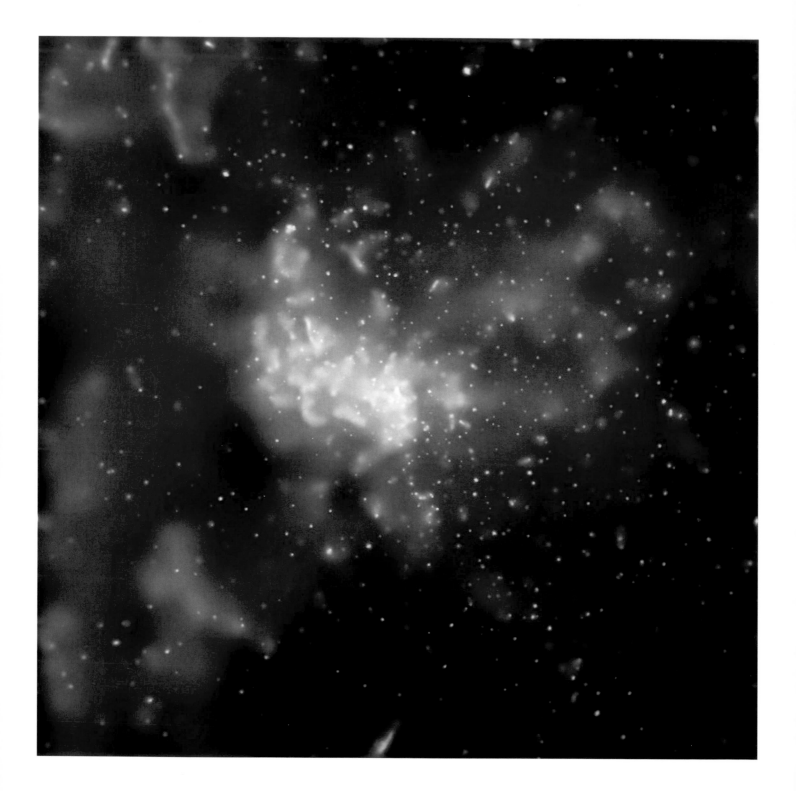

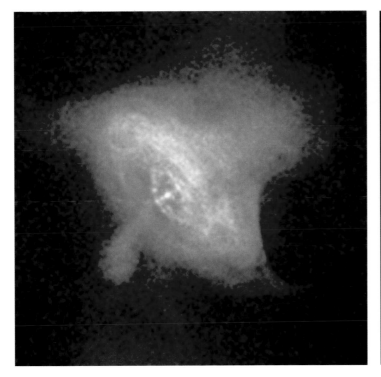

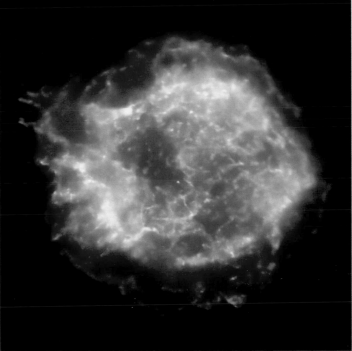

Sagittarius A

NASA/CXC/MIT/F. K. Baganoff et al.

Chandra Telescope x-ray image

Electronic imaging transmissions

2003

Crab Nebula

NASA/CXC/SAO

Chandra Telescope x-ray image

Electronic imaging transmissions

1999

Cassiopeia A

NASA/CXC/SAO

Chandra Telescope x-ray image

Electronic imaging transmissions

2000

SMITHSONIAN ASTROPHYSICAL OBSERVATORY

The Chandra X-Ray Observatory, launched on July 23, 1999, is funded and managed by NASA and operated by the Smithsonian Astrophysical Observatory in Cambridge, Massachusetts. The observatory coordinates the scientific community's use of Chandra with its own operations and data collection.

Chandra rode into space on the space shuttle Columbia, where it was put into an elliptical orbit that extends as far as 85,000 miles above the Earth. The large orbit takes 64 hours to complete and allows Chandra to collect data for 55 consecutive hours.

This powerful X-ray telescope enables scientists worldwide to see and study what is truly invisible to the naked eye, and to the most powerful optical telescopes. The observatory's precise mirrors and electronic detectors can capture X-ray images and measure the spectra of X-rays from multimillion-degree gases, thereby shedding light on such cosmic mysteries as dark matter and black holes. The Chandra mission is expected to extend through at least 2009.

Spectrograph

John William Draper

Daguerreotype

ca. 1840

PROOF^s POSITIVE

Born from a marriage of chemistry and optics, and nurtured by artists and entrepreneurs primarily interested in visual spectacle, photography entered the world as a unique, modern hybrid — part science, part art, part industry, part craft — yet its purely empirical usefulness for observing and reporting on the natural and man-made world was recognized from the beginning. In August 1839 François Arago, the director of the Paris Observatory, announced the details of Daguerre's photographic process at a joint meeting of the Académie des sciences and Académie des beaux-arts. Even then Arago could speak with great optimism about the possibility of one day photographing galaxies millions of light years distant and, conversely, revealing the origins of life by bringing into view infinitesimally small life forms. As part of a broad mid-nineteenth-century roster of scientifically useful discoveries and inventions, photography brought records of biological specimens, geological structures, and all manner of previously unseen physical evidence into the laboratories of scientists around the world — but perhaps it served science best by intimately connecting the act of seeing and the thing seen.

By offering a mirrorlike representation of the world, photography seemed to be the ideal medium for making a permanent record of scientific observations. Both photography and the natural historian's scientific catalogue emerged as new, objective fixtures of the modern era. As illustration, photographs wielded the authority of realism: they were, after all, literally taken from life, and as such, they promised to bring knowledge through visual representations. They also offered a solution to collecting the ephemeral evidence of nature. After photography's invention it was possible to collect the abstract elements of human culture. Museums of art, natural history, and ethnography, institutions that were rapidly springing up in Europe and North America, soon understood the importance of maintaining visual records of works of art and artifacts, and most especially of natural science specimens. With photography they could compile an accurate and accessible visual catalogue and share it with an increasingly interested public in the form of prints and publications. Perhaps more importantly, photography, as a means of possessing, knowing, and studying objects and natural phenomenon — from the eclipse of the Sun to the complex pattern of frog's blood — began to constitute the collections themselves.

To nineteenth-century scientists, seeing was the most reliable of the senses, and photography, as a servant of sight, seemed

capable of equal reliability. Today we sometimes question the innate truthfulness of photographs, but this does not deny the camera can provide invaluable evidence. Among the first tasks to which scientists brought the camera was measuring light itself. John William Draper's 1845 photograph of the light spectrum, measured by means of a roughly ruled wooden stick, is at once self-reflexive (photography, after all, is about recording with light) and visually astonishing, even now. The urge to measure the world with photographs is evident throughout early pictures, sometimes literally — see Timothy O'Sullivan's image of a Spanish inscription framed by a ruler (page 82) — and sometimes figuratively, as when human beings are placed in the frame to lend scale to the subject. These kinds of evidentiary pictures measure not only space but also time. Just as the Spanish conquistadors of the New World left their inscription carved in rock, so too did O'Sullivan inscribe the presence of his survey team of geological explorers.

 The measurement of time, and its disassembly into ever-smaller fragments, became one of photography's main subjects in the late nineteenth century. At first, cameras themselves were so slow that movement created only a blur. Gradual improvements in the sensitivity of emulsions and the light-gathering ability of lenses led to "instantaneous" photography. Eadweard Muybridge, a pioneer of stop-motion photography, needed to slice time even more minutely to achieve his goal of showing the successive stages of human and animal locomotion. He devised shutters that let each lens in his battery of cameras "see" only a brief glimpse of a passing movement. By putting these frozen moments in sequence, Muybridge gave science, and the world, a way of visualizing anatomy in action. He also paved the way for cinema, which returned the camera's slices of time to their original seamless coherence.

 In the twentieth century, other practitioners devised ways to measure time visually. Frank and Lillian Gilbreth developed an idiosyncratic, arguably poetic method of showing movement over time in the service of efficiency. Their "time-motion studies" were meant to help industry by illustrating how workers' movements could be purely functional (page 132). Their recognition that a short burst of light could serve the same purpose as a rapid shutter — and slice time even more finely — led to many experiments that depended on the visual result of a photograph. Electric sparks froze sound waves in midair, while the even briefer blast of the electronic "strobe," invented by Harold Edgerton at MIT, appeared to stop bullets in flight (pages 140–41). Edgerton's invention produced exposure durations of a hundred-thousandth of a second and later formed the basis both for the repeating strobe light and for all the built-in flash units found in today's amateur cameras.

Installation View of Scientific Photography Exhibition
Thomas Smillie
Cyanotype

ca. 1913

Photography also helps us measure our own place in the world. In the nineteenth century, as the United States expanded across the continent, Americans' visual boundaries expanded as well. Survey teams of geologists, artists, photographers, and military engineers fanned out across the West after the Civil War, with the aim of bringing back reports on largely uncharted territories. These reports prominently featured photographs, which both confirmed the geologists' findings and provided proof of the rugged beauty of the land. (Yellowstone, the Rocky Mountains, and the Grand Canyon were favorite subjects, then as now.) Americans on the East Coast wanted to see the West, of course, but their curiosity extended to the world at large. Pictures of the Near and Far East, and of Rome and Athens, held an exotic fascination and connected American culture to the origins of civilization.

In large part, an interest in scientific investigations resulted from either practical needs or the exigencies of exploring and taming the continent. Inspired by a romantic attachment to the natural wonders and

Historic Spanish Record of the Conquest,
South Side of Inscription Rock, New Mexico
for the Wheeler Survey
Timothy H. O'Sullivan
Albumen print

1873

vast beauty of America, but embracing a wide range of both established and developing branches of research, photography was utilized by new scientific disciplines, such as ethnography, linguistics, archaeology, and other promising fields of inquiry.

While most of these photographs appear to be essentially scenic, some images led scientists to new discoveries. Perhaps the most notable instance involves the Burgess Shale, a rich fossil deposit discovered in the mountains of British Columbia by Charles D. Walcott, the Smithsonian's fourth Secretary. Walcott routinely traveled with a panoramic camera as part of his geology equipment. The panoramas he took of the site helped him identify and describe the Burgess Shale as dating to the Cambrian period — some 520 million years ago — and formed when the western part of the continent was a vast sea. His methodology, in fact, depended on his photographs (pages 104 – 105). Made during his summer excursions to the western mountains, his panoramic photographs, printed and mounted on the wall of his office, gave him the advantage of time for thoughtful reflection. Seen once, but studied over time, like the

very geology they described, Walcott's photographs ultimately yielded significant information.

Other photographs produced and collected by expeditionary surveys are more prosaic in nature but no less fascinating. For today's civil engineers, images of bridges and buildings help explain structural principles in use a hundred years ago. For meteorologists, thousands of photographs of snowflakes—all with a longevity independent of temperature or weather—offer a trove of information. The pioneers of aviation relied on photographs of kites and wings as a means of understanding how flight was possible. For ornithologists and ichthyologists, photographs of bird and fish skeletons provided reliable data for distinguishing and classifying species.

Not all of the scientific uses of photography have produced purely empirical results. This was especially true in the study of our own species. Comparative anatomy and anthropology, two scientific fields born in the same century as photography, adopted the camera as a means of cataloguing and classifying the world's peoples. While such activity seemed innocent enough when directed towards, say, animals in the National Zoo, its application to humans was often problematic. Nineteenth-century scientists photographed the skulls of various races— Caucasian, Negro, Native American—and made composite images of them in an effort to identify overreaching racial characteristics. Others filled the skulls with water to determine which race had the largest cranial capacity (pages 88 – 89). Such efforts were meant to shore up an idea of Darwinian evolution in which the dominant culture, that of white Americans, would prove to be the pinnacle. Today we recognize these photographs less as science and more as evidence of how cultures can devise "proofs positive" to fit their own preconceptions.

Nevertheless, even culturally biased images can convey valuable information. The thousands of photographs taken of American Indians, many of them catalogued by tribe and geographic location, may have been intended as a tribute to what was in the nineteenth century romantically, if erroneously, called "the vanishing race," but they nonetheless supply evidence of tribal dress and activity that remains important to both modern anthropologists and the subjects' ancestors. The same could be said of "historical" pictures made on battlefields and at public events: they contain useful information, but that evidence must be viewed in the context of the intentions and preconceived notions of the photographer and, often, his employer. What contemporary scientists have learned about their own laboratory work also holds true for photographs: the presence of an observer cannot help but change what is observed. As a result, photographs are no longer necessarily believed to be "proofs" but rather are considered with a critical eye in the interest of separating facts from fictions.

Chicken Entrails

John William Draper

Daguerreotype

ca. 1850

Draper's desire to use images of physiological specimens as teaching aids and illustrations to his scientific writings complemented his interest in photography. Some of the specimen daguerreotypes in the National Museum of American History's collection were utilized to create wood engravings that were published in Draper's book *Human Physiology* (1856), one of the first scientific volumes to employ photography for instructive purposes.

Photomicrograph of a Fly's Proboscis

John William Draper

Daguerreotype

ca. 1850

25242

View of Stuffed Animal Installation
Thomas Smillie
Cyanotype

ca. 1906

SMITHSONIAN INSTITUTION ARCHIVES

Thomas Smillie worked as a photographer for the Smithsonian beginning around 1869 until his death in 1917. His duties and his accomplishments were vast: photographing museum installations and specimens collected by the Smithsonian; creating reproductions for use as printing illustrations; documenting important events; acting as a chemist for Smithsonian scientific researchers; traveling to photograph Smithsonian-sponsored scientific research trips; managing a large staff as his responsibilities grew; and later, acting as curator and custodian of the collections of historical photographic material he gathered for the Smithsonian.

This photograph of stuffed specimens is an example of the day-to-day documentation of Smithsonian life and museum installations that Smillie and his staff regularly performed. The blue cyanotype medium seen here, a cheap and quick way of making photographic prints, was actually Smillie's way of keeping track of all the glass-plate negatives his staff made. The glass negatives were numbered and filed, and a corresponding blue print catalog was kept to help readily locate the bulkier negative.

Measuring Skull Cavities with Water

John S. Billings and Washington Matthews

Albumen print

ca. 1884–85

NATIONAL MUSEUM OF NATURAL HISTORY
NATIONAL ANTHROPOLOGICAL ARCHIVES

These scientists practice an early research technique employed in the
study of physical anthropology, but the method is now considered to be
inaccurate and not useful. Cranial specimens of different races were
collected and compared in an effort to draw conclusions about racial
differences and the development of the human species. Data collection
included taking external as well as internal measurements of skulls.
After each cranial cavity was filled with water, the volume of water used
was carefully measured and then compared to denote differences in
brain and cavity size among various races.

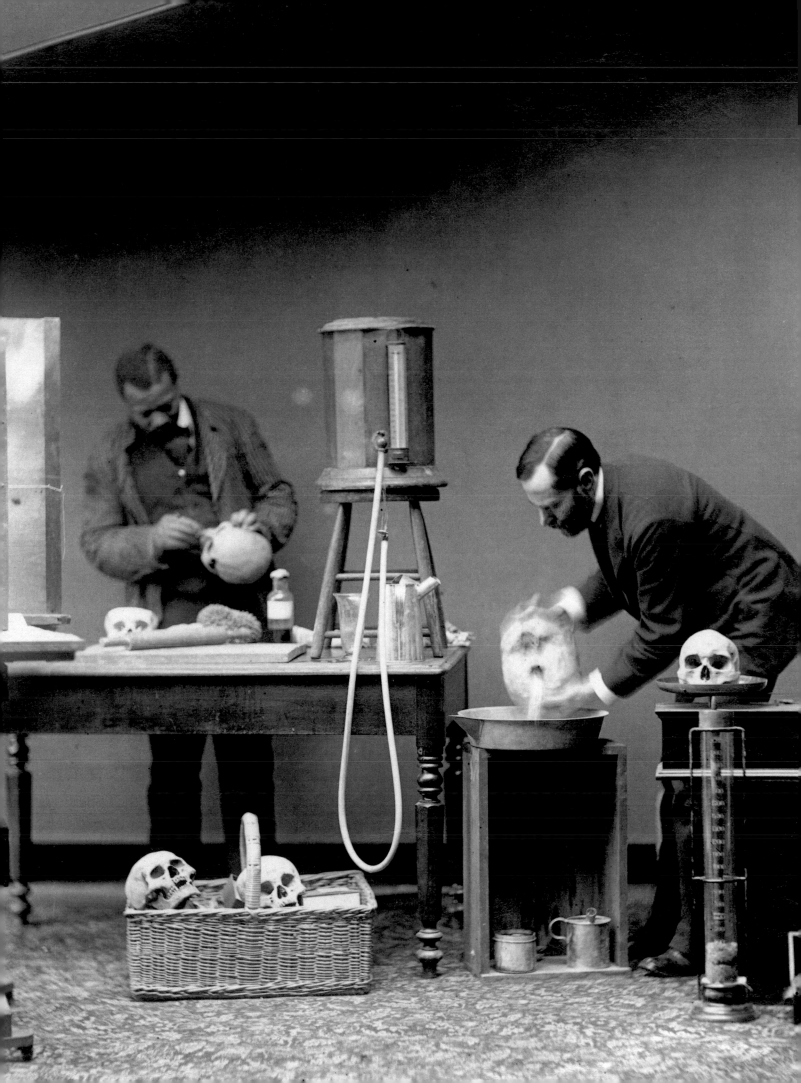

Eight male adult Ponca-Indians skulls.
N° 836, 837, 835, 834, 831, 487, 486, 877. Dry
process; exposure 3 seconds each.

WAR DEPARTMENT,
SURGEON GENERAL'S OFFICE,
ARMY MEDICAL MUSEUM,
WASHINGTON, D. C.
Photograph No. 6–A

Eight Adult Male Ponca Skulls (Superimposed, Frontal View)
John S. Billings and Washington Matthews
Albumen print

ca. 1884–85

NATIONAL MUSEUM OF NATURAL HISTORY
NATIONAL ANTHROPOLOGICAL ARCHIVES

Five Adult Ogalalla Skulls (Superimposed, Lateral View)

John S. Billings and Washington Matthews

Albumen print

ca. 1884–85

In the nineteenth century, the emerging science of physical anthropology relied on detailed drawings and measurements of anatomy to study differences between races and to track the development of mankind over the ages. Many anthropologists in the late nineteenth century experimented with photography for their work, although much disagreement surrounded the questions of how exactly to utilize the medium for the benefit of research and if it really was preferable to drawings and tracings.

Physician John S. Billings of the U.S. Army Medical Museum experimented with a composite photography technique that was first developed by British scientist Francis Galton in 1877 to study the cranial typology of criminals. Billings worked to improve the technique of producing multiple exposures of skulls of similar origins, then overprinting them to create a composite image of all the exposures taken. He hoped that comparing cranial profiles would result in conclusive evidence of physiological structural differences between races, but this technique was later abandoned.

General H. A. Barnum, Recovery after a Penetrating Gunshot Wound

William Bell

Albumen print

1865

Lieutenant Goodwin, Deceased, Ununited Gunshot
Fracture of the Upper Third of the Right Femur,
Seven Months after the Injury

William Bell

Albumen print

ca. 1865

SMITHSONIAN AMERICAN ART MUSEUM

William Bell began his photography career in a Philadelphia studio around 1848. After
serving in both the Mexican War and the Civil War, Bell was appointed the official photo-
grapher for the Army Medical Museum in Washington, D.C., where he worked from
1865 to 1869. His photographs of soldiers who suffered war wounds, and of body parts of
soldiers who had succumbed to their wounds, were used to illustrate volumes of medical
and surgical history published by the U.S. surgeon general. The photographs were
presented in the form of printed engravings to catalog the wounds and treatments soldiers
received during the Civil War — a war for which weapons were created that inflicted
unprecedented trauma to the human body. Elaborate case histories accompanied Bell's
graphic illustrations.

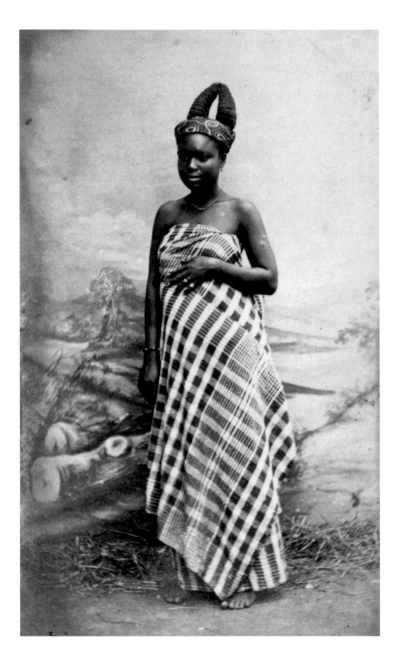

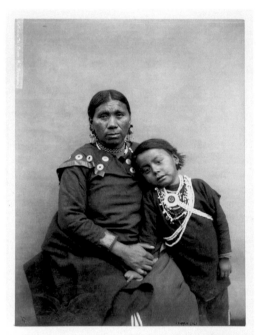

Collection anthropologique du Prince Roland Bonaparte.

Portrait of a Fante Woman, Cape Coast, Ghana

J. Lascoumettes

Carte-de-visite

ca. 1890

NATIONAL MUSEUM OF AFRICAN ART
ELIOT ELISOFON PHOTOGRAPHIC ARCHIVES

Va-Shesh-Na-Be (Beautiful Hill) and Child, Omaha Indians,
Photographed at the Jardin d'Acclimation Exposition in Paris

Prince Roland Bonaparte

Albumen print

1883

NATIONAL MUSEUM OF NATURAL HISTORY
NATIONAL ANTHROPOLOGICAL ARCHIVES

Travelers in Winter Dress, Japan

Baron Raimond von Stillfried

Albumen print

ca. 1870–1911

FREER GALLERY OF ART AND ARTHUR M. SACKLER GALLERY ARCHIVES
HENRY AND NANCY ROSIN COLLECTION OF EARLY PHOTOGRAPHY OF JAPAN

Illustrator John H. Richard's Studio
Unidentified photographer
Gelatin silver print

ca. 1879

SMITHSONIAN INSTITUTION ARCHIVES

Scientific illustrator John H. Richard poses in his studio in the Smithsonian Institution Castle around 1879. Richard was preparing and painting casts of fish for the Smithsonian's entry into the Berlin International Fishery Exhibition of 1880. His expert artistry garnered the exhibition's grand prize. Many examples of Richard's work remain a valuable part of the Smithsonian's vast scientific collections. Despite advances in photography, the highly detailed work of the scientific illustrator, who is able to capture in line drawings particular physiological elements such as exact gill and scale counts, has not been replaced. The tools have changed, since many scientific illustrators now generate their work with computer-assisted drawing programs, but the necessity of the job remains intact.

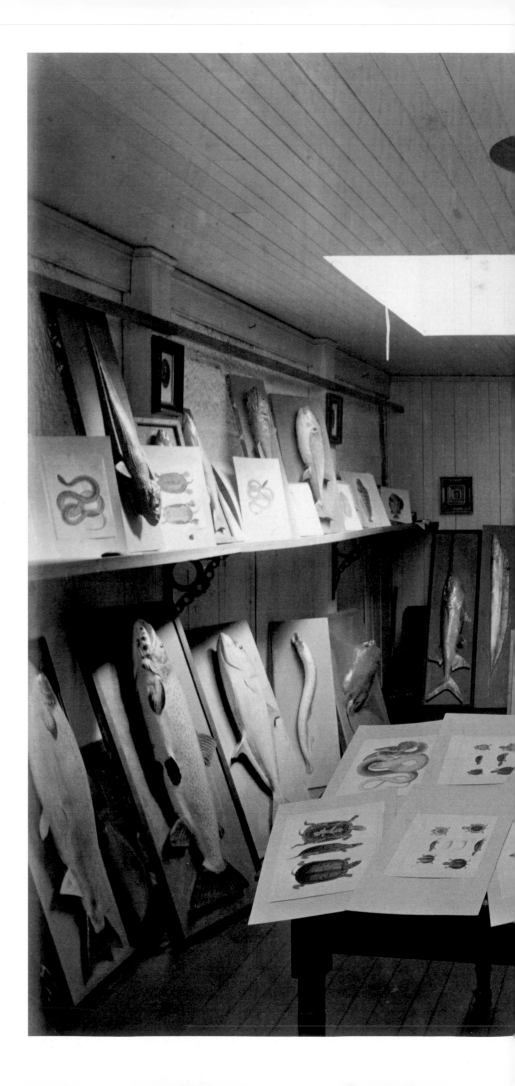

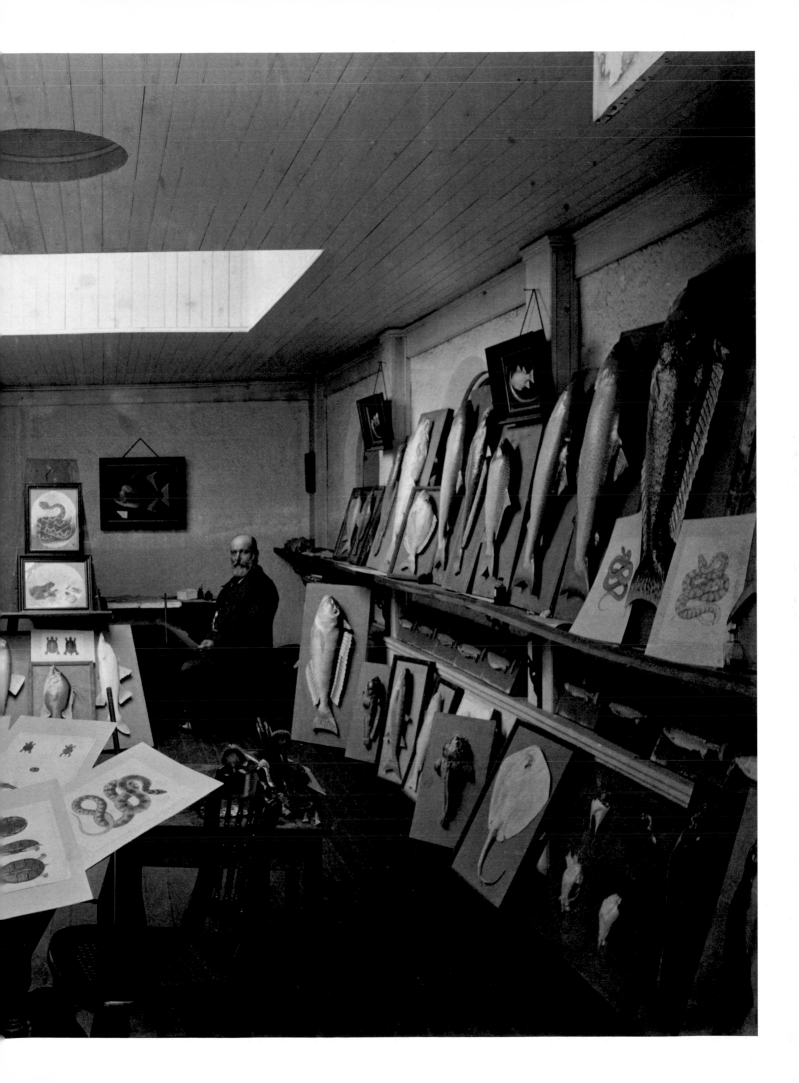

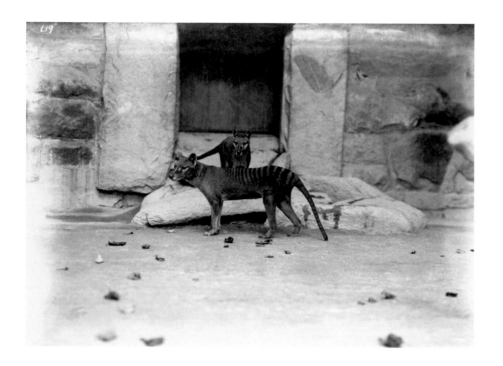

Tasmanian Hyena at the National Zoo

Thomas Smillie

Gelatin silver print from vintage glass-plate negative

ca. 1891

NATIONAL ZOO, PHOTO ARCHIVES

The National Zoo opened in 1891 in an area of Rock
Creek Park in Washington, D.C. Thomas Smillie and
his staff photographed the grounds and collections
of the zoo, primarily for record-keeping purposes,
although souvenir postcards later were created from
some of the photographs. Such specimen photographs
tell the history of the zoo's collecting. In some cases
they show species that are now extinct, such as the
Tasmanian hyena.

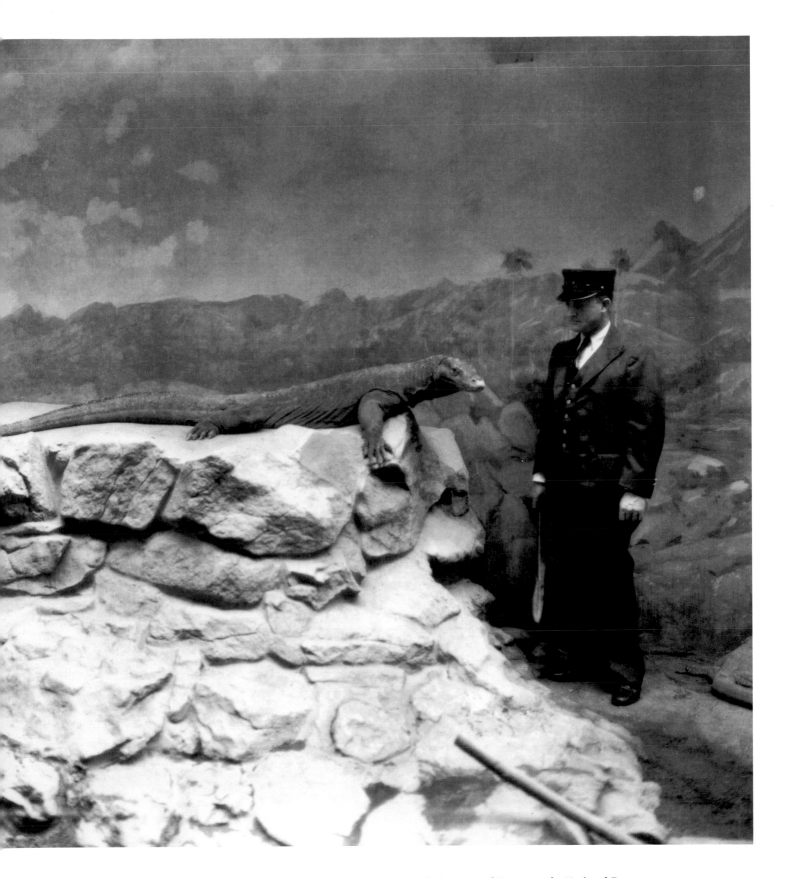

Komodo Dragon and Keeper at the National Zoo

Thomas Smillie

Gelatin silver print from vintage glass-plate negative

ca. 1891

EXPLORATIONS AND EXPEDITIONS

Pamela Henson
Smithsonian Institution Archives

The Smithsonian Institution was founded in 1846 during a period of tremendous expansion for the young nation. From the 1850s to the 1870s Spencer Fullerton Baird, the Smithsonian's curator and later Secretary, trained scientists to accompany government survey expeditions to map the natural resources of North America. Young naturalists collected specimens of flora, fauna, and minerals, compiled notebooks to document diverse environments, and made drawings and, more and more frequently, photographs. Together, the specimens, notes, an visual images form a body of knowledge that is still useful to scientists at the National Museum of Natural History.

Expedition photography proved challenging, since it involved moving large quantities of equipment, glass plates, and chemicals over rough and often unchartered terrain. The first known expedition photographs in the Smithsonian are campsite images from the 1865 Russian-American Telegraph Expedition in search of an overland telegraph route through Alaska, across the Bering Strait and Asia, and finally to Europe. By the 1870s photographers routinely accompanied the U.S. Geological Surveys of the Territories that were authorized by Congress. Romantic paintings by Thomas Moran, who participated in the expeditions, captured the breathtaking views of the Rocky Mountains for a fascinated public, but this generation of photographers created a new and equally captivating genre. Although taken to provide scientific documentation of the American West, these images, with their views of towering mountains, vast expanses, and rugged camp life, caught the public imagination. The photographs served as scientific records, works of art, and public relations tools.

Notable early photographers were Timothy O'Sullivan and John K. Hillers. O'Sullivan honed his craft during the Civil War and later accompanied expeditions to the American West and to Panama. He was especially intrigued by the challenges of capturing perspective through the camera's lens. Hillers joined John Wesley Powell's second expedition down the Colorado River after being discharged from the army in 1871. He learned photography as he went and soon took over the duty of photo-

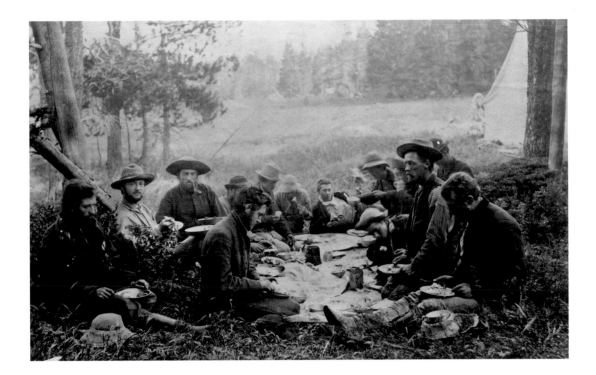

Hayden Survey Party Picnicking

William Henry Jackson

Gelatin silver print

ca. 1872

graphing Native Americans and the drama of the Grand Canyon. He continued as a government photographer for the rest of his career.

The camera was also used to document natural phenomena. Smithsonian astronomers, who traveled to North Carolina in 1900 to document a solar eclipse, relied on photographs to provide lasting images of this ephemeral event. During former president Theodore Roosevelt's 1909 expedition to Africa, photographers captured the outdoorsman standing atop his prey, furthering his rugged image. Roosevelt's specimens were put on display in the Smithsonian's new Museum of Natural History the following year.

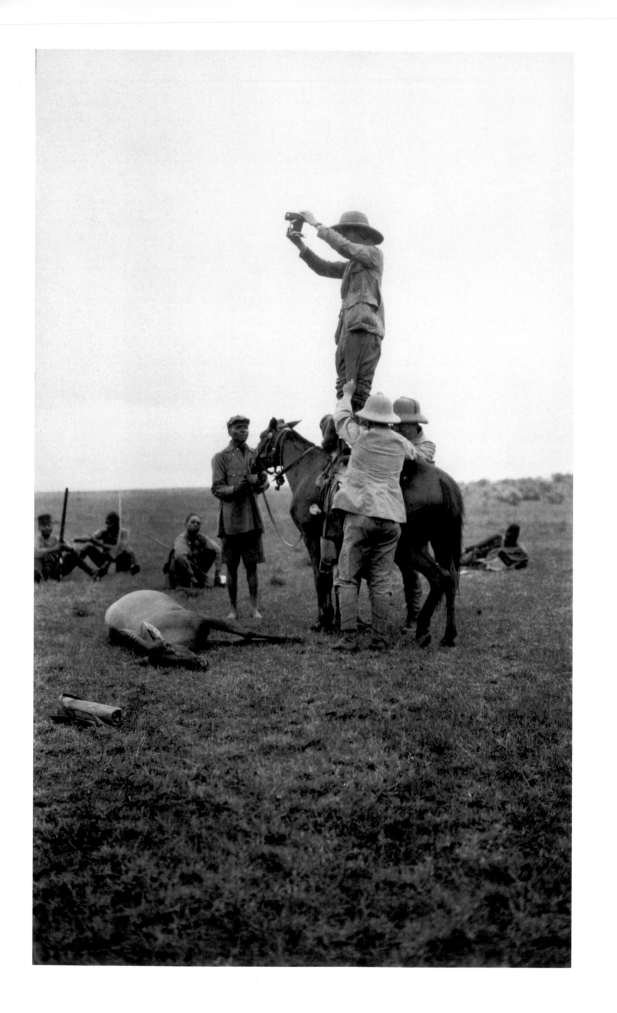

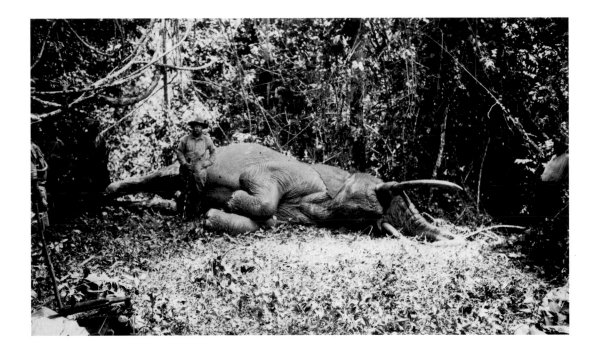

"The First Bull Elephant,"
Roosevelt African Expedition, 1909–10
R. J. Cunningham
Gelatin silver print

ca. 1909

Damaliscus Being Photographed
by Kermit Roosevelt,
Roosevelt African Expedition, 1909–10
Unidentified photographer
Gelatin silver print

ca. 1909

Just after President Theodore Roosevelt's second term ended in early March of 1909, he set sail for British East Africa, serving as the commander of an expedition to obtain specimens for the Smithsonian Institution. Roosevelt, a notable big game hunter, along with his son Kermit, who acted as the safari's official photographer, led a team that included naturalist Edmund Heller. Among Heller's duties were caring for the large mammals collected, writing up specimen descriptions, and taking photographs during the expedition.

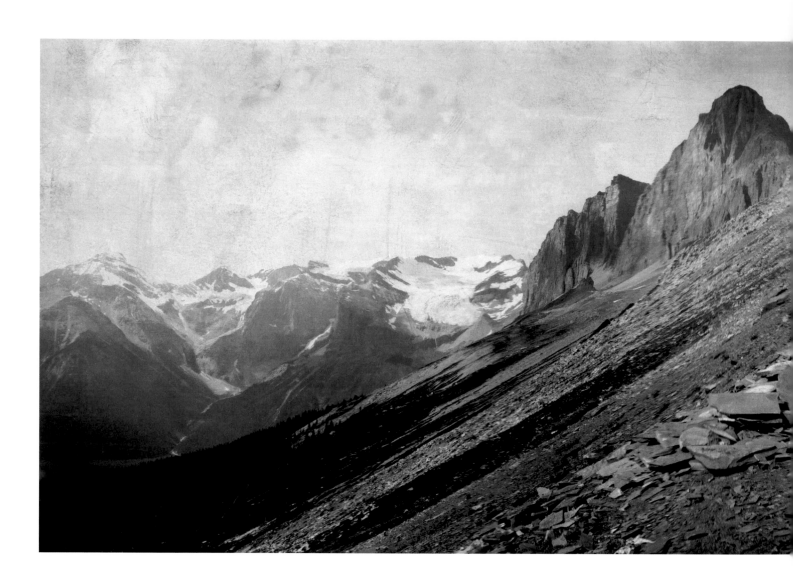

Dr. Walcott at Fossil Quarry on Mt. Stephen, Canadian Rockies

Charles Walcott

Albumen print

ca. 1892

Charles Doolittle Walcott's accomplishments in the fields of paleontology and geology distinguished his long career of scientific research and government service. In 1894 Walcott was appointed director of the United States Geological Survey. He worked simultaneously for the Smithsonian Institution, where he served as assistant secretary until 1907. At that time he was appointed the Institution's fourth Secretary, a position he held until his death in 1927.

Walcott continued his scientific research on fossil formations throughout his government appointments. He began using photography to aid his research in 1885 and progressed to making panoramic photographs by 1891. He took this photograph on one of his many trips to explore the Canadian Rockies. There, aided by his sweeping photographs of the extant rock and fossil formations, Walcott discovered the Burgess Shale, fossil formations from the Cambrian period that supported the big bang theory. The National Museum of Natural History houses the world's largest collection of Burgess Shale fossils and specimens, while the Smithsonian Institution Archives holds Walcott's papers, which contain numerous examples of his research-related panoramic photography.

Hayden Survey Party

William Henry Jackson

Albumen print

ca. 1872

SMITHSONIAN INSTITUTION ARCHIVES

Moss and Ingersoll on Hayden Survey

Unidentified photographer

Albumen print

ca. 1872

SMITHSONIAN INSTITUTION ARCHIVES

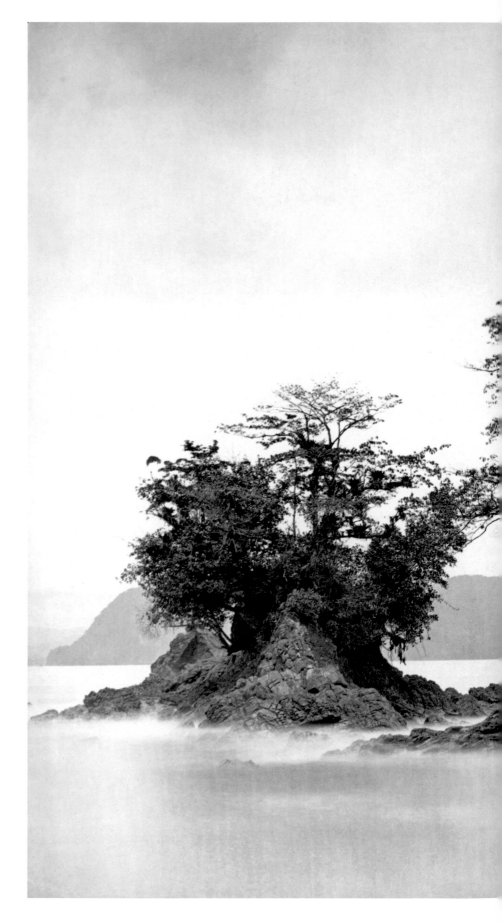

View of a Three-Masted Sailing Ship between
Tree-Covered Rock Formations in Misty Harbor,
Panama, from Darien Survey

Timothy H. O'Sullivan

Albumen print

1870

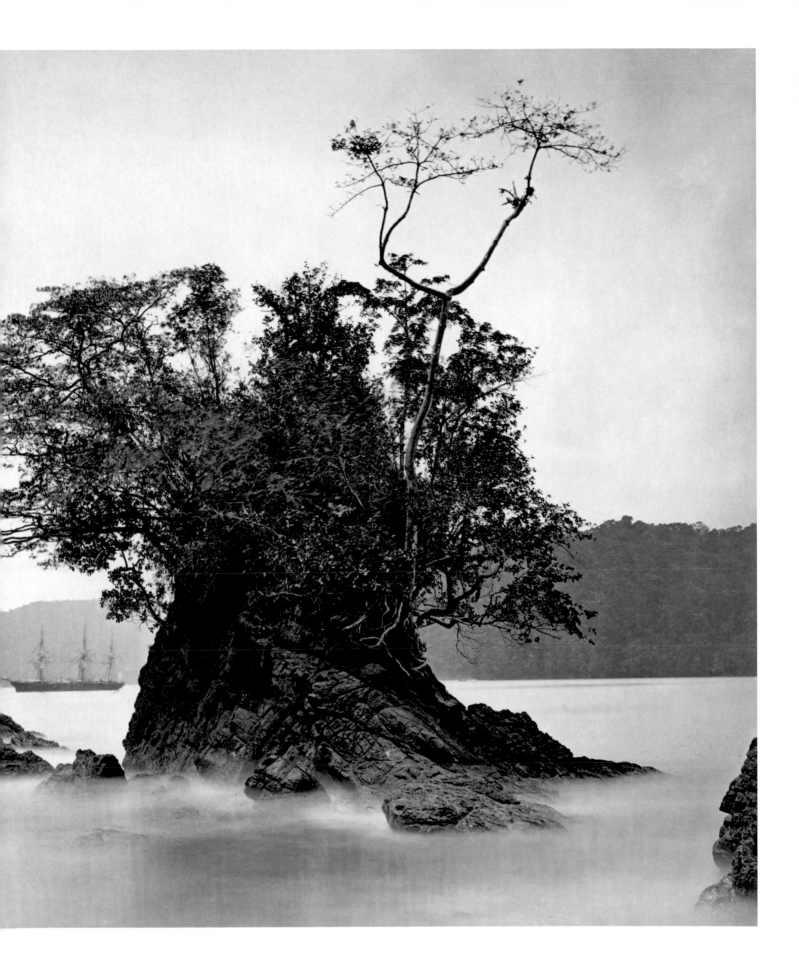

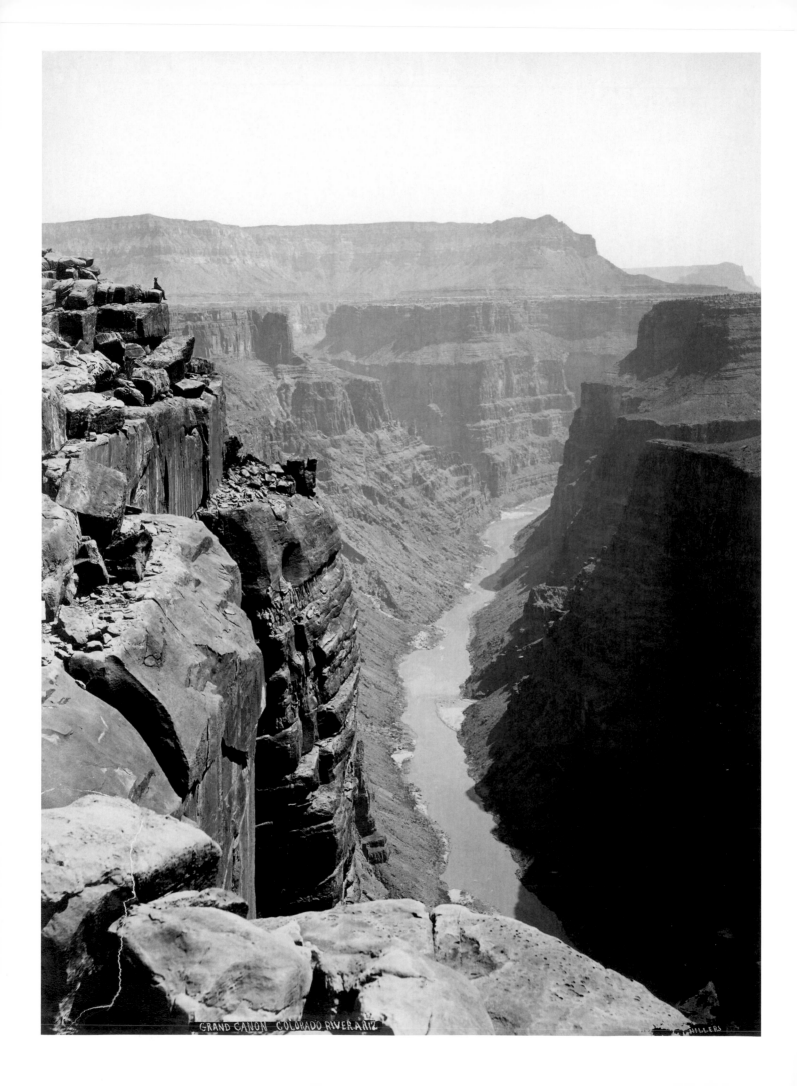

GRAND CAÑON COLORADO RIVER, ARIZ. HILLERS

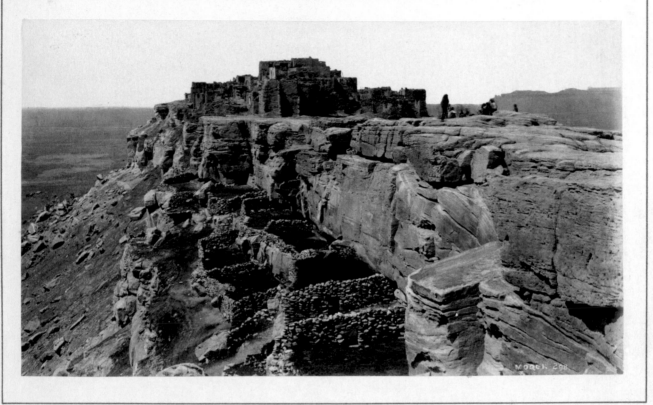

W.H.JACKSON, PHOTO.

View of Moqui Pueblos, Colorado

William Henry Jackson

Albumen print mounted on U.S. Geological Survey presentation board

ca. 1872

SMITHSONIAN INSTITUTION ARCHIVES

View from Above of River in Canyon (Arizona Grand Canyon)

John Hillers

Albumen print

1872

NATIONAL MUSEUM OF NATURAL HISTORY
NATIONAL ANTHROPOLOGICAL ARCHIVES

THE ENGINEERED LANDSCAPE

William E. Worthington Jr.
National Museum of American History

Where would we be without engineers? For better or for worse, we are surrounded by their work. Engineers have exerted a remarkable impact on our nation's history, and the fields of mechanical and civil engineering have been inextricably connected to the management and modification of the natural landscape. Bridges, roads, tunnels, canals, waterworks, sewerage systems, and buildings — objects far too large for a museum to collect — are all the work of civil engineers. Their projects tend to be long-lasting, if not permanent, and they can be as dramatic as moving mountains or shaping waterways. The means for carrying out and supporting these changes, including designing the needed equipment, have become the domain of mechanical engineers. Since the scope and character of these projects often preclude collecting physical remnants of them, museums rely heavily on the documentation that photographs provide.

Engineering projects during the Antebellum period piqued the interest of America's earliest photographers. Perhaps it arose from a sense of national pride or simply from a fascination in seeing others work. Whatever the reason, these photographers sought to capture the moment. In the process, artisans produced an important and sometimes unique historic record of what was built. Some engineers created their own photographic records. Not only did photographs document the process, but particularly striking images were also useful as promotional tools when an engineer sought further employment.

No one in the 1850s was more attuned to the value of photography as an engineering tool than was Montgomery C. Meigs of the United States Army Corps of Engineers. Aside from being in charge of several civil projects in and around Washington, Meigs developed into an avid photographer. He saw to it that his work on projects such as the Washington Aqueduct, the erection of the cast-iron dome on the Capitol, and the construction of the Pension Building was thoroughly photographed. As a result, Meigs left an unparalleled photographic account of what lies beyond the facades of a significant part of monumental Washington.

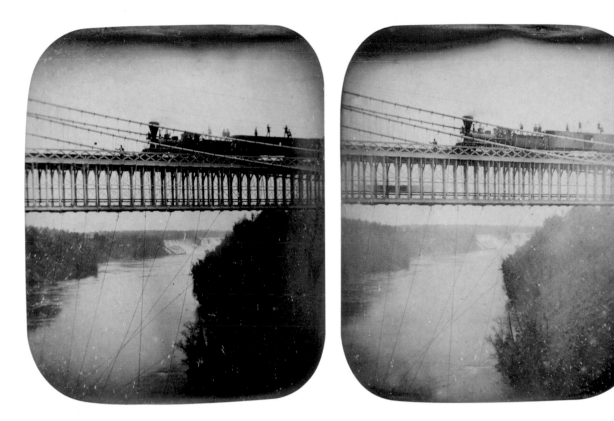

**The Tioga, a Steam Locomotive on a Trestle Bridge,
with Niagara Falls in the Background**
Unidentified photographer

Stereo daguerreotype

1848

NATIONAL MUSEUM OF AMERICAN HISTORY
DIVISION OF INFORMATION TECHNOLOGY AND SOCIETY
PHOTOGRAPHIC HISTORY COLLECTION

Three-dimensional artifacts of everyday life can provide cultural historians with information that otherwise might have gone unrecorded. Just as wear on a handle or blade might reveal how a tool was utilized as well as something about the person who used it, a photograph of an engineering project can greatly benefit historians of technology. From the relative positions of workers and equipment, historians can make deductions about the process of work. A series of similar images taken over time may explain how an idea evolved and provide clues to the project's ultimate success or failure. The challenge for the historian is to interpret what is seen and construct a three-dimensional image from what is not.

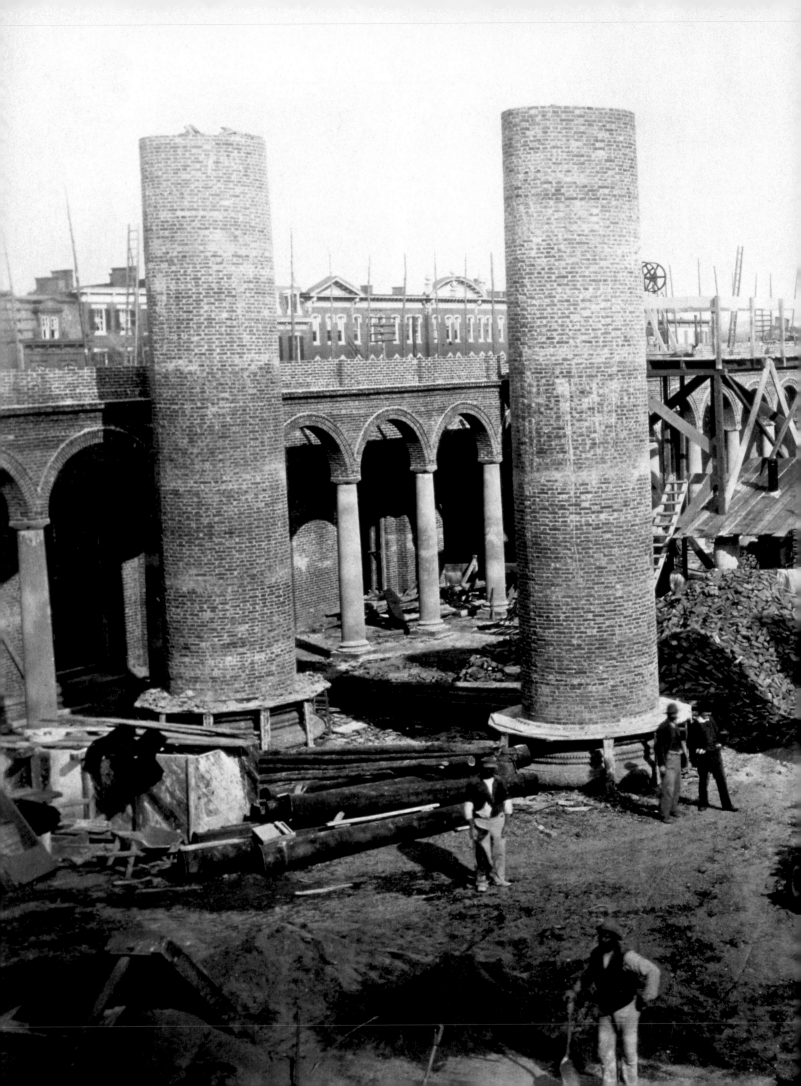

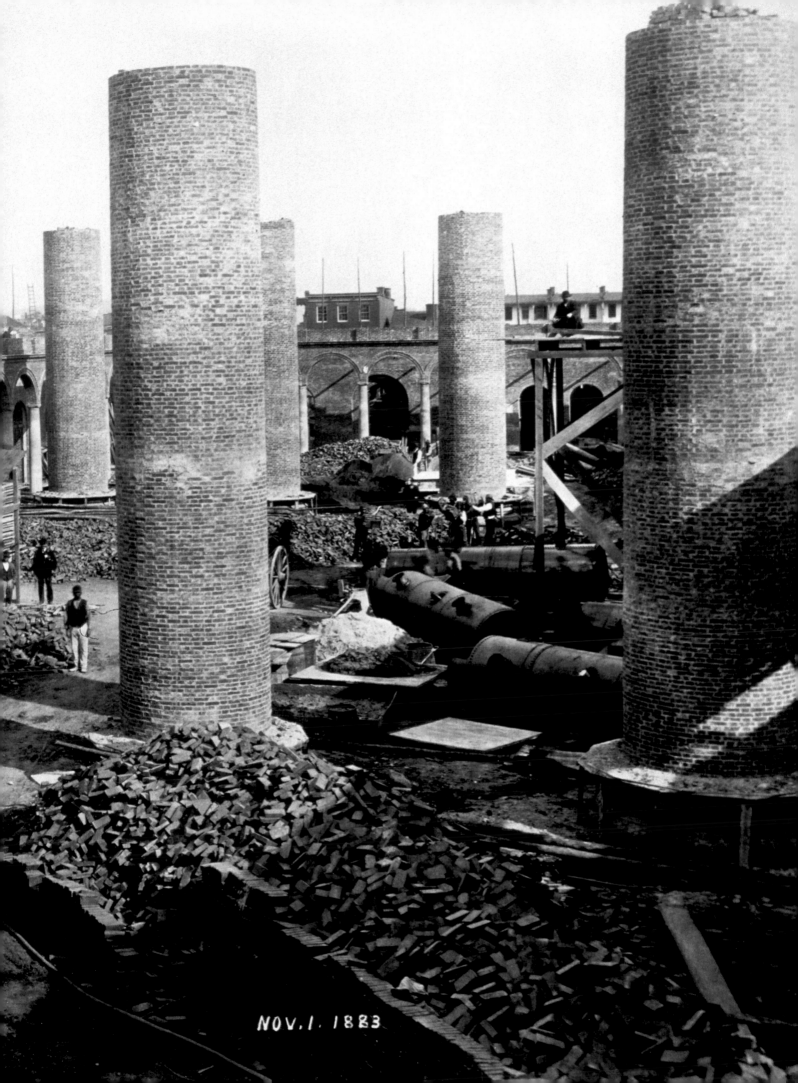

NOV. I. 1883

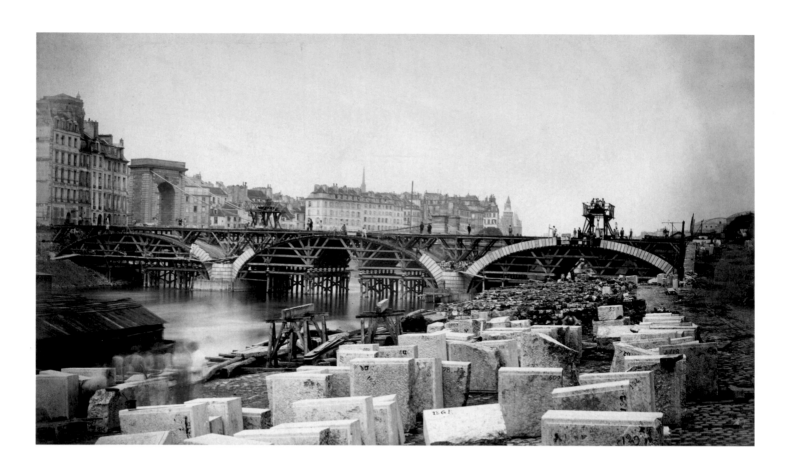

Construction on the River Seine, Pont Louis Philippe

Unidentified photographer

Albumen print

ca. 1865

NATIONAL MUSEUM OF AMERICAN HISTORY
DIVISION OF **THE HISTORY OF TECHNOLOGY**
ENGINEERING COLLECTION

PREVIOUS SPREAD

Construction of the Pension Building,
Designed by Montgomery Meigs

Unidentified photographer

Albumen print

ca. 1883

NATIONAL MUSEUM OF AMERICAN HISTORY
DIVISION OF **THE HISTORY OF TECHNOLOGY**
ENGINEERING COLLECTION

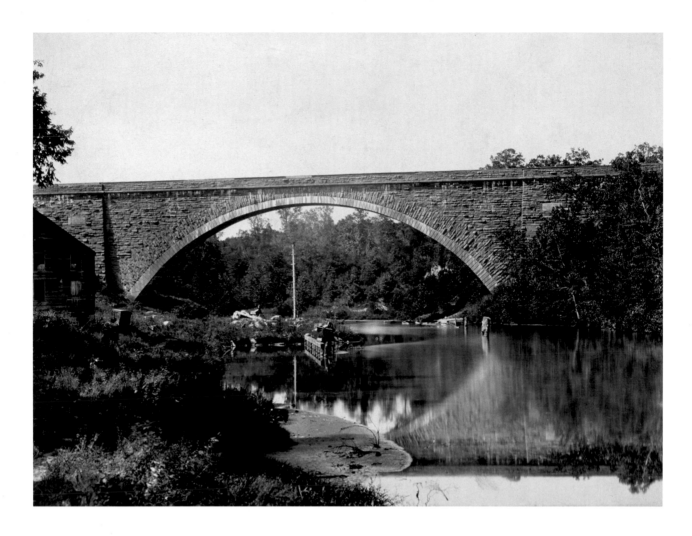

Construction of the Washington, D.C., Aqueduct,
Designed by Montgomery Meigs

Unidentified photographer

Salted-paper print

ca. 1855

NATIONAL MUSEUM OF AMERICAN HISTORY
DIVISION OF THE HISTORY OF TECHNOLOGY
ENGINEERING COLLECTION

Construction of the Washington Aqueduct began in 1853 under the charge of Montgomery C. Meigs of the U.S. Army Corps of Engineers. An avid photographer himself, Meigs commissioned photographs of the construction throughout the project until it was completed in 1860. Meigs was one of the first engineers to use photography as a tool in his work. He ordered photographs made not only of the construction progress but also of construction drawings (which saved time since they did not have to be copied by hand) for his assistants to use as reference. Meigs also relied on the photographs to promote his projects to Congress. By documenting his progress, the photographs helped him secure additional appropriations to support his work. During his career Meigs served as the quartermaster general of the Union army during the Civil War, and he later designed and constructed many other important structures in Washington, D.C. Two of his projects that were also fully documented in photographs were the addition of the wings and dome of the U.S. Capitol (1855–66) and the construction of the Pension Building.

Chinese Kite Frames

Thomas Smillie

Cyanotypes

ca. 1906

SMITHSONIAN INSTITUTION ARCHIVES

13036

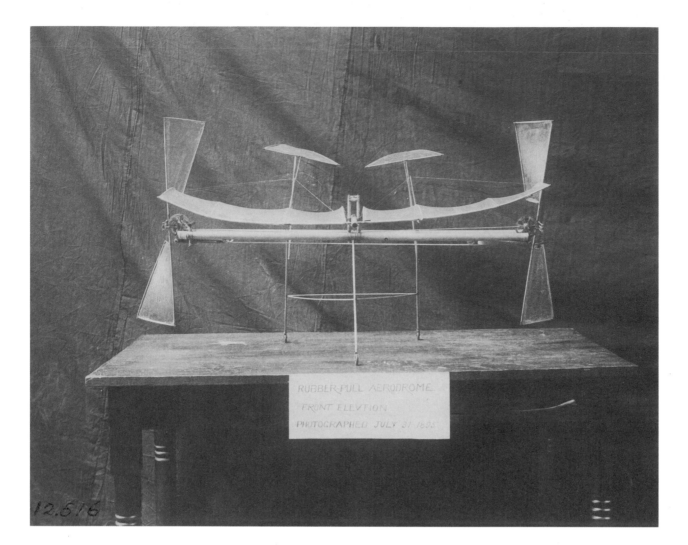

Twelve Airplane Models Designed by Samuel P. Langley

Thomas Smillie

Cyanotypes

ca. 1893

Samuel Pierpont Langley served as the third Secretary of the Smithsonian from 1887 to 1906. During that time he was deeply involved in scientific research on many different fronts, including astronomy, physics, and perhaps most passionately, aeronautics. Langley was one of the few professional scientists convinced that people were destined to fly. As Secretary of the Smithsonian, he secured government backing to experiment with the creation of an engine-powered manned aircraft. When early endeavors with steam-powered engines proved less than successful, Langley began to experiment with gasoline-powered engines.

Smithsonian photographer Thomas Smillie most likely took this series of photographs of the many aircraft models that Langley used for his flight experiments in the aerodrome where the scientist conducted his tests. Unfortunately, after two unsuccessful public tests of his aircrafts on October 7 and December 8, 1903, the government withdrew its financial support of Langley's experiments. Nine days after the failed trial on December 8, the Wright brothers successfully flew their engine-powered airplane in Kitty Hawk, North Carolina.

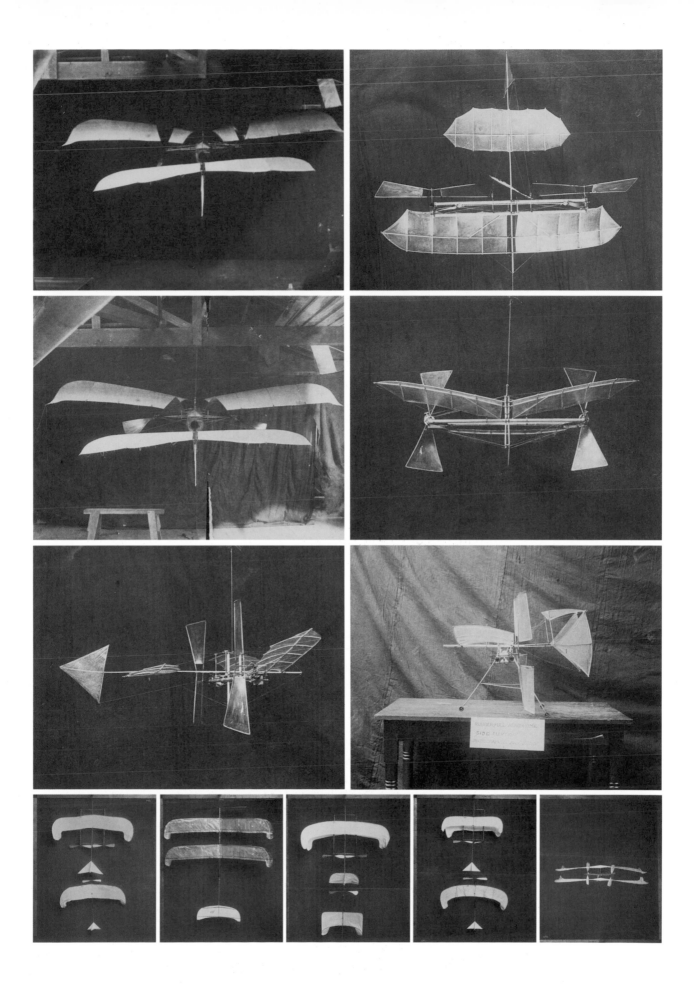

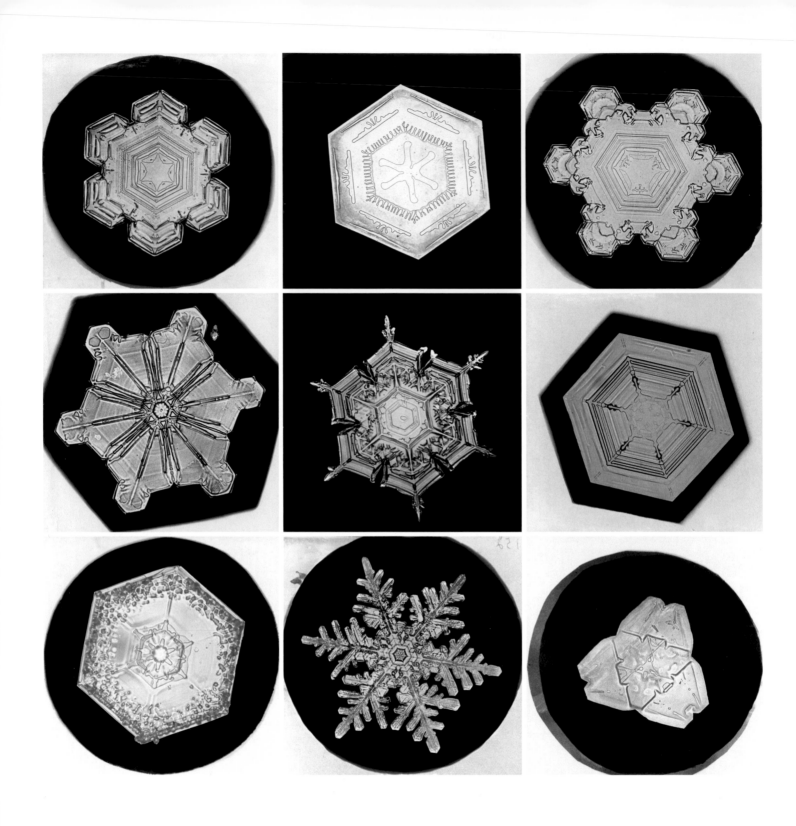

Eighteen Snowflake Studies

Wilson A. Bentley

Albumen prints

ca. 1890

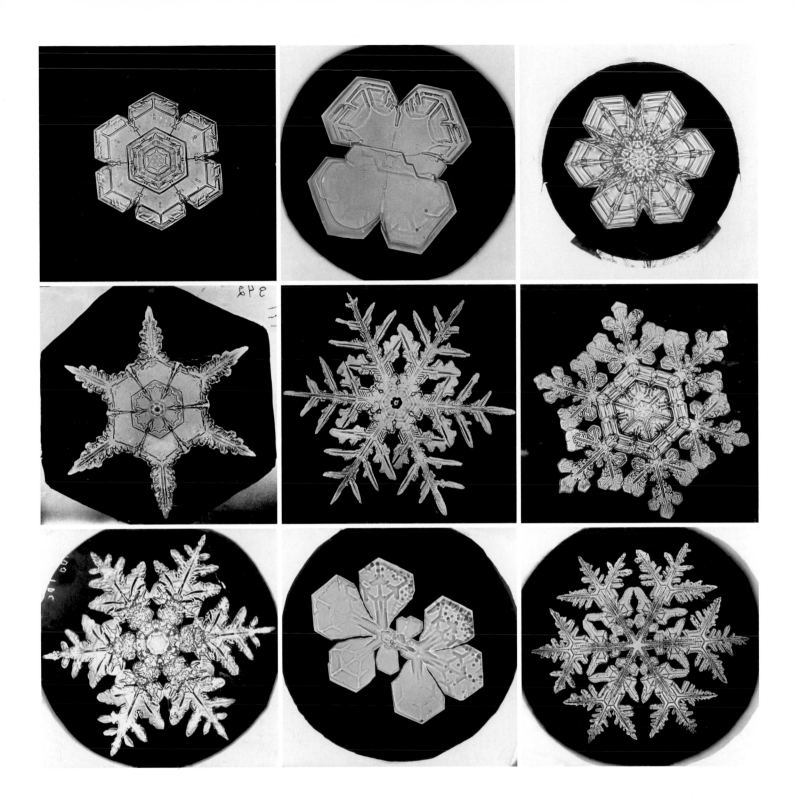

Wilson A. Bentley's fascination with snow started in his youth as a Vermont farm boy. Self-educated, Bentley experimented for years with ways to view individual snowflakes in order to study their crystalline structure. He eventually attached a camera to his microscope and successfully photographed the flakes in 1885. His photomicrographs of over five thousand snowflakes supports the belief that, indeed, no two snowflakes are alike. Scientists studied Bentley's work and published it in numerous scientific articles and magazines. In 1903 Bentley sent prints of his snowflakes to the Smithsonian, thinking they might be of scientific interest to Secretary Langley.

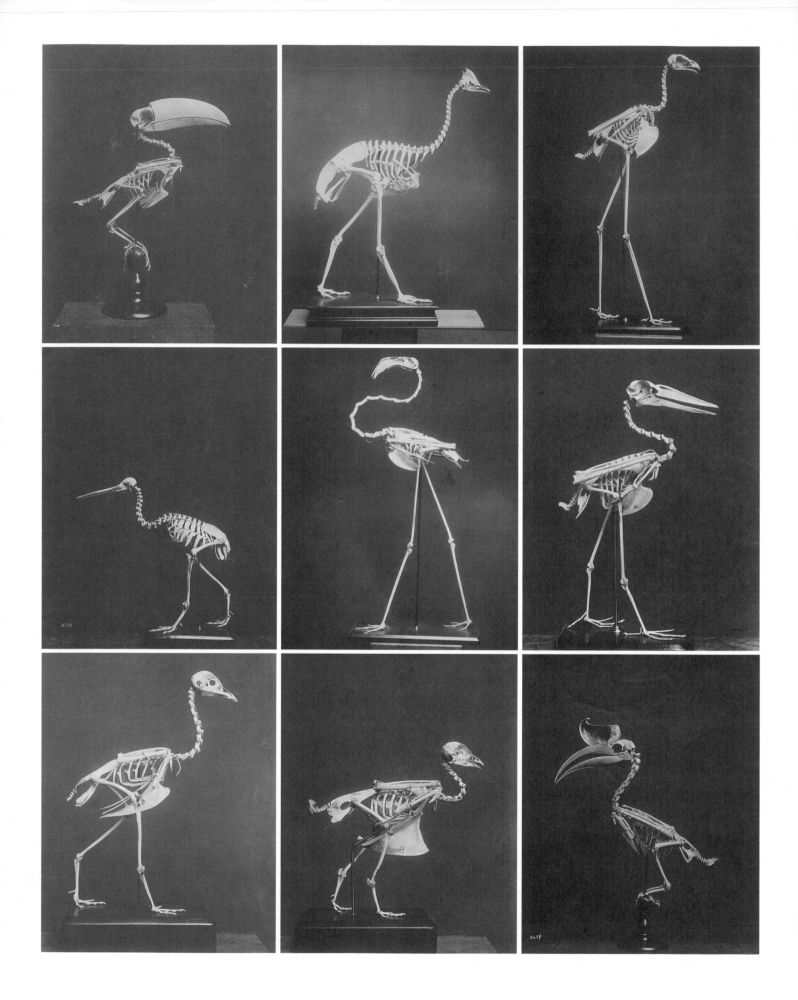

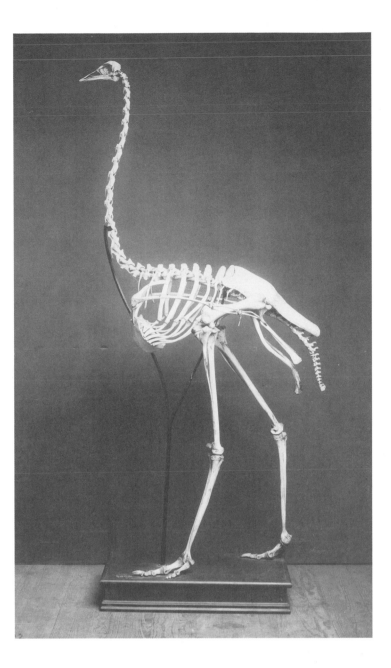

Ostrich *(Struthio camelus)* Skeleton
Thomas Smillie
Cyanotype

ca. 1906

NATIONAL MUSEUM OF NATURAL HISTORY
DIVISION OF **BIRDS**

Keel-billed Toucan *(Ramphastos sulfuratus)* Skeleton
Cassowary *(Casuarius casuarius)* Skeleton
Secretary Bird *(Sagittarius serpentarius)* Skeleton
Brown Kiwi *(Apteryx australis)* Skeleton
Greater Flamingo *(Phoenicopterus ruber)* Skeleton
Greater Adjutant *(Leptoptilus dubius)* Skeleton
Spotted Nothura *(Nothura maculosa)* Skeleton
Unidentified Bird Skeleton
Rhinoceros Hornbill *(Buceros rhiniceros)* Skeleton
Thomas Smillie

Cyanotypes

ca. 1906

NATIONAL MUSEUM OF NATURAL HISTORY
DIVISION OF **BIRDS**

Thomas Smillie and his staff spent a large portion of their time photographing and keeping records of the specimens that Smithsonian scientists acquired for research and public display. These cyanotypes of bird skeletons, as well as the actual stuffed specimens, still reside in the National Museum of Natural History's Division of Birds.

PHOTOGRAPHY AND ICHTHYOLOGY

Susan Jewett
National Museum of Natural History

Photographs of beautiful fishes, as seen on calendars, magazines, note cards, and elsewhere, are familiar to all of us. Few realize, however, how important such images are to ichthyology, the scientific study of fishes.

When scientists study fishes and describe new species, color is one of many distinguishing characteristics they use. Unfortunately, nearly all the natural color disappears when a fish is preserved. This makes it critical to document the specimen while it is still alive or immediately after it has died. In the eighteenth, nineteenth, and early twentieth centuries, before the use of color photography was commonplace, artists accompanied scientists on collecting expeditions to record the distinct coloration of live or freshly killed fishes. With the routine practice of color photography, colors of live fishes can be permanently recorded and incorporated into scientific descriptions of color differences among juveniles and between males and females, and to describe possible new species.

Radiography (recording an X-ray image) also facilitates ichthyology by revealing the internal skeleton without having to dissect or otherwise alter the specimen. The number, shape, and configuration of bony elements help distinguish different species, and radiographs provide a lasting record of the internal skeletal anatomy of specimens.

In recent years digital photography and radiography have rapidly replaced traditional methods that require film be processed before the image is visible. One can now photograph or X-ray a fish and immediately view the image on a computer screen. In fact, most of the radiographs shown here were produced using a digital X-ray machine.

In addition to streamlining and greatly accelerating the process of creating a photograph or radiograph, digital photography and radiography result in images that can be rapidly transmitted by electronic means to researchers, publishers, and others worldwide. Images can be easily "enlarged" for close examination of minute details by zooming in on the computer screen. One of the most useful applications of digital images in museum collections today is electronically linking images of specimens to catalog records. In the near future the Internet will provide worldwide electronic access to records of selected specimens.

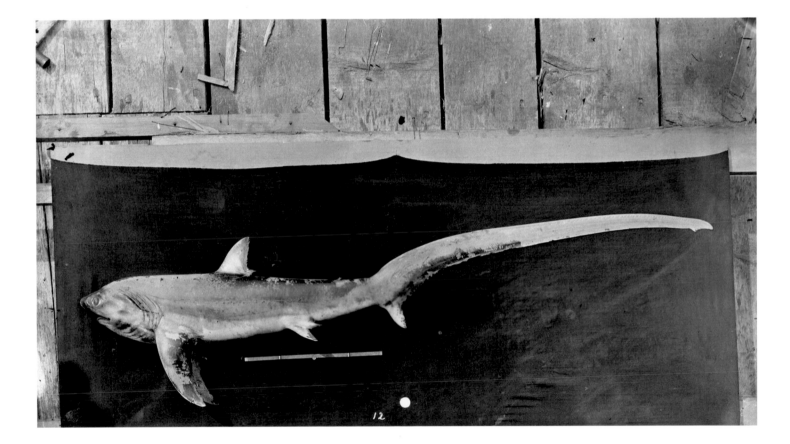

Alopias vulpinus (Thintail Thresher)
Unidentified photographer
Albumen print

1871

NATIONAL MUSEUM OF NATURAL HISTORY
DIVISION OF FISHES

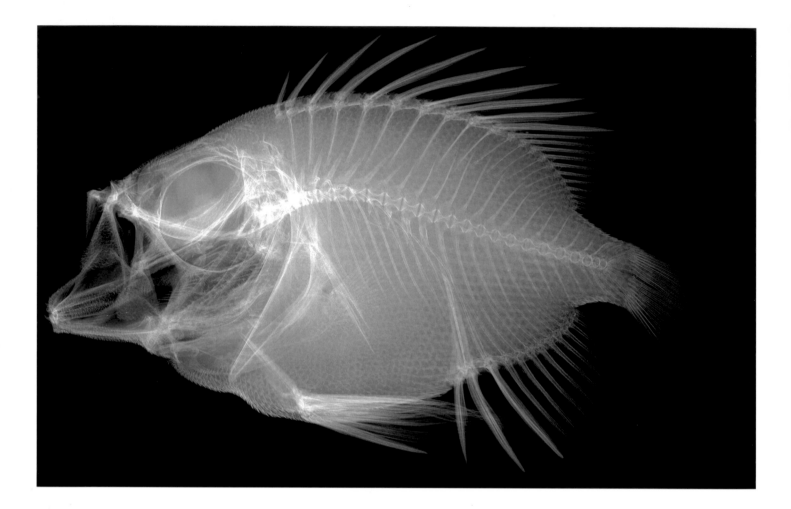

Pristigenys alta (Short big eye)

Sandra J. Raredon

Digital radiograph, lateral view

2002

NATIONAL MUSEUM OF NATURAL HISTORY
DIVISION OF FISHES

Himantura signifier (Stingray)

Sandra J. Raredon

Digital radiograph, dorsal view

2002

NATIONAL MUSEUM OF NATURAL HISTORY
DIVISION OF FISHES

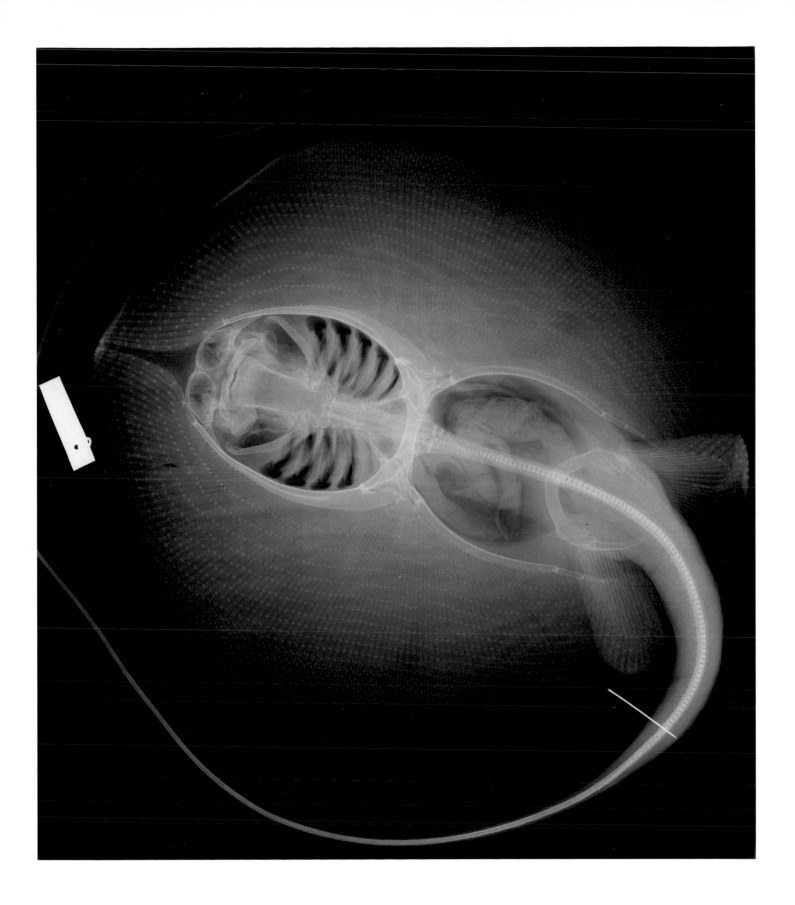

Mounted Cyanotypes, the Working Proofs for
Eadweard Muybridge's *Animal Locomotion*, Plate 55,
"Walking, Turning Around, Action of Aversion"
(Miss Larrigan, July 28, 1885)

Eadweard Muybridge

Cyanotypes pasted on board

ca. 1885

NATIONAL MUSEUM OF AMERICAN HISTORY
DIVISION OF INFORMATION TECHNOLOGY AND SOCIETY
PHOTOGRAPHIC HISTORY COLLECTION

Eadweard Muybridge's cyanotypes are working proofs
(contact prints) made from the more than 20,000
negatives he took at the University of Pennsylvania
from 1884 to 1886 while he was photographing human
and animal subjects in motion from lateral (parallel),
front, and rear positions. For the lateral views he
used up to 36 lenses in 12 to 24 cameras placed at
90-degree angles to his subjects, and he added two
more cameras, each holding up to 12 lenses and placed
at 60-degree angles, for the front and rear "foreshort-
ening" views.

Since the original negatives no longer exist,
the cyanotypes record complete images before
Muybridge edited and cropped them for publication.
The mounted cyanotypes for plate 55 represent one
of over 800 sets of proofs in the unique collection
found in the Photographic History Collection of the
National Museum of American History. Comparisons
between Muybridge's working cyanotype proofs
and his final collotype prints prove that he freely
reprinted, cropped, deleted, or substituted negatives
to make the assemblage of 781 collotypes in the
portfolio *Animal Locomotion*.

In plate 55, frame 3 of the rear views is blank
and crossed out, indicating the camera must have
malfunctioned. The remaining 11 frames were
reassembled and renumbered for the final print.

Michelle Anne Delaney, National Museum of American History

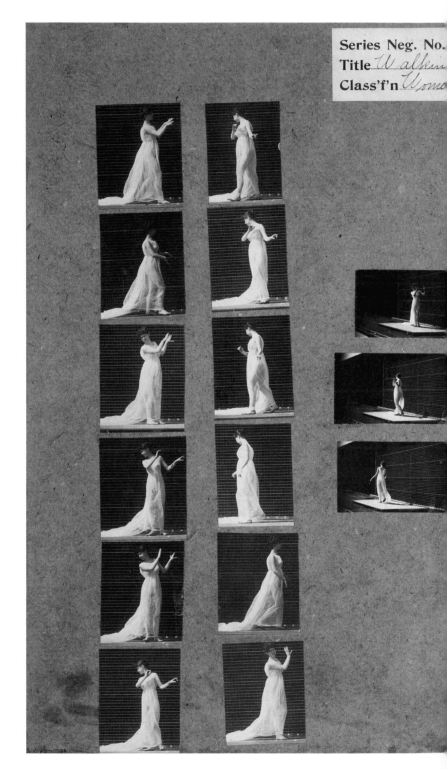

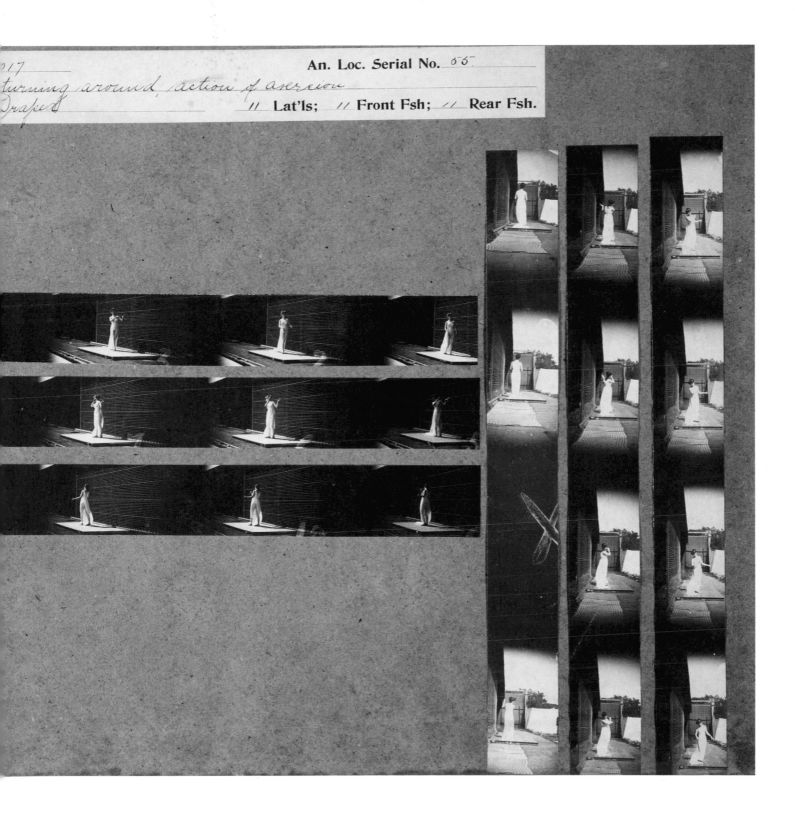

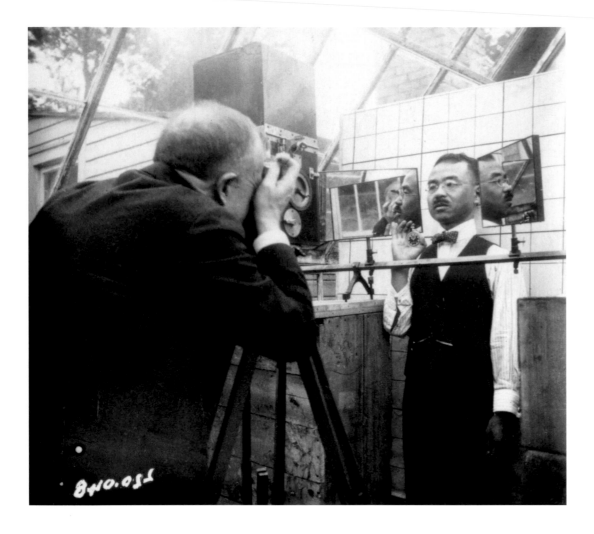

Frank Gilbreth Filming a Motion Study

Frank Gilbreth

Gelatin silver print

ca. 1916

NATIONAL MUSEUM OF AMERICAN HISTORY
DIVISION OF THE HISTORY OF TECHNOLOGY
INDUSTRY COLLECTION

Frank and Lillian Gilbreth employed time-lapse photography to verify their study and philosophy of "work simplification" — the relationship of human effort to the volume of work the effort accomplishes. Frank Gilbreth, himself a brick mason and a building contractor, initially set out to improve efficiency in the construction industry. His ideas expanded to embrace the study of human motion, with the goal of improving work efficiency as a tool of scientific industrial management. He and his wife Lillian went on to create the study of micromotion.

By attaching a camera to a timing device, the Gilbreths were able to photograph workers performing various tasks. The essential elements of their movements were called "therbligs" (Gilbreths spelled backward). Using these photographs to offer analysis and proof of their effort versus efficiency theories, the Gilbreths traveled across the United States lecturing to engineering and manufacturing audiences.

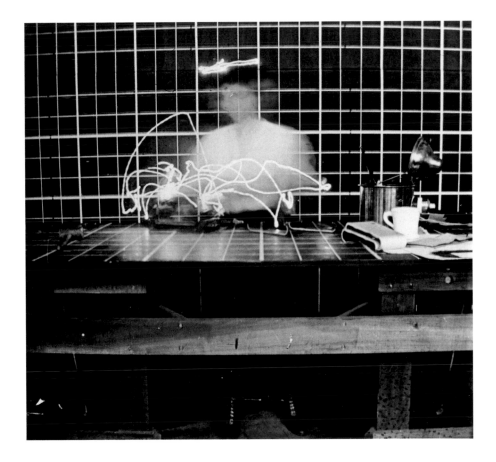

Motion Efficiency Study

Frank Gilbreth

Gelatin silver print

ca. 1910–24

NATIONAL MUSEUM OF AMERICAN HISTORY
DIVISION OF THE HISTORY OF TECHNOLOGY
INDUSTRY COLLECTION

Genius Engaged in Multiple Tasks

Science Service Incorporated

Gelatin silver print

ca. 1940

NATIONAL MUSEUM OF AMERICAN HISTORY
DIVISION OF SCIENCE, MEDICINE, AND SOCIETY
MEDICAL SCIENCES COLLECTION

Science Service Incorporated, located in Washington, D.C., began in the 1920s as a stock photography and news clearinghouse for the science industry. The Science Service regularly sent out press releases and photographs to announce new inventions, improvements, experiments, and discoveries in all fields of science. Today maintained in several collections in the Museum of American History, the images created by the Science Service range from the fascinating to the bizarre and document both highly revered and long-forgotten scientific discoveries.

Color Blindness Card Test

Science Service Incorporated

Gelatin silver print

ca. 1930

NATIONAL MUSEUM OF AMERICAN HISTORY
DIVISION OF SCIENCE, MEDICINE, AND SOCIETY
MEDICAL SCIENCES COLLECTION

Camera Testing at the Photo Science Laboratory
of the Naval Air Station, Washington, D.C.

United States Navy

Gelatin silver print

ca. 1944

NATIONAL MUSEUM OF AMERICAN HISTORY
DIVISION OF INFORMATION TECHNOLOGY AND SOCIETY
PHOTOGRAPHIC HISTORY COLLECTION

IMAGING THE UNSEEN

Steven Turner
National Museum of American History

These "spark" or "shadow" images utilize photography's ability to subdivide time. Taken by Harvard professor William Sabine around 1913, they show the progress of a single sound wave as it travels through a model space. Sabine used them in his pioneering studies of architectural acoustics.

In the first photograph, the sharp snap of an electric spark (located on the other side of the black circle) has created a single sound wave, much like the circular wave produced by dropping a stone in a still pond. A small fraction of a second later, a distant second spark illuminates the entire scene and creates an image of the wave's position. In the time between the two sparks, the wave has reflected off the back and sides of the box. The tangled mass around the black circle is acoustic noise from the spark apparatus.

By controlling all aspects of the photographic process, Sabine was able to model the real-world behavior of sound waves. For photos two and three he assembled cross-sectioned miniatures of existing auditoriums and produced sound waves from the position of the stage. He then adjusted the spark apparatus that produced the sound waves so the model wave would be the same scale as an actual sound wave in a real auditorium. Multiple reflected waves in the models corresponded to annoying reverberations in the real spaces.

While these photographs are generally presented as illustrations of sound waves, the image is actually caused by a change of density in the air as the sound wave travels through it. Much like a lens, this dense air refracts the light and produces a band of light and shadow that reveals the presence and position of the wave. Due to the wave's optical effect, this type of photography did not require a camera. The model was simply placed on a photographic plate in a dark room, and the illuminating spark generated an image by projection.

Reflection in Closed Space
William Sabine
Lantern slide

ca. 1913

Holy Trinity Church, Buffalo, New York
William Sabine
Lantern slide

ca. 1913

**Model of Century Theatre, New York,
before Correction**
William Sabine
Lantern slide

ca. 1913

NATIONAL MUSEUM OF AMERICAN HISTORY
DIVISION OF SCIENCE, MEDICINE, AND SOCIETY
PHYSICAL SCIENCES COLLECTION

Shock Waves from Impact

Harold E. Edgerton

Gelatin silver print

ca. 1936

Bullet through Balloons

Harold E. Edgerton

Gelatin silver print

1964/printed later

SMITHSONIAN AMERICAN ART MUSEUM

Harold E. Edgerton invented the "stroboscope" in 1931 while he was a student of electrical engineering at the Massachusetts Institute of Technology. The stroboscope relied on pulsing lights to create an electronic flash capable of recording a motion taking place in 1/1,000,000 of a second. Edgerton taught at MIT for more than forty years, and all the while he continued to experiment with his variation of stop-motion photography, which he labeled "high-speed" photography. His ground-breaking stroboscopic photography allowed scientists to study many different forms of matter and reactions to the application of force in ways that were never before possible.

July 8th 1896. Photograph of Sun Taken in presence of the Emperor of Brazil. Refractor 11½ inch aperture Solar camera

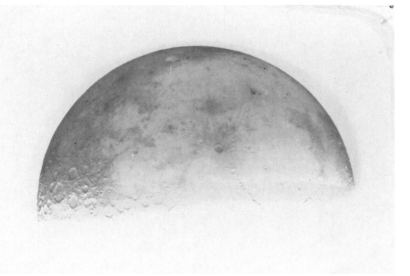

Glass Positive of the Moon
Henry Draper
Glass positive affixed with optical resin on glass slide

ca. 1876

NATIONAL MUSEUM OF AMERICAN HISTORY
DIVISION OF SCIENCE, MEDICINE, AND SOCIETY
PHYSICAL SCIENCES COLLECTION

Glass Positive of the Sun
Henry Draper
Glass positive affixed with optical resin on glass slide

ca. 1876

NATIONAL MUSEUM OF AMERICAN HISTORY
DIVISION OF SCIENCE, MEDICINE, AND SOCIETY
PHYSICAL SCIENCES COLLECTION

Combining cameras with optical instruments eventually resulted in significant advances in the accuracy and sensitivity of scientific observations, but more importantly, optical observations could finally be recorded and shared. In effect, the observer's eye had been replaced by the camera as the instrument's tool of perception.

When the emperor of Brazil visited Dr. Draper's observatory in 1876, the scientist let him look at the Sun through his telescope and then demonstrated his new photographic technique. On the negative Draper later wrote: "July 8th 1876. Photograph of Sun taken in presence of Emperor of Brazil." Amazingly, Draper was able to record not only the fact of the emperor's visit but also an image of what the visiting dignitary actually saw.

Steven Turner, National Museum of American History

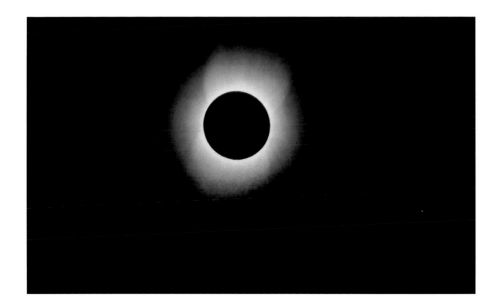

Corona of the Sun during a Solar Eclipse
Thomas Smillie
Albumen print

1900

SMITHSONIAN INSTITUTION ARCHIVES

In 1900 the Smithsonian Astrophysical Observatory, then based in Washington, D.C., loaded several railroad cars with scientific equipment and headed to Wadesborough, North Carolina. Scientists had determined that this small town would be the best location in North America for viewing an expected total solar eclipse. Among the Smithsonian Solar Eclipse Expedition scientists was photographer Thomas Smillie, who headed up the photographic component of the mission. The goal was to capture photographic proof of the solar corona for further study. Smillie rigged cameras to seven telescopes and successfully made eight glass-plate negatives ranging in size from 11 by 14 inches to 30 by 30 inches. At the time, Smillie's work was considered an amazing photographic and scientific achievement.

Portrait of a Man Holding a Photograph

Unidentified photographer

Tintype

ca. 1860

NATIONAL MUSEUM OF AMERICAN HISTORY
DIVISION OF INFORMATION TECHNOLOGY AND SOCIETY
PHOTOGRAPHIC HISTORY COLLECTION

A DEMOCRACY OF IMAGES

"What a spectacle!" In 1846, a mere six years after photography arrived in America, Walt Whitman enthusiastically described the medium's phenomenal presence and prodigious index of contemporary life. The occasion was a visit to photographer John Plumbe's New York Gallery, where, Whitman reported, photographic images — "hundreds of them" — were hung floor to ceiling. "Indeed," he said, "it is little else on all sides of you, than a great legion of human faces … creating the impression of an immense Phantom concourse — speechless and motionless, but yet realities."

Whitman, more than any other writer of his time, appreciated photography as a quintessentially American activity, one rooted in everyday people and ordinary things presented in a straightforward way. Photography wed technology to the intellect, senses, and spirit. Even better, as Whitman believed, it produced a democratic art. Unlike traditional forms of depiction, such as painting and sculpture, it seemed to make everyone and everything a potential subject. Like many who first encountered photography, Whitman quickly recognized the camera's ability to reproduce commonplace details of life and to shape public perceptions.

In some accounts of the medium's history, photography became a fully democratic art in the 1880s, with the introduction of pre-loaded, easy-to-use cameras and commercial, mail-order processing. George Eastman introduced the first roll-film camera, the Kodak, in 1888, with the memorable slogan, "You press the button — we do the rest." For the first time, anyone could take photographs and view them as prints without any special technical expertise or meaningful instruction. The result was an avalanche of picture taking by Americans blessed with the relatively new social phenomenon of leisure time. As a result, the intimate and casual events of daily life were recorded as never before.

A vocabulary of everyday experience, however, had been with photography since its beginnings. Even during the 1840s, when making daguerreotypes was a specialized profession that required practitioners to invest heavily in custom equipment and furnishings, the subjects of the camera reached beyond the social pantheon that was accustomed to having elegant portraits made in oil paint. By 1850 hundreds of daguerreotype studios in large cities and small towns attracted thousands of middle-class Americans. Later, lower-cost variants

of the daguerreotype, most notably the tintype, extended the democracy of images into the frontier and across the economic spectrum. Soldiers taking leave of their loved ones to fight in the Civil War made certain to leave behind tintypes as keepsakes, and tintypes of their loved ones were mailed to the front lines, where they were carried into battle in breast pockets.

Consider a small tintype portrait of a young man holding a photograph (page 144). Like Whitman, we may find ourselves in awe of the reality of the sitter's direct and unabashed gaze into the camera (made even more poignant now by its persistence over time). And we may marvel at the resourcefulness of whoever's idea — sitter's or maker's — it was to add another picture into this picture to create a portrait that signals the man's self-awareness of his outward countenance. By the time this common tintype was made, photographs were no longer rare objects of miraculous admiration, but instead were seen everywhere and were used by everyone.

The passionate regard for the keepsake, which lodged near the heart of the average American's love of photography, encouraged entrepreneurs to open photography studios in cities and small towns across the country. Itinerant practitioners traveled rural roads in search of paying customers. Anyone with a few cents to spare could possess a mirror image of their dearest loved ones, their favorite dog, or the biggest fish they ever caught. A visit to Niagara Falls or the time the circus came to town could be commemorated. The ability of the photographic image to "transcribe faithfully" became a hallmark of this vernacular tradition in American photography, a tradition that lies behind the works of Mathew Brady and the Boston studio of Southworth and Hawes as much as it does the annual reports of twentieth-century industry. As photography proliferated, so did Americans' comfort with photographs as messengers of plain seeing.

Among the more avidly collected images were stereographs, which consisted of two paper photographs mounted side-by-side on a card. When placed in a stereographic viewer, the pictures merged to create a three-dimensional effect. These "stereos" brought the marvels of the world into the drawing rooms of small-town America. The pyramids of Egypt, the ruins of Athens, and the splendors of imperial India provided hours of entertainment much the way video games do today. Americans came to recognize their own country's landmarks, as photographers on surveys of the West produced glorious landscapes of the Rocky Mountains, Yellowstone, and Yosemite Valley. Commercial publishing companies sold millions of stereo cards, and the fad extended well into the twentieth century.

Photography emerged, developed, and proliferated within the larger context of the nineteenth century's prosperity and progress. In

Installation View of Smithsonian Photography Exhibition

Thomas Smillie

Cyanotype

ca. 1913

the years following the Civil War, the United States increasingly evolved from a rural and agrarian nation into one that was largely urban and industrial. America's great symbol of expansion, the frontier, was officially declared closed in the census of 1890. By the end of World War I, statistics revealed that most Americans lived in cities and towns. The population of the United States was expanding. Waves of immigrants arriving from Europe and Asia made American society ever more heterogeneous. The middle of the country—once merely considered a necessary route from one coast to another—was being filled in while the indigenous Indians were rapidly being displaced. And as mass transportation, industrial technology, factory production, engineering skills, and mechanical invention became dominant forces in everyday life, photography played an important role in documenting the resulting social changes.

To the nineteenth-century archives of indigenous peoples were added images of immigrants and child laborers. At the turn of the century great public interest surrounded the social and political issues of immigration and the experiences of new arrivals to America.

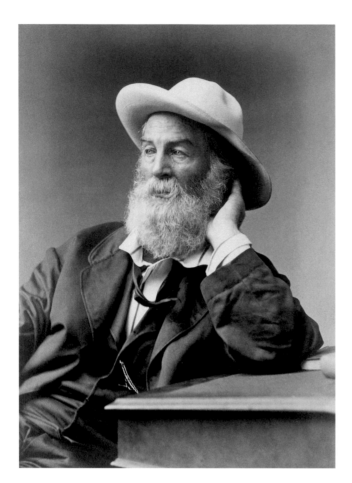

Walt Whitman
G. Frank Pearsall
Albumen print

1872

NATIONAL PORTRAIT GALLERY

Lewis Hine was one of many photographers who documented the living conditions of immigrants interned on Ellis Island. His images were published widely in both reform and popular journals. Today his pictures are admired for aesthetic reasons, but at the time Hine's aesthetics stirred immense sympathy for the often-reviled newcomers. Hine's style, which proved both instrumental and influential, came to be known as documentary, a term acknowledging his ability to make pictures that seem to have the status of fact.

Business and industry appropriated the convincing language of documentary photography to lend authenticity to their reports. Photographs of modern industry, whether commissioned by the companies themselves or by a new breed of "picture magazines," such as *Life* and *Fortune*, are almost always celebrations of progress. Companies eager to transform the intricacies and power of manufacturing into more human terms often employed photographers to accomplish the task. In the 1920s and 1930s, for example, the Consolidation Coal Company hired photographers to record the new company towns that it was

building in the valleys of the Appalachian Mountains (pages 186 – 89). The clean and welcoming houses, schools, and hospitals in these pictures give the impression of an instantly created ideal community. What these pictures did not address was the demographic shift that accompanied the new towns, which transformed mountain people from farmers to mine workers.

To call such pictures "vernacular" perhaps stretches the meaning of the term, since they were consciously created to shape public perceptions of social issues and social change. This is as true of Hine's "documentary" pictures of child labor as it is of the Consolidation Coal Company photographs. Nonetheless, they are part of the long tradition of photography that addresses the condition of everyday life in the United States. This tradition lives on in the work of photographers who devote themselves to one particular community or place throughout their careers. Addison Scurlock, whose career as a professional photographer was centered in the African American community of Washington, D.C., is a recent example of this. His archives, now preserved by the Smithsonian, confirm that the best documentary photography engages in a sympathetic dialogue with its subjects.

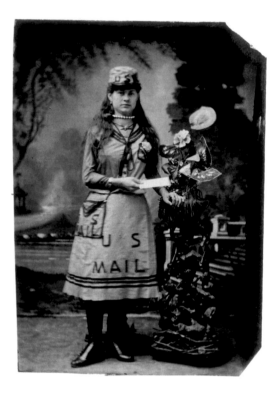

Drummer Boys

Unidentified photographer

Tintype

ca. 1860

NATIONAL MUSEUM OF AMERICAN HISTORY
DIVISION OF INFORMATION TECHNOLOGY AND SOCIETY
PHOTOGRAPHIC HISTORY COLLECTION

Mail Girl

Unidentified photographer

Tintype

ca. 1860

NATIONAL MUSEUM OF AMERICAN HISTORY
DIVISION OF INFORMATION TECHNOLOGY AND SOCIETY
PHOTOGRAPHIC HISTORY COLLECTION

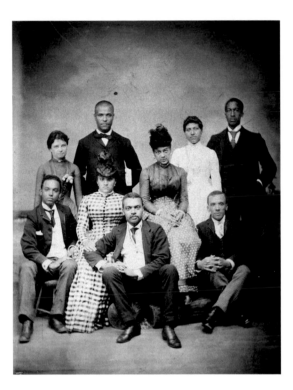

Two Women with Spoons
Unidentified photographer

Tintype

ca. 1860

NATIONAL MUSEUM OF AMERICAN HISTORY
DIVISION OF INFORMATION TECHNOLOGY AND SOCIETY
PHOTOGRAPHIC HISTORY COLLECTION

African American Family
Unidentified photographer

Tintype

ca. 1860

NATIONAL MUSEUM OF AMERICAN HISTORY
DIVISION OF INFORMATION TECHNOLOGY AND SOCIETY
PHOTOGRAPHIC HISTORY COLLECTION

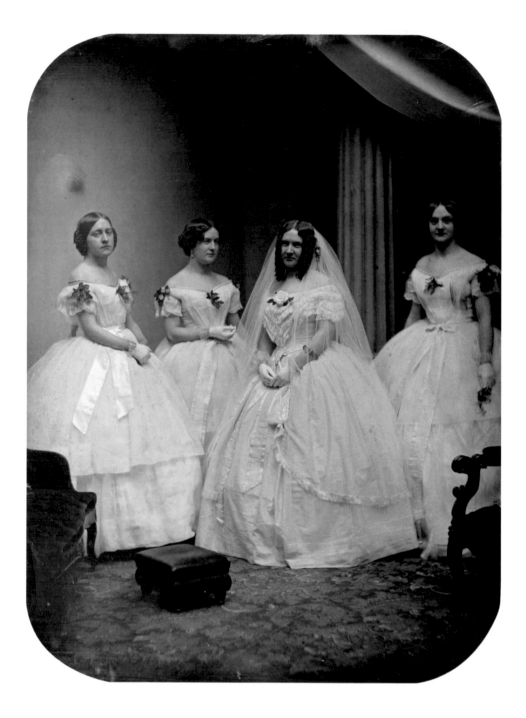

A Bride and Her Bridesmaids

Southworth and Hawes

Full-plate daguerreotype

ca. 1845

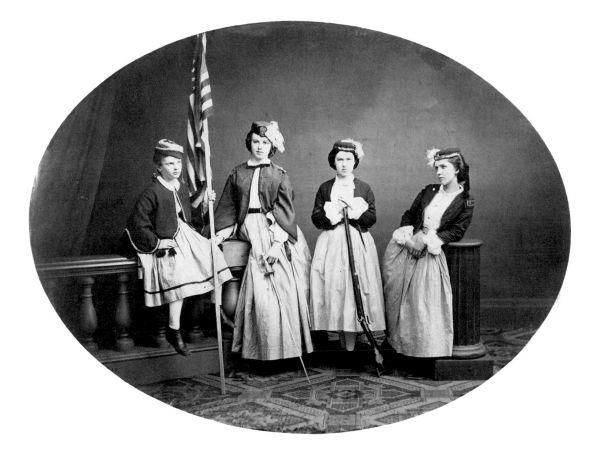

Group at the Sanitary Commission Fair, Albany, New York

Attributed to Churchill and Dennison Studios

Salted-paper print

1864

SMITHSONIAN AMERICAN ART MUSEUM

These girls with guns express their patriotic support of the Union army at the industrial fair sponsored by the U.S. Sanitary Commission in Albany, New York, in 1864. The Sanitary Commission was organized in 1861 to generate funds and increase public support for the health and welfare of the soldiers engaged in the Civil War effort. Fairs held throughout the United States showcased Northern industry and the arts to raise money for the cause. Photography was often featured through exhibitions and competitions where prizes were awarded. Photographers also set up temporary studios to take and sell portraits, which not only promoted their work to the visiting public but also benefited the Sanitary Commission's coffers.

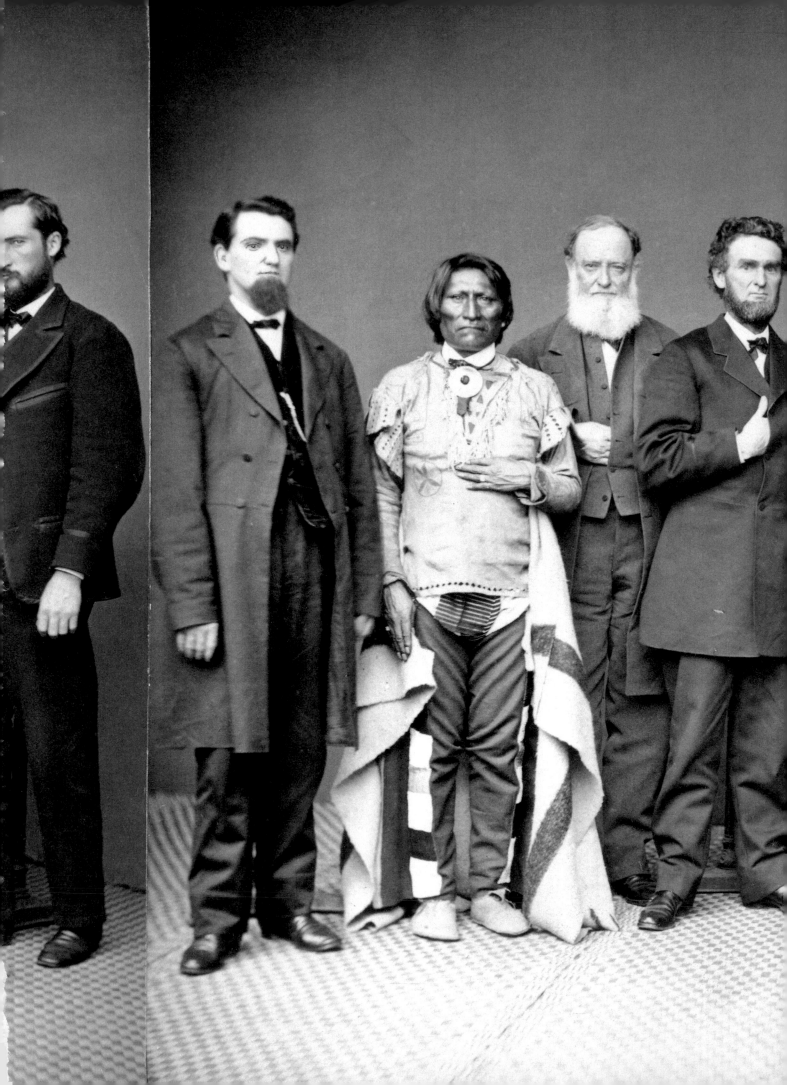

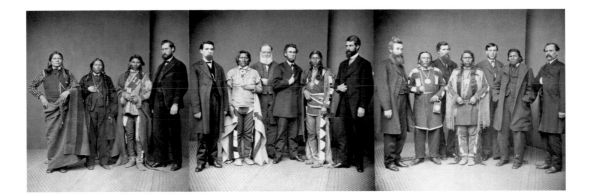

Ute Delegation
Mathew Brady Studio
Albumen print

1868

many Indian photographs that Blackmore had gathered around the country. A small catalogue accompanied the presentation, which may well have been the first photography exhibition in an American museum.

The U.S. government ceased negotiating treaties with Indian tribes in the 1870s. Delegations, however, continued to journey to the capital, where their photographs were made in professional studios. Others were taken by the Smithsonian's own photographers, whose efforts supported the work of the Bureau of American Ethnology and the evolving field of anthropology. Instead of being artistically posed in the manner of visiting foreign diplomats, as was done in portraits from the McClees Studio, delegates were photographed in rigid front and side poses so physical details could be easily studied and measured.

While these nineteenth-century delegation photographs put faces to names mentioned in unillustrated news stories about westward expansion and wars with the Indians, the information they contain goes beyond mere portraiture. Elements of costume can be documented, as can the use of props. Delegates frequently posed in new suits that had been purchased for them as part of an effort to "civilize" the Indians.

Combined with their exotic nature and the craze for collecting photographic portraits of famous people, images of American Indians entered both private and public collections. Scientists used the photographs for scholarly purposes, while the public relied on them to form various stereotypes about Native Americans, such as the concept of the blood-thirsty savage or the noble "vanishing race." The body of delegation photographs remains an invaluable historical resource, one that provides significant insights into the cultures of the subjects as well as of those who sponsored, produced, and viewed the images.

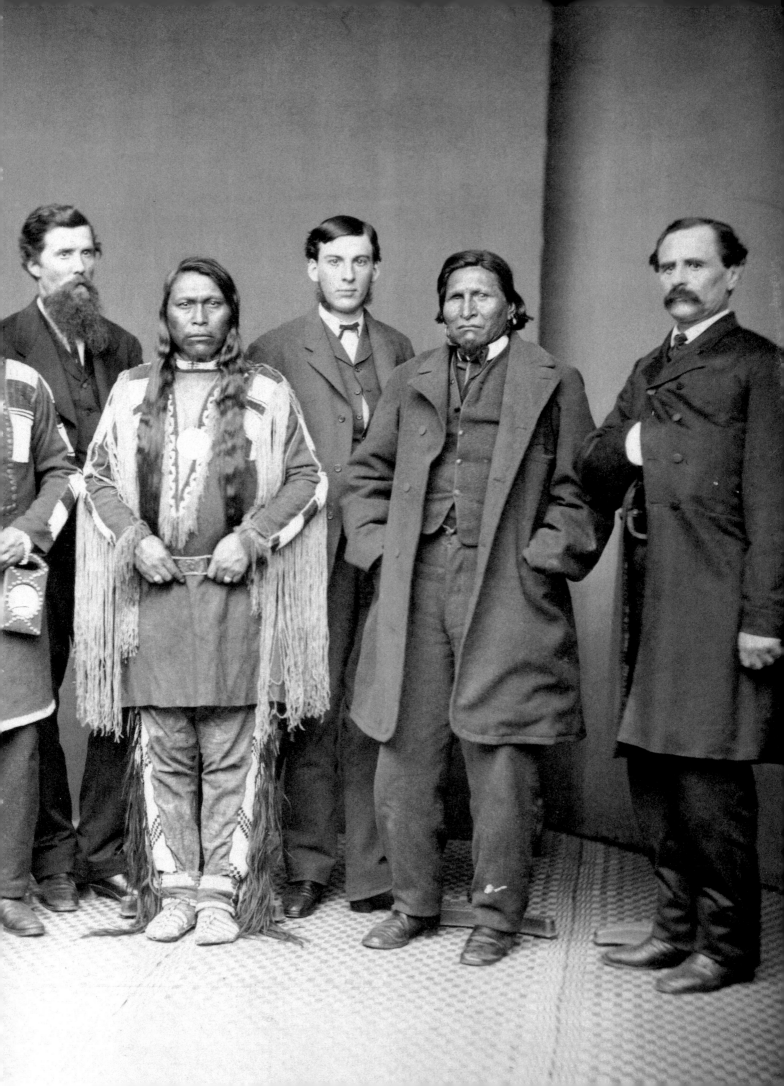

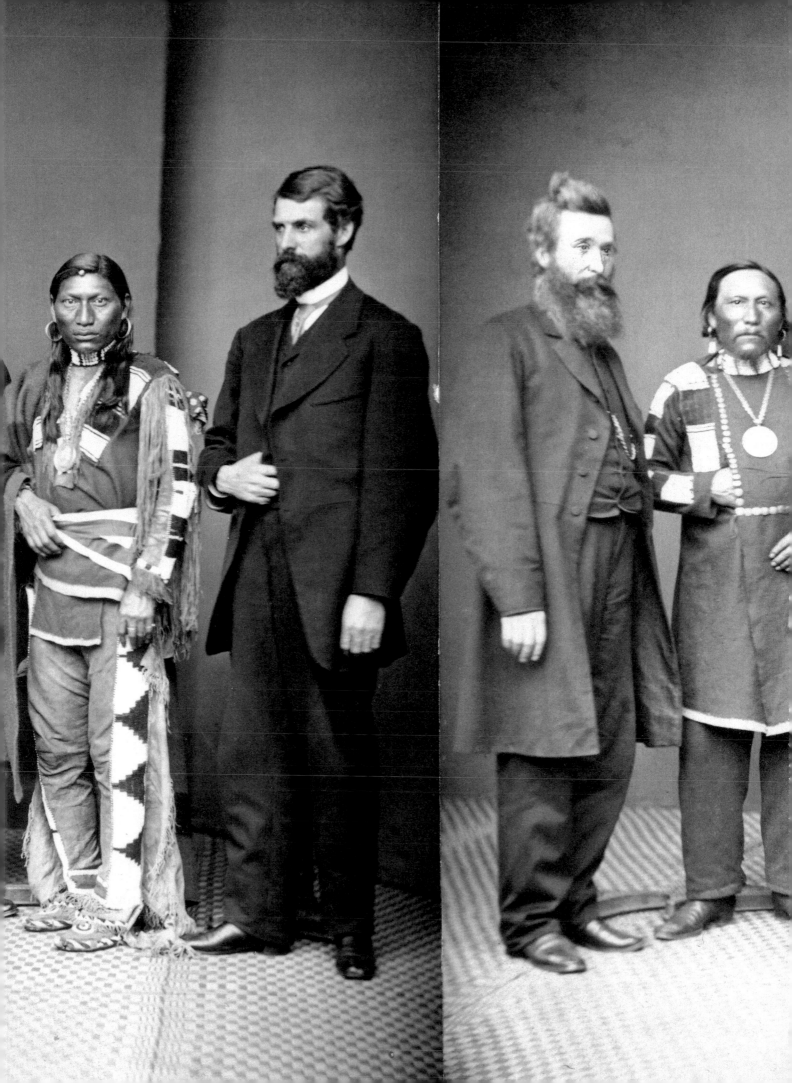

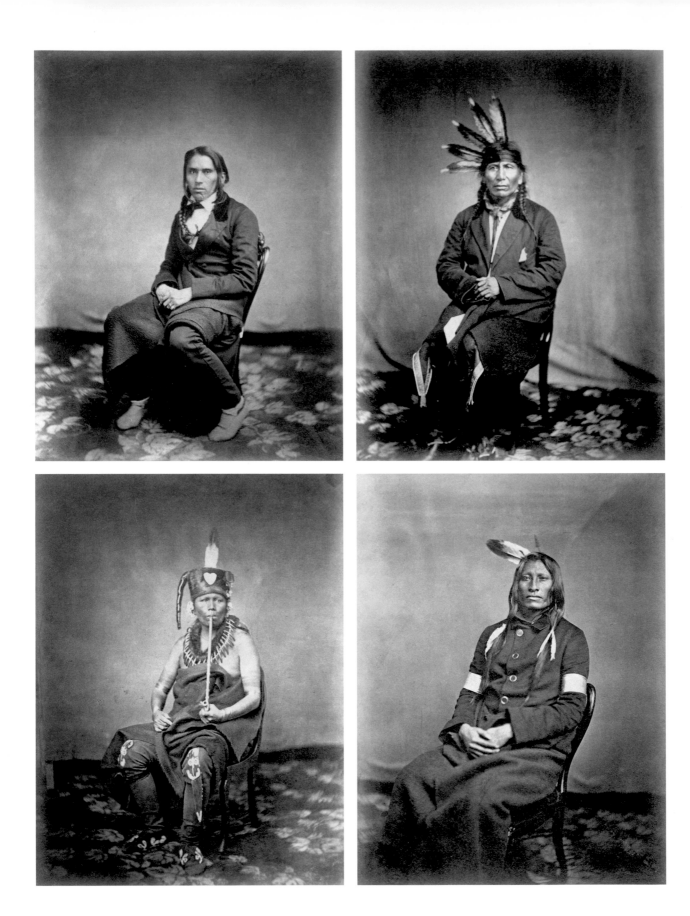

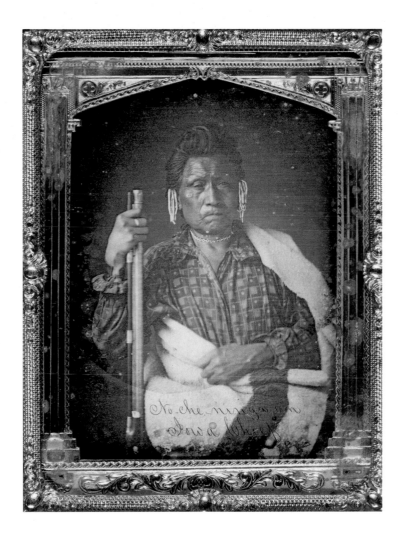

No-Che-Ninga-An (Chief of the Iowas)

Thomas Easterly

Daguerreotype

ca. 1845

NATIONAL MUSEUM OF AMERICAN HISTORY
DIVISION OF INFORMATION TECHNOLOGY AND SOCIETY
PHOTOGRAPHIC HISTORY COLLECTION

Pko-Ne-Gi-Zhik (Chief Hole in the Sky)
Ma-Za-O Ma-Ni (Walking in Iron)
Ta-Ka-Ko (Chief Grey Fox)
Psi-Tsha Wa-King-A (Chief Jumping Thunder)

Julian Vannerson and James McClees

Albumen prints

ca. 1858

NATIONAL MUSEUM OF NATURAL HISTORY
NATIONAL ANTHROPOLOGICAL ARCHIVES

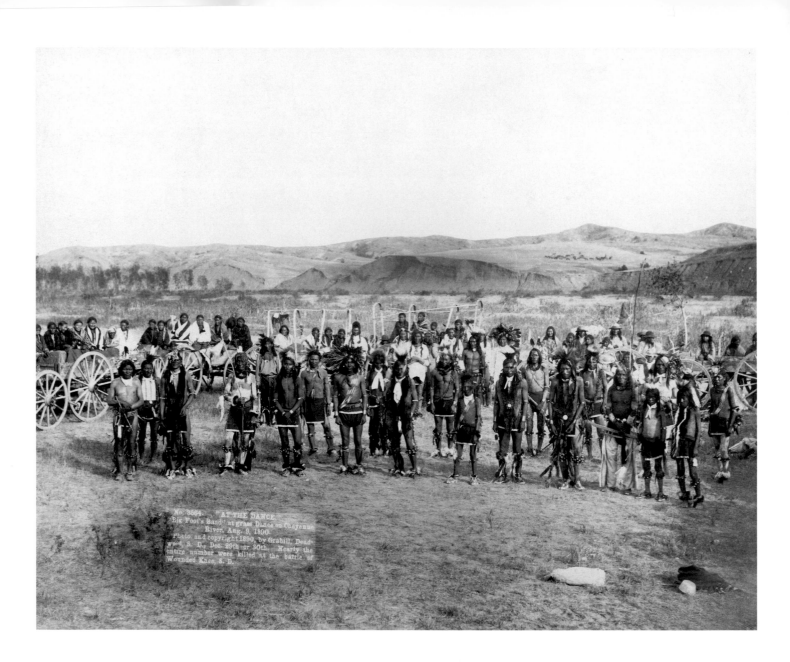

Big Foot's Band (Minneconjou Sioux)
at a Grass Dance on the Cheyenne River
John C. H. Grabill
Albumen print

August 9, 1890

In the winter of 1890, Big Foot, the leader of the Miniconjou band of Lakota Indians, and his followers retreated from their Cheyenne River Reservation and moved deeper south into Dakota territory to avoid further violence from federal Indian agents. The agents had been sent to squelch the practice of the spiritual Ghost Dance ceremony, which had gained a following among tribal members. Big Foot and his followers had no intention of opposing the government agents. While the group camped at Wounded Knee Creek on the Pine Ridge Reservation on December 28, they were surrounded by soldiers of the Seventh Cavalry, who had been tracking them. The next day, when the troops began confiscating the Lakota's weapons, one of the Indian's guns went off accidentally. The troops opened fire and moments later, Big Foot and more than 350 Lakota lay dead, senselessly massacred by the soldiers.

A Chief and His Followers, Burundi
Unidentified photographer
Albumen print

ca. 1908

NATIONAL MUSEUM OF AFRICAN ART
ELIOT ELISOFON PHOTOGRAPHIC ARCHIVES
PÈRES BLANCS COLLECTION

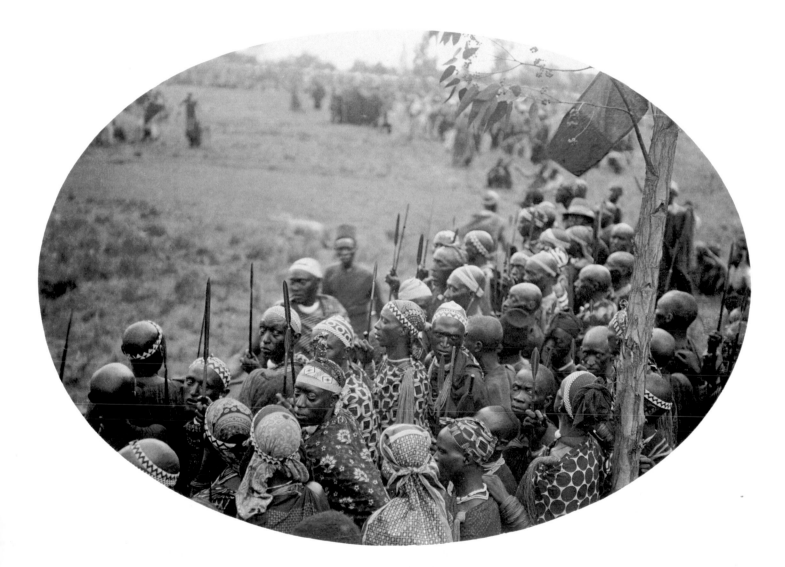

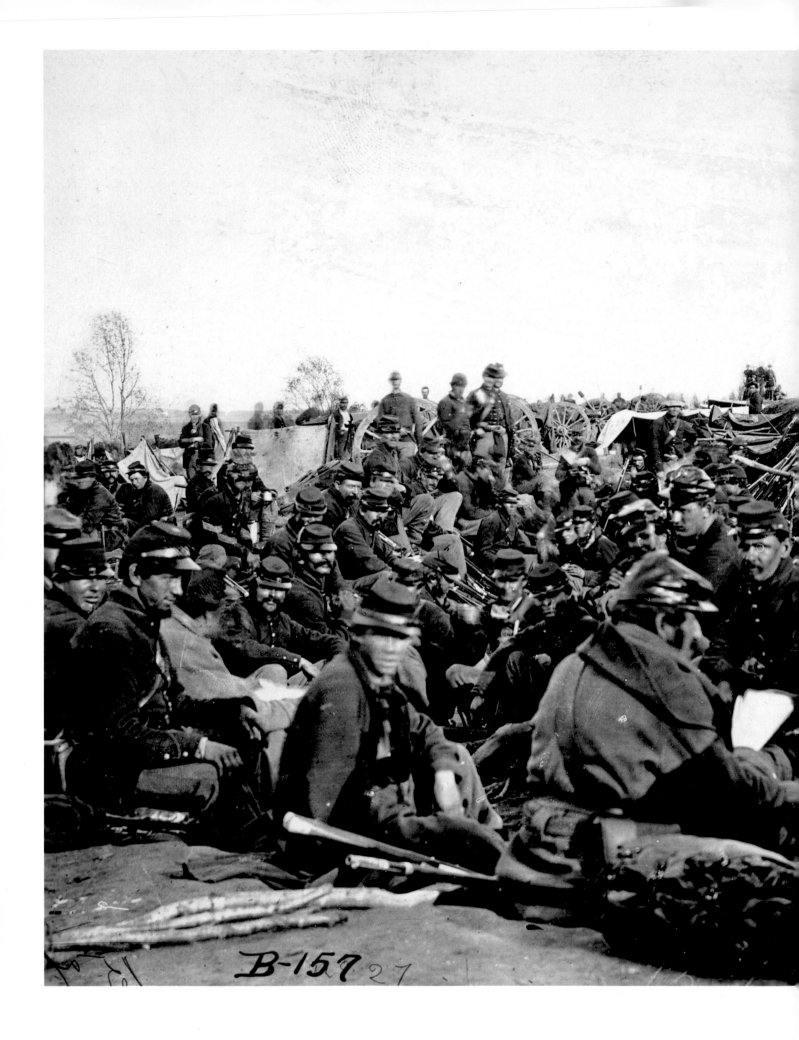

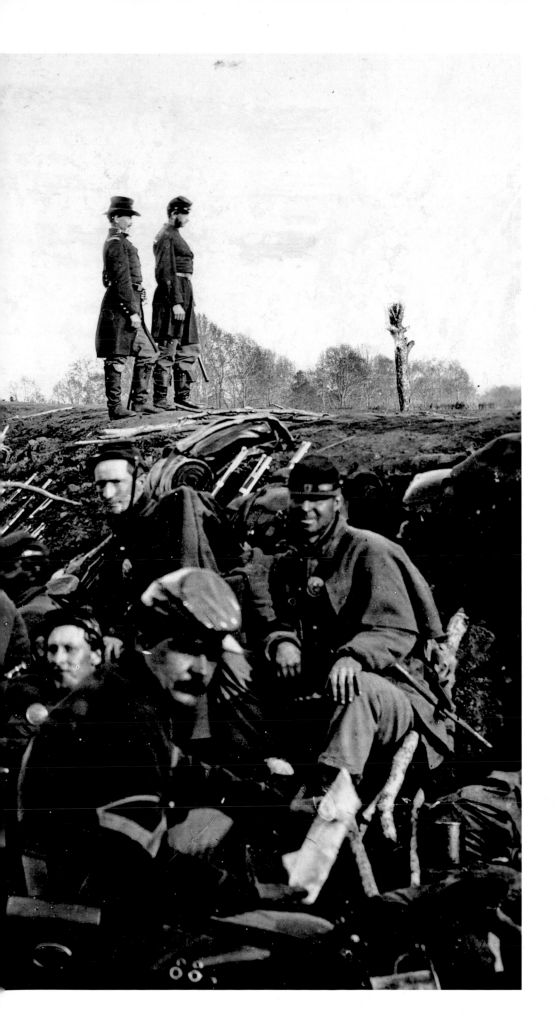

Union Army Encampment
Outside Petersburg, Virginia
Mathew Brady Studio
Gelatin silver print

ca. 1864

NATIONAL MUSEUM OF
AMERICAN HISTORY
DIVISION OF INFORMATION
TECHNOLOGY AND SOCIETY
PHOTOGRAPHIC
HISTORY COLLECTION

This fascinating view of Union soldiers camped outside Petersburg, Virginia, is attributed to Mathew Brady, although the image itself is relatively unknown. The photograph came to the department of Photographic History at what is now the National Museum of American History from the U.S. Army Signal Corps in 1921. Two years earlier the War Department gave the Signal Corps a huge cache of photographic negatives and prints made by Brady and purchased from the photographer. While the Brady material was housed at the War Department, an additional series of photographs made by the Army Corps of Engineers during the Civil War was combined with it. Brady did not commonly present this kind of striking image during his lifetime. Instead, it may have originated in the subjects photographed by the Army Corps of Engineers, which often focused on the more mundane aspects of documenting the soldiers and their encampments.

Sherman and His Generals

Mathew Brady Studio

Albumen silver print

1865

Butch Cassidy and the Wild Bunch

John Swartz

Gelatin silver print

1900

NATIONAL PORTRAIT GALLERY

A NEW TOOL OF HISTORY

Jeana K. Foley
International Art Museums Division

The carte-de-visite was paper photography's cheapest answer to the call for popular photographs. French portrait photographer André-Adolphe-Eugène Disdéri patented the carte-de-visite in 1854. Cartes-de-visite became extremely popular in the United States by the 1860s. The card's format allowed eight small photographs to be taken on and printed from the same glass-plate negative. By exposing multiple images at one time, the photographer could then offer the sitter more prints at a lower cost. An advertisement for the photographer's studio was often printed on the back.

The small photos were mounted on card stock measuring 4½ by 2½ inches, the same size as calling cards, which were already commonly exchanged among Victorian friends and acquaintances. The size and lower cost contributed to their quick rise in popularity and the collection of carte-de-visite photographs. Since more than one picture could be taken at a time, numerous images could be easily produced, freely traded, and eagerly purchased.

Soldiers going off to the Civil War visited photography studios in droves to create a memento they could leave behind for their families. Likewise, wives, sweethearts, mothers, and fathers also had their own cartes-de-visite made for their favorite soldier to carry into battle. Many photographers made the cartes-de-visite of famous people who had posed in their studios available for sale to the public as well. Special albums were manufactured to hold and display the cards, and viewing them became a common form of entertainment and remembrance in American parlors.

Soon these palm-sized pictures became the means by which a newly affluent middle class collected and placed in albums the likeness of their favorite family members next to authors, artists, actors, politicians, and military heroes. Cartes-de-visite, like baseball trading cards in the next century, made even ordinary individuals appear dramatic and significant. In a 2-by-3-inch picture could appear the likeness of President Abraham Lincoln — or the face of Lewis Powell, a conspirator in his assassination.

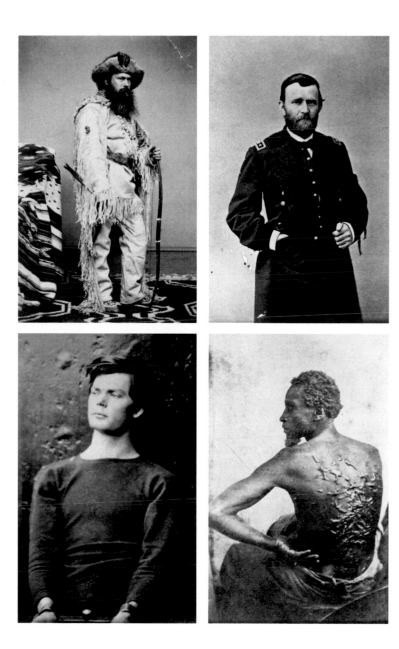

Alexander Gardner

Mathew Brady Studio

Albumen silver print

ca. 1861

Ulysses S. Grant

Frederick Gutekunst

Albumen silver print

1865

Lewis Powell

Alexander Gardner

Albumen silver print

1865

Private Gordon

**Mathew Brady Studio after
William D. McPherson and Mr. Oliver**

Albumen silver print

1863

NATIONAL PORTRAIT GALLERY

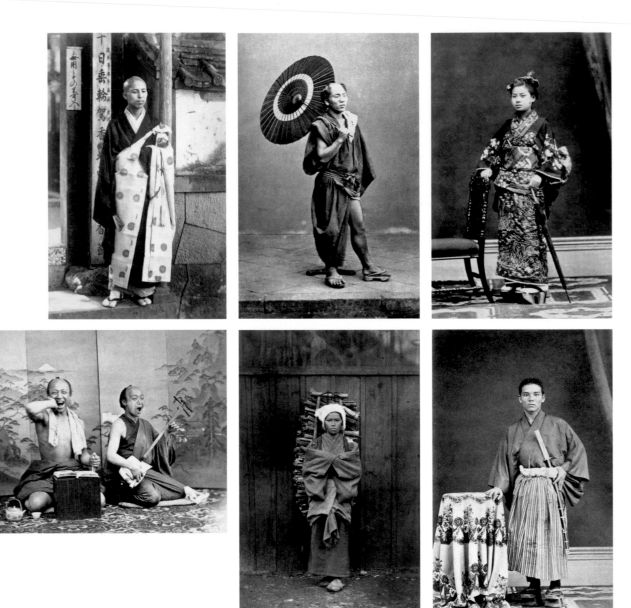

Japanese Man Standing on a Step in Front of a Building
Man with Open Parasol
Woman with a Chair and Umbrella
Actors
Woman Carrying Wood
Young Man with a Sword Standing by a Table
Unidentified photographers

Cartes-de-visite

ca. 1864

FREER GALLERY OF ART AND ARTHUR M. SACKLER GALLERY ARCHIVES
HENRY AND NANCY ROSIN COLLECTION OF EARLY PHOTOGRAPHY OF JAPAN

Trade treaties with the West opened Japan's port cities to foreigners by the late 1850s, but many travel restrictions were not eased for Western tourists until the 1880s. By then, the foreign tourism industry was booming throughout Japan. Souvenir photographs and Japanese cartes-de-visite formed an important commodity of the tourist trade. Westerners sought out depictions of traditional Japanese life for their photographic souvenirs, even though many Japanese were adopting modern styles of dress influenced by their contact with the West. As a result, fictional scenes and traditional costumes from Japan's feudal era were recreated in photographers' studios for sale to tourists.

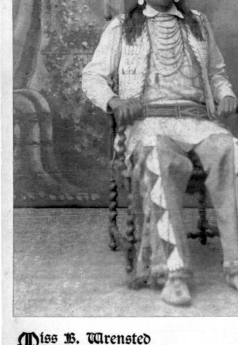

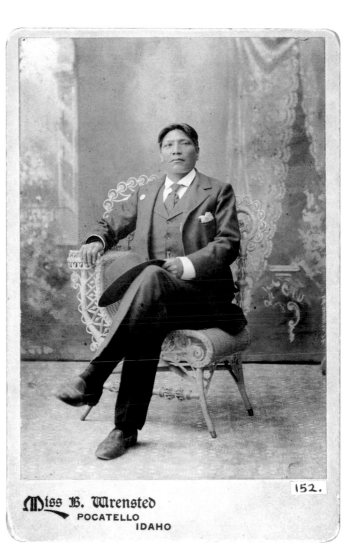

Pat Tyhee in Native Dress
Benedicte Wrensted
Cabinet card

ca. 1898

Pat Tyhee after Conversion
Benedicte Wrensted
Cabinet card

ca. 1899

NATIONAL MUSEUM OF NATURAL HISTORY
HANDBOOK OF NORTH AMERICAN INDIANS
LEONARD COLLECTION

Benedicte Wrensted, a Danish immigrant who came to the United States in 1894, learned photography in her native Denmark. Her exceptional talents were recognized by Mary Steen, the Danish royal court photographer. Wrensted purchased an existing studio in Pocatello, Idaho, in 1895 and practiced there until 1912, photographing both the Anglo townspeople and the Northern Shoshone, Bannock, and Lemhi Indians from the nearby Fort Hall Reservation.

In the first of these two photographs, taken about 1898, Wrensted depicted Pat Tyhee from the Bannock tribe "before." He wears a cloth shirt, multiple strands of clam shells, shell earrings, a metal-studded belt, and moccasins and leggings beaded in characteristic Northern Shoshone-Bannock geometric design. The "after" photograph shows Pat Tyhee in a new broadcloth suit about the time of his conversion to Christianity in 1899.

Joanna Cohan Scherer, National Museum of Natural History

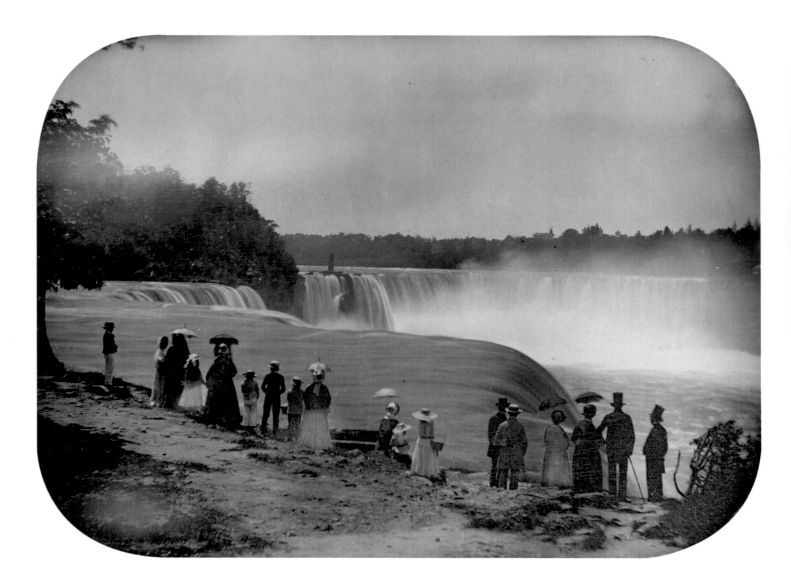

Niagara Falls

Platt D. Babbitt

Hand-colored daguerreotype

ca. 1854

Tourism in the United States surged in the mid-nineteenth century. The rise of a middle class with more leisure time and disposable income, as well as the popularity of works by Henry David Thoreau, Ralph Waldo Emerson, and other Transcendentalist writers who espoused the sublime in nature, motivated more and more Americans to visit natural land-marks. One of the country's first tourist destinations was the powerful grandeur of Niagara Falls in upstate New York. Entrepreneurial photographers recognized a lucrative opportu-nity and opened photography studios near the thundering falls. Platt D. Babbitt, the first photographer to set up shop at Niagara Falls, cornered the market for years with his studio situated next to the main viewing pavilion. There, he posed tourists, photographed them, and sold them stunningly beautiful views of the falls from 1850 through the 1870s.

Rafting Party
Unidentified photographer
Albumen print

ca. 1910

SMITHSONIAN AMERICAN ART MUSEUM

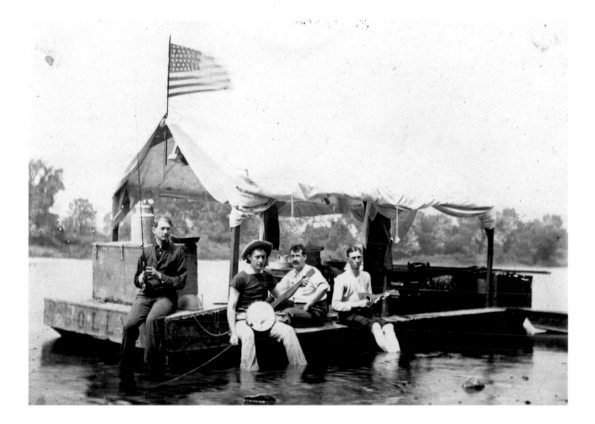

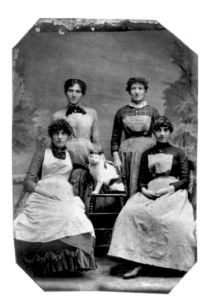

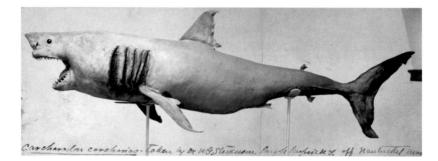

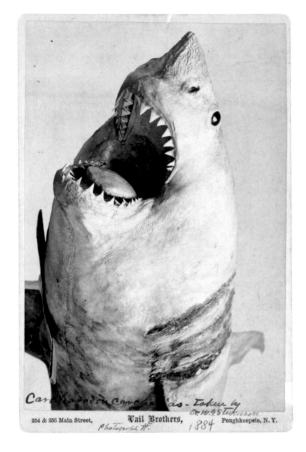

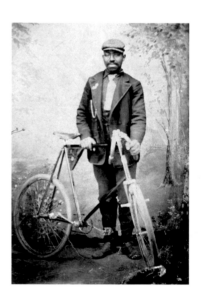

Four Women with a Cat

 Unidentified photographer

Tintype

ca. 1865

NATIONAL MUSEUM OF AMERICAN HISTORY
 DIVISION OF **INFORMATION TECHNOLOGY AND SOCIETY**
 PHOTOGRAPHIC HISTORY COLLECTION

Carcharodon carcharias
(Great White Shark)

 Vail Brothers Studio

Albumen print

ca. 1880

Carcharodon carcharias
(Great White Shark)

 Vail Brothers Studio

Cabinet card

ca. 1880

NATIONAL MUSEUM OF NATURAL HISTORY
 DIVISION OF **FISHES**

Man with a Bicycle

 Unidentified photographer

Tintype

ca. 1860

NATIONAL MUSEUM OF AMERICAN HISTORY
 DIVISION OF **INFORMATION TECHNOLOGY AND SOCIETY**
 PHOTOGRAPHIC HISTORY COLLECTION

Mohawk Youths
(Man on Right is Ga-wa-so-wa-neh),
Rye Beach, New York
>**Unidentified photographer**
Tintype

>>ca. 1890

Sleeping Dog
>**Unidentified photographer**
Tintype

>>ca. 1860

Three Acrobats
>**Unidentified photographer**
Tintype

>>ca. 1860

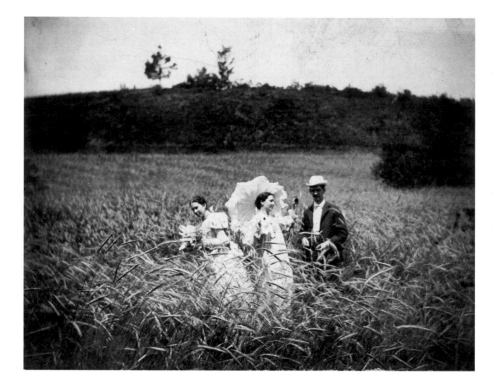

Three Friends in a Field

Unidentified photographer

Gelatin silver print

ca. 1900

These two photographs share a similar quiet beauty and sentimentality. Although both were taken early in the twentieth century, they represent two distinct kinds of photography at that time: amateur photography and Pictorialism. *Three Friends in a Field* resulted from the rise of amateur photography due to the availability of smaller, more portable cameras and George Eastman's invention of commercial dryplate negatives in the 1880s. What was once a complicated, technical process became a rewarding hobby for average Americans. Kodak, Eastman's first film camera, was offered to the public in 1888. Thereafter, anyone who could afford a camera could document their daily life or try their hand at aesthetically inspired photography. Since photography was primarily practiced outdoors, as seen in this charming snapshot, it was hailed as a healthful pastime as well.

The carefully composed and manipulated photograph *Rest Hour (Columbia Teacher's College)* exemplifies Pictorialist photography — a style that celebrated aesthetic considerations over documentary ones and preferred a softer, unclear focus over sharper lens work in an effort to achieve more spiritually introspective, artistic images. The Photo-Secession movement espoused Pictorialism as its preferred style of art photography. Clarence White, along with Alfred Stieglitz, Gertrude Käsebier, and other photographers, founded the Photo-Secession movement in 1902.

Rest Hour (Columbia Teacher's College)

Clarence H. White

Gelatin silver print

1912

Blackfoot Indians Gathered in Front of a Tipi,
Chanting and Drumming, Montana
Unidentified photographer
Gelatin silver print

ca. 1890

NATIONAL MUSEUM OF THE AMERICAN INDIAN
MARY ROBERTS RINEHART COLLECTION

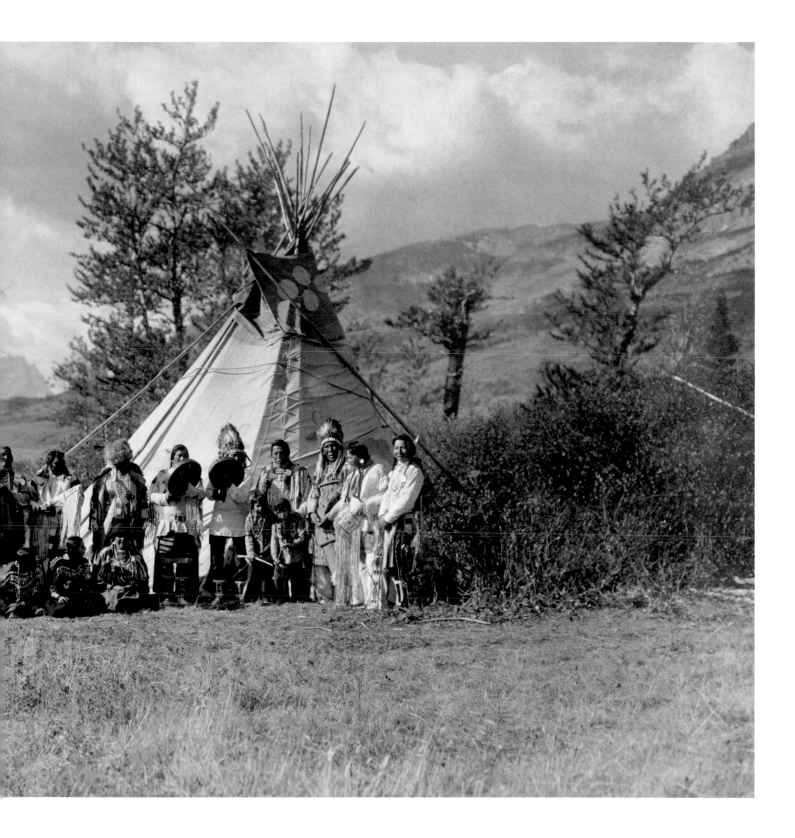

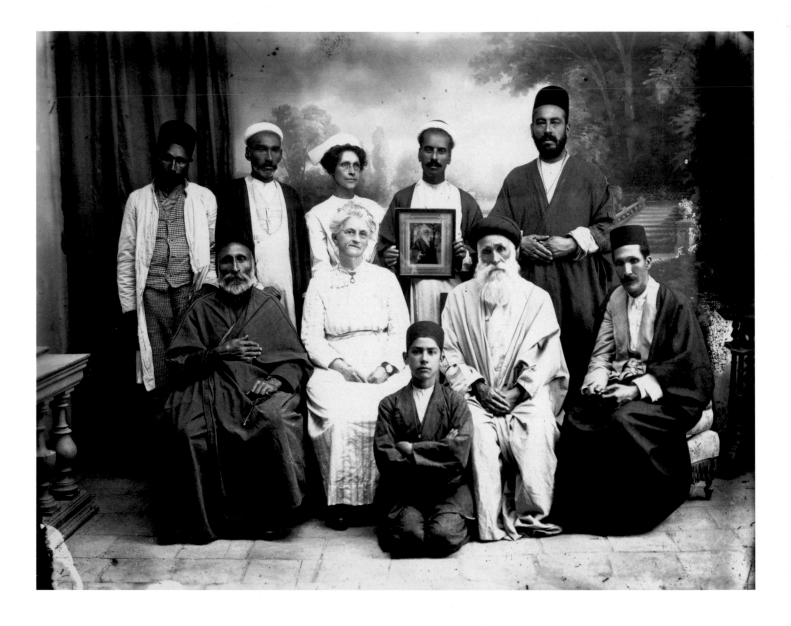

Group Portrait of Bahá'ís

Antoin Sevruguin

Modern gelatin silver print from glass negative

ca. 1900

Antoin Sevruguin's photographs from the 1880s to 1930 capture the exotic atmosphere of his native Persia. His work includes aesthetically inspired photographs that both document and artfully portray the royal court of successive shahs, as well as the lives of commoners, the ancient landscapes, and the historic events that shaped Iran at a time when tradition and modernity uneasily coexisted. A commercial photographer with a prosperous studio in Tehran, Sevruguin used his photography to serve both local customers and a foreign audience of Western travelers and scholars who were seeking souvenirs and travel images of the Near East.

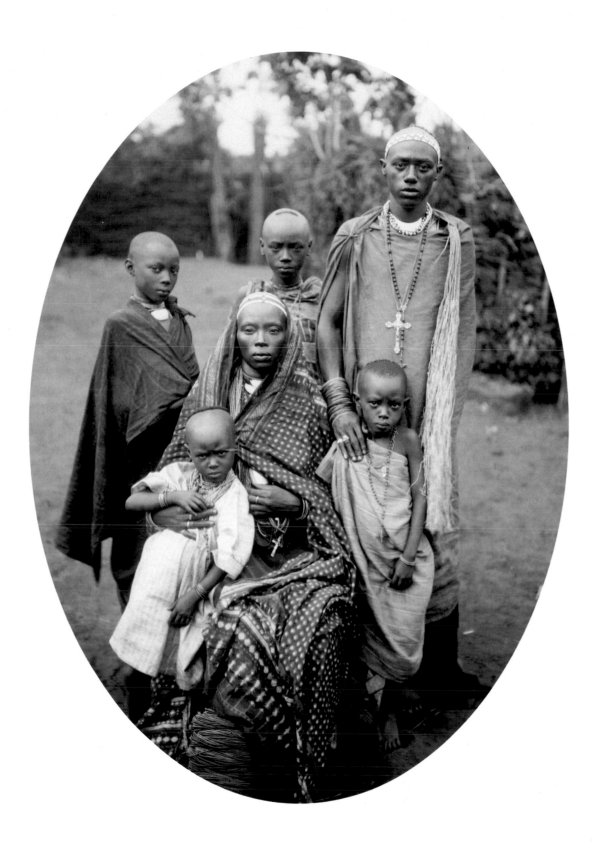

Burundi Family

Unidentified photographer

Gelatin silver print

ca. 1908

NATIONAL MUSEUM OF AFRICAN ART
ELIOT ELISOFON PHOTOGRAPHIC ARCHIVES
PÈRES BLANCS COLLECTION

FASHIONING A PICTURE OF PROGRESS

Peter Liebhold
National Museum of American History

Industrial photographs—images made for annual reports, advertising, and public relations—have been produced in greater numbers and seen by wider audiences than many other genres of photographs. They are filled with information that, if carefully deconstructed, lead to social, cultural, and technological insight. Like all photographs, industrial images do not simply reproduce a scene: they are crafted and manipulated to promote a point of view.

The apparent simplicity of Russell Aikins's photographs of the steel industry, for example, obscures a complex context of circumstance, subject, and cultural connotation. Aikins combined his art school training and a background in news photography to create a hybrid style that he called "camera reporting." By 1937 he had focused his attention solely on the activities of business and industry. Although his work appeared in various corporate publications and industry newsletters, Aikins styled his images after photojournalism and advertisements published in *Time* and *Fortune* magazines. In an advertisement for his services, Aikins proclaimed, "Today, what industry is doing is news. Take the public visually into your plant and show them the basis upon which the modern industry is built." From how-to manuals to motion pictures, Aikins dramatically communicated to the public a heroic image of industry. In this photograph taken for United States Steel, he cast a worker, both literally and figuratively, in adoring light, replacing the reality of the labor with the romance of industrial progress.

Looking back on these photographs from a historical perspective, it is important to remember the context in which they were made. There is no "true" photographic reality—only a constructed reality. Pictures, like words, are crafted and manipulated to illustrate a point of view. They cannot be read simply and directly, as photographs outside of historic context. Instead, the purposes for which they were taken, the manner in which they were made, and the ways they were used have to be considered. Like other photographs, industrial images cannot be accepted at face value: they were, after all, created to tell a story.

Fairfield Works, Tennessee Coal, Iron and Railroad Company
(a Division of U.S. Steel)

Russell Aikins

Gelatin silver print

ca. 1940

Burden's Wheel

Unidentified photographer

Albumen print

ca. 1890s

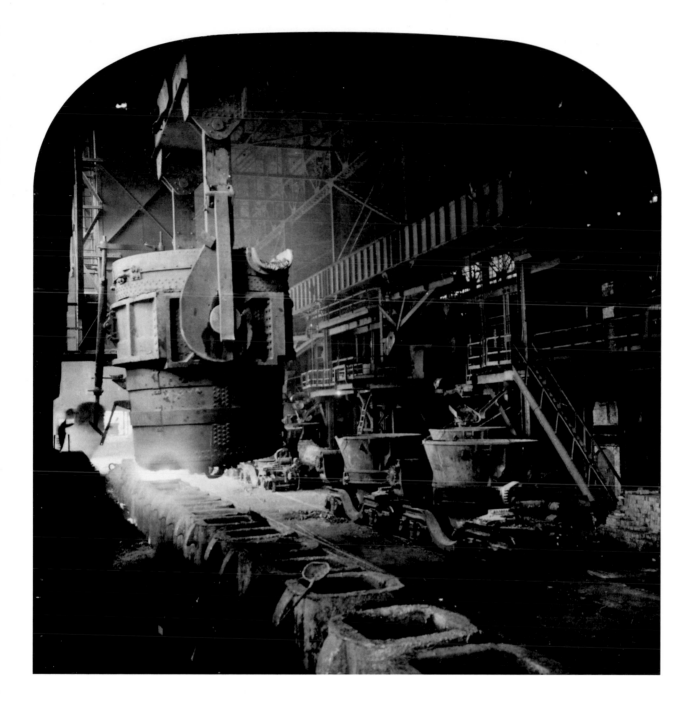

Pouring Molten Steel

Keystone Stereograph View Company

Stereograph card

ca. 1905

NATIONAL MUSEUM OF AMERICAN HISTORY
DIVISION OF **THE HISTORY OF TECHNOLOGY**
ENGINEERING COLLECTION

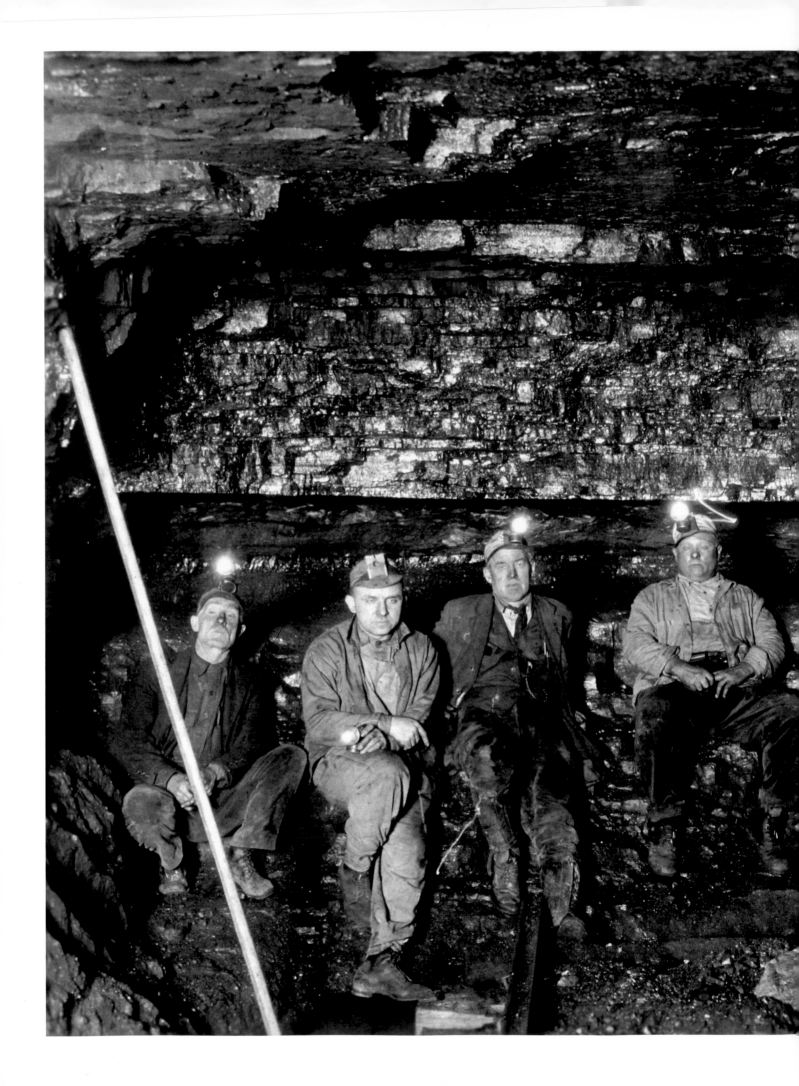

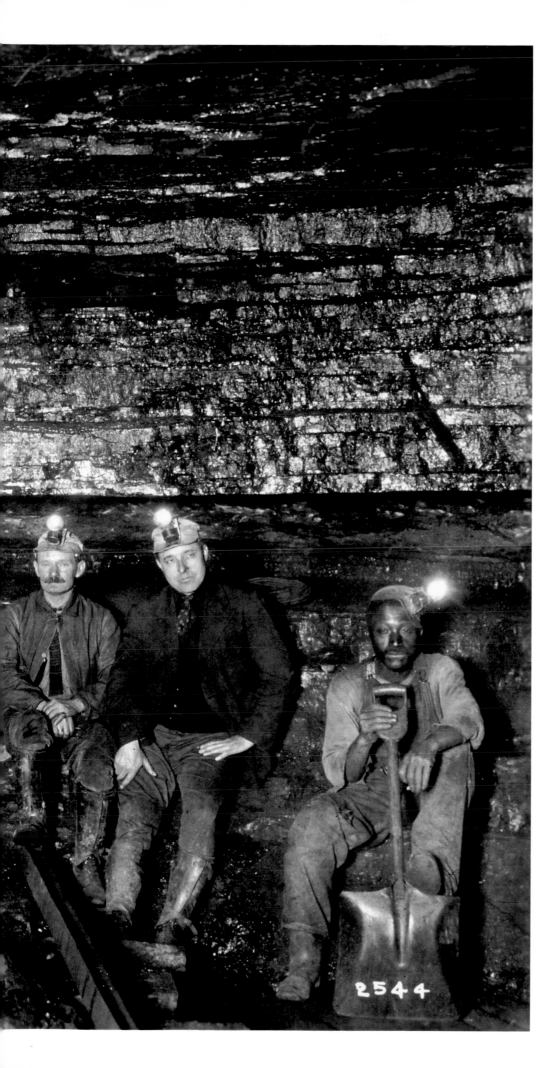

Proper Method for Shooting Coal,
Jenkins, Kentucky, March 23, 1924,
from the Consolidation Coal
Company Albums
Unidentified photographer
Gelatin silver print

1924

**NATIONAL MUSEUM OF
AMERICAN HISTORY
DIVISION OF THE HISTORY
OF TECHNOLOGY
INDUSTRY COLLECTION**

The Consolidation Coal Company
constructed entire towns in
Kentucky and West Virginia for
its employees, as shown in these
evocative photographs made
between 1907 and 1932. Hundreds
of images mounted and assembled
into albums by the company town's
location make up this collection.
Together, they provide a poignant
look into the past and document
the environmental, work, and
social conditions that mining
companies manufactured for their
employees in the first half of the
twentieth century.

Kindergarten Classroom in Burdine, Kentucky,
from the Consolidation Coal Company Album, Season 1916
Unidentified photographer
Gelatin silver print

1916

NATIONAL MUSEUM OF AMERICAN HISTORY
DIVISION OF THE HISTORY OF TECHNOLOGY
INDUSTRY COLLECTION

Work of Children's Sewing Class, Jenkins, Kentucky,
from Consolidation Coal Company Album, Season 1915
Unidentified photographer
Gelatin silver print

1915

NATIONAL MUSEUM OF AMERICAN HISTORY
DIVISION OF THE HISTORY OF TECHNOLOGY
INDUSTRY COLLECTION

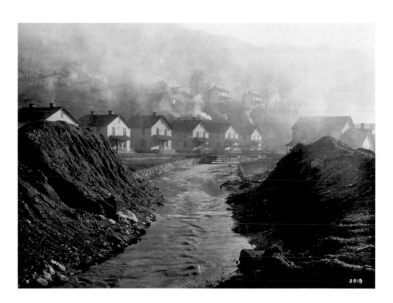

Creek Channel after a Slide, Burdine, Kentucky, December 30, 1923,
from Consolidation Coal Company Album, Elkhorn Division 5
Unidentified photographer
Gelatin silver print

1923

NATIONAL MUSEUM OF AMERICAN HISTORY
DIVISION OF THE HISTORY OF TECHNOLOGY
INDUSTRY COLLECTION

PICTURING MODERN LIFE

Liza Kirwin
Archives of American Art

In the early twentieth century, stop-time photography provided the perfect means of freezing the rapid, radical changes shaping modern life. From the neck-craning spectacle of an early air show to the hurly-burly of Times Square at night, photographic images captured the visual experience of thousands of Americans. Photographers Berenice Abbott, Lewis W. Hine, and Addison Scurlock documented the unfolding drama of the new, and in the process informed modern attitudes about work, leisure, education, child welfare, immigration, urban development, and civil rights. Through their subject matter and aesthetic decisions, they changed the way we see ourselves.

While Hine was not the first photographer to use his camera in the service of social reform, his sympathetic images of child laborers in dark coal mines and dusty textile mills set new standards in the art of documentary persuasion. Early in the century he also photographed the maelstrom of humanity at Ellis Island, where millions of immigrants were numbered, tagged, interrogated, and often detained on their way to a new world of promise and possibility. Hine's seemingly straightforward impressions belie the difficulties he encountered. In 1938 he wrote to art critic Elizabeth McCausland, "Now, suppose we are elbowing our way thro the mob at Ellis [Island] trying to stop the surge of bewildered beings oozing through the corridors, up the stairs and all over the place, eager to get it all over and be on their way. Here is a small group that seems to have possibilities so we stop 'em and explain in pantomime that it would be lovely if they would only stick around just a moment. The rest of the human tide swirls around, often not too considerate of either the camera or us."

Hine carried a 5×7 box-type camera, dry-plate negatives, a rickety wooden tripod, and a flashlamp into which he measured enough explosive powder to light the scene (and routinely singe his hair). By the time he had planted his camera, he continued, "most of the group were either silly or stony or weeping with hysteria because the bystanders had been busy pelting them with advice and comments, and the climax came when you raised the flash-pan aloft over them and they waited, rigidly, for the blast. It took all the resources of a hypnotist, a super-sales-man and a ball pitcher to prepare them to play the game and then to out-

**Waiting at the Clinic — Hull
House Neighborhood**
Lewis Hine
Gelatin silver print

ca. 1908

ARCHIVES OF AMERICAN ART

guess them so most were not either wincing or shutting eyes when the
time came to shoot."

On the back of his photograph that he titled the *Joys and
Sorrows of Ellis Island* (1905), he wrote: "A group of Slavic Immigrants
register many shades of emotion. The baby salutes his new home"
(page 195). By giving faces and feelings to the foreigners, Hine humanized
the "huddled masses." His Ellis Island photographs documented the
greatest migration in history, but they also captured, with compassion
and candor, an emergent American culture made of many nations.

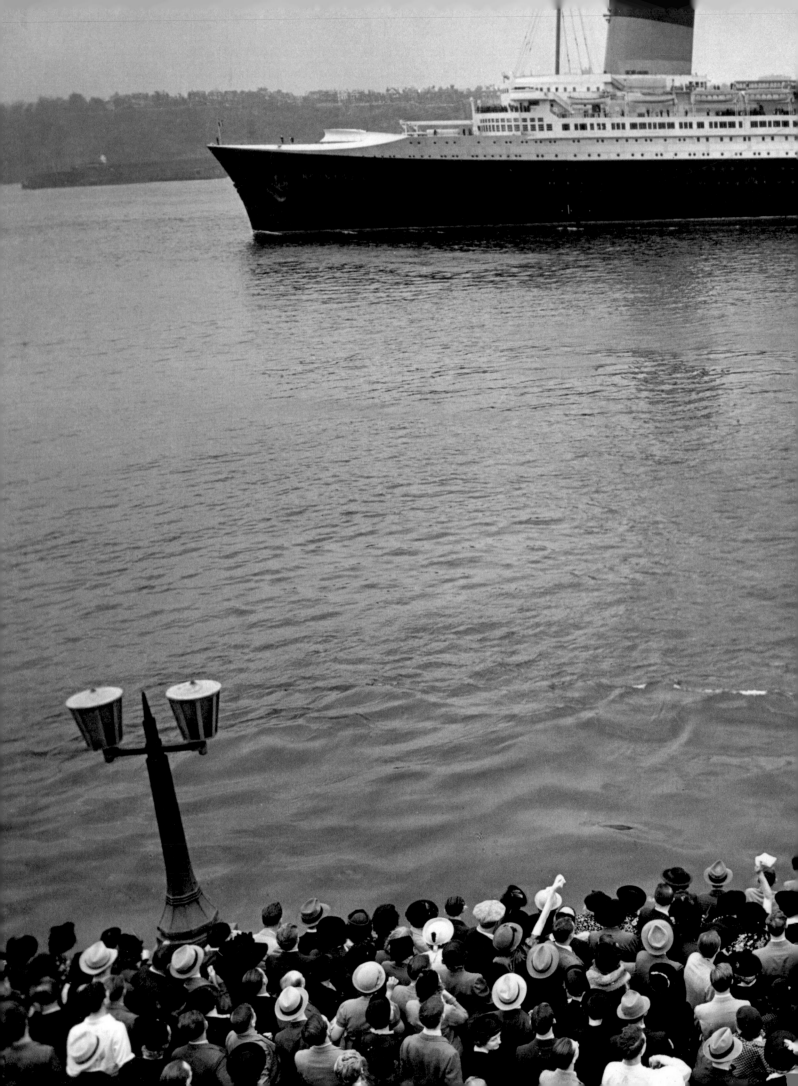

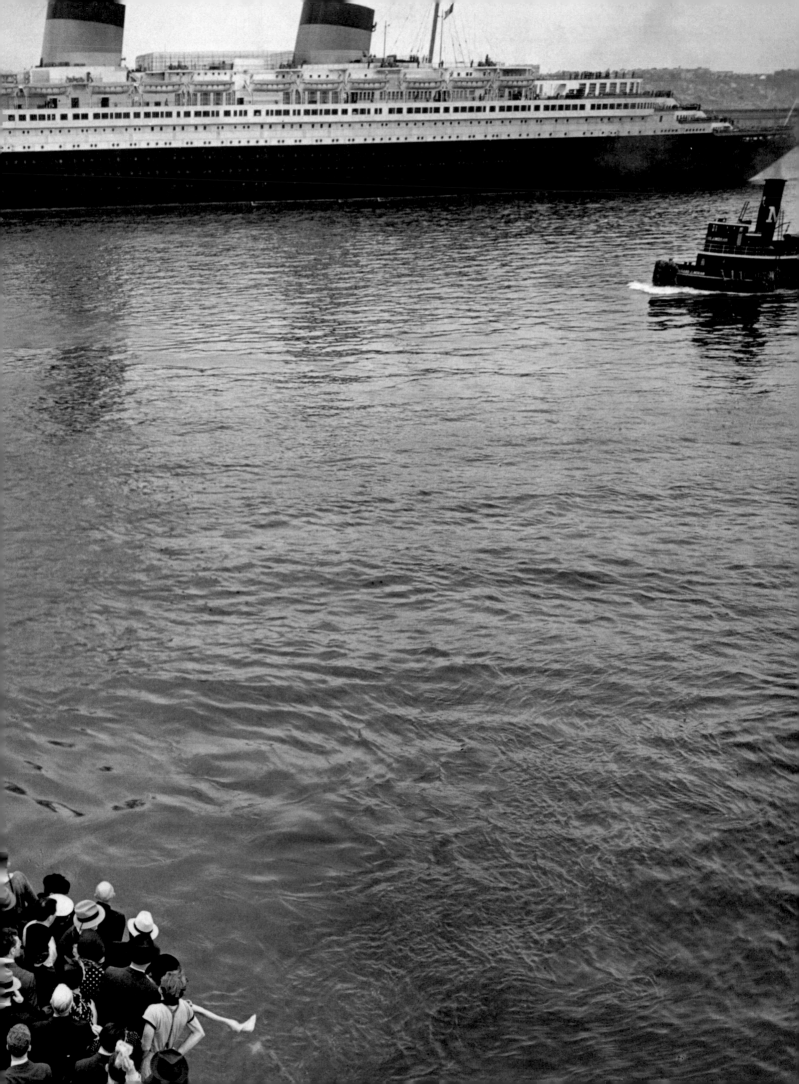

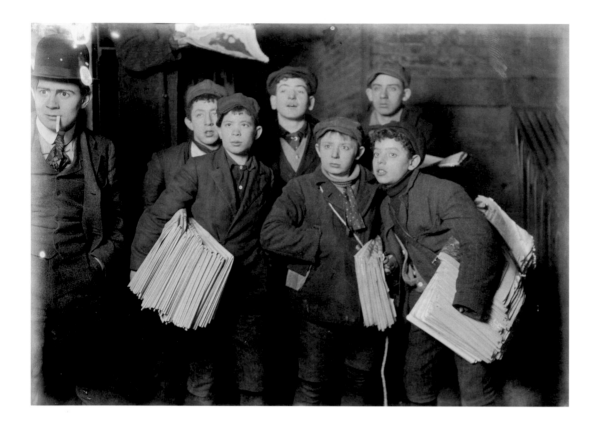

One A.M. Sunday Edition of *New York American* — at Brooklyn Bridge
Lewis Hine
Gelatin silver print

1905

PREVIOUS SPREAD

Normandie, North River, Manhattan, from Pier 88
(from the series "Changing New York")
Berenice Abbott
Gelatin silver print

1938

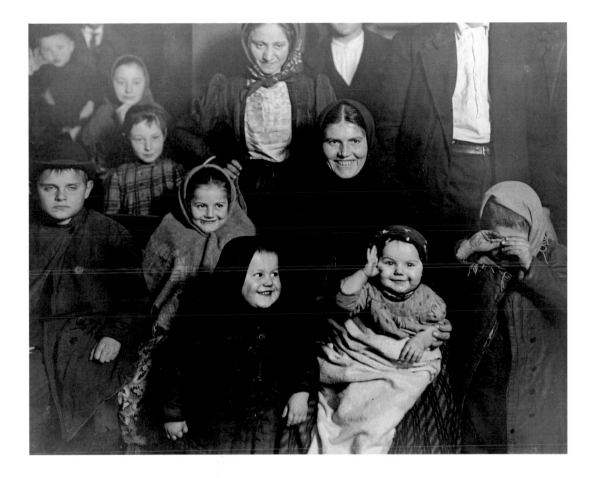

Joys and Sorrows of Ellis Island
Lewis Hine
Gelatin silver print

1905

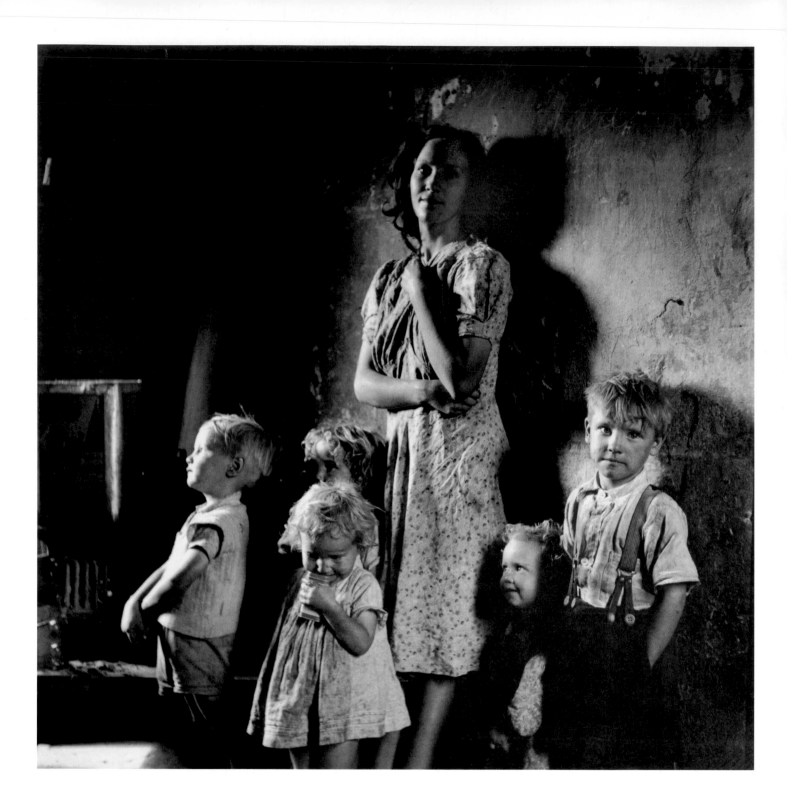

Woman and Children,
Johannesburg, South Africa
(from the series "White Social Welfare")

Constance Stuart Larrabee

Gelatin silver print

1948

NATIONAL MUSEUM OF AFRICAN ART

Constance Stuart Larrabee began photographing at an early age in South Africa, where she was raised by her Scottish and British parents. (She received a Brownie box camera for her tenth birthday.) After studying photography in Europe for three years, Larrabee returned to South Africa and opened a successful portrait studio in Pretoria. At the same time she became recognized for her work in documentary photography and photojournalism. Larrabee was the first South African woman accredited as a war correspondent by the South African military, covering World War II on fronts in Egypt, Italy, and France. Her artistically composed views of life in South Africa in the "White Social Welfare" series from 1948 powerfully recall the work of American photographers who documented the rural United States in the 1930s and 1940s for the Farm Security Administration. In 1997 Larrabee generously donated three thousand of her South African photographs to the National Museum of African Art.

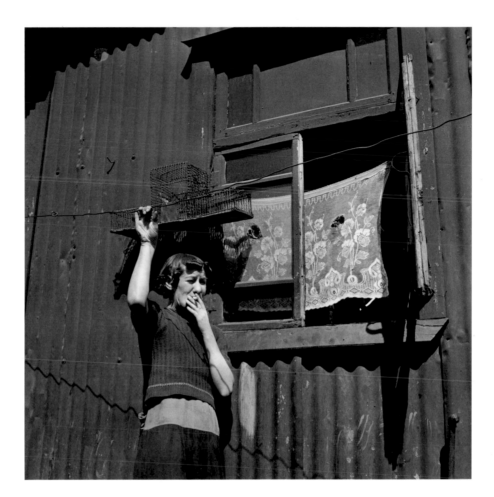

Woman, Johannesburg, South Africa
(from the series "White Social Welfare")
Constance Stuart Larrabee
Gelatin silver print

1948

NATIONAL MUSEUM OF AFRICAN ART

Soweto, Johannesburg, South Africa
(from the series "White Social Welfare")
Constance Stuart Larrabee
Gelatin silver print

1948

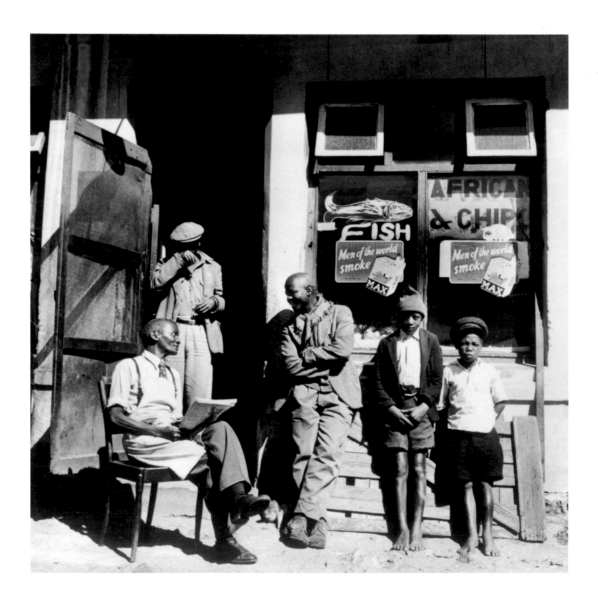

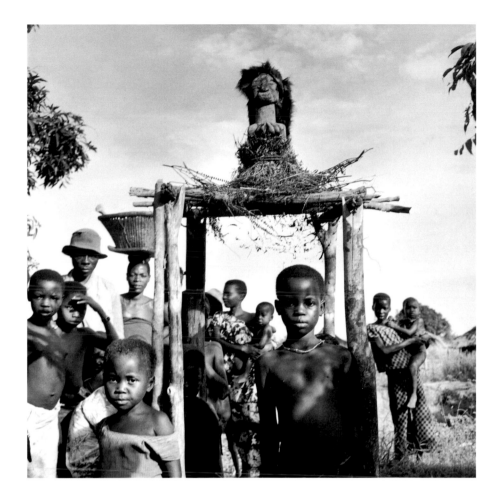

Untitled Photograph (from the series "Nile 1947")
Eliot Elisofon
Gelatin silver print

1947

A self-taught photographer, Eliot Elisofon began his professional career as a commercial and fashion photographer. In the 1930s he turned to documenting the squalid conditions of New York tenements. In later years he taught at the New School for Social Research and became a member of the New York Photo League. Elisofon joined the staff of *Life* magazine in 1942 as a photojournalist and war correspondent. After World War II, Elisofon continued to work for *Life* until 1964, all the while traveling and photographing around the world.

Elisofon was a founding trustee of the National Museum of African Art, and upon his death in 1973, the museum received a collection of more than eighty thousand photographs he took in Africa. These works form the basis of the museum's Eliot Elisofon Photographic Archives.

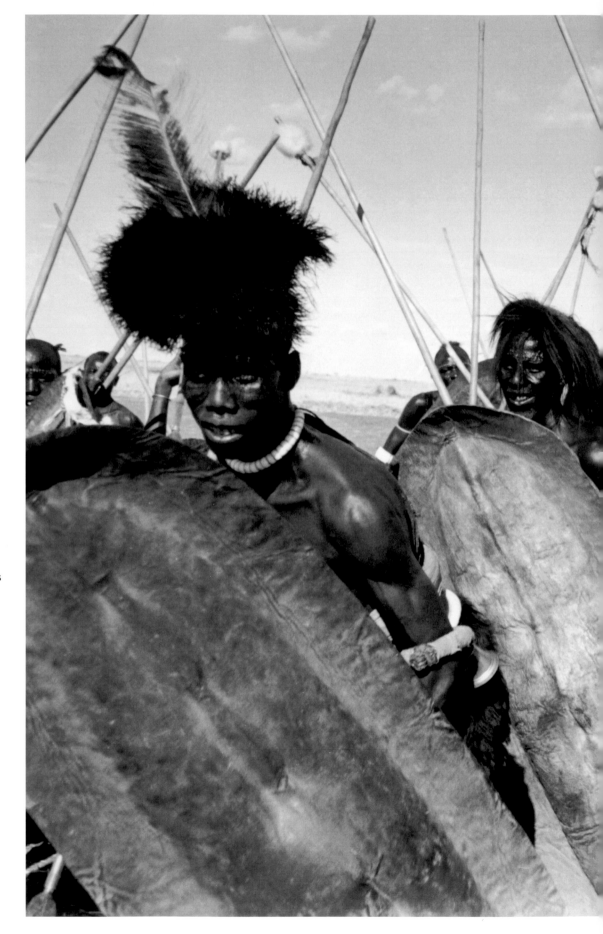

Songye ritual, Belgian Congo

Eliot Elisofon

Gelatin silver print

1947

NATIONAL MUSEUM OF
AFRICAN ART
ELIOT ELISOFON
PHOTOGRAPHIC ARCHIVES

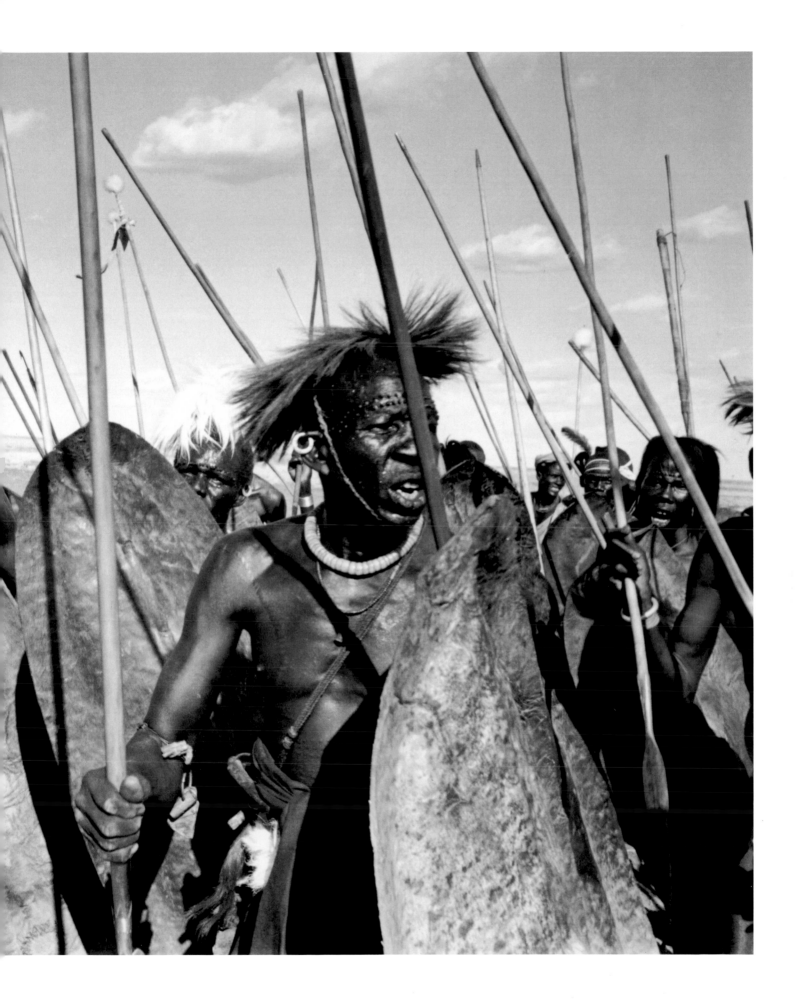

Untitled (Family on Street)
Rebecca Lepkoff
Gelatin silver print

1948

SMITHSONIAN AMERICAN
ART MUSEUM

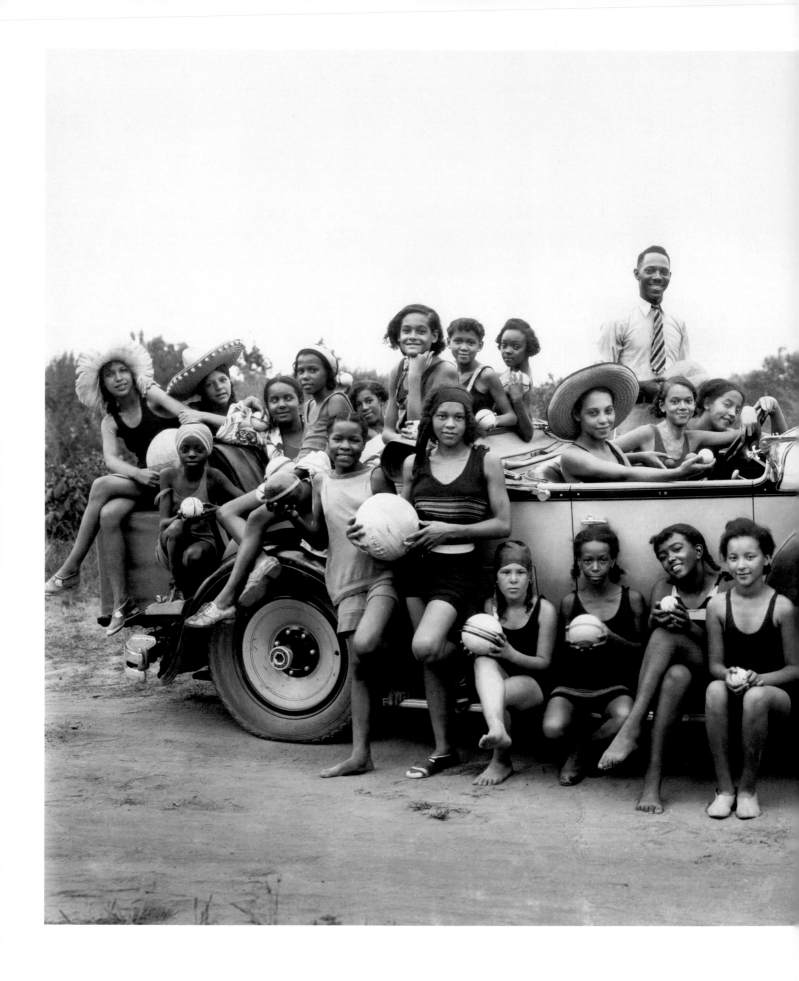

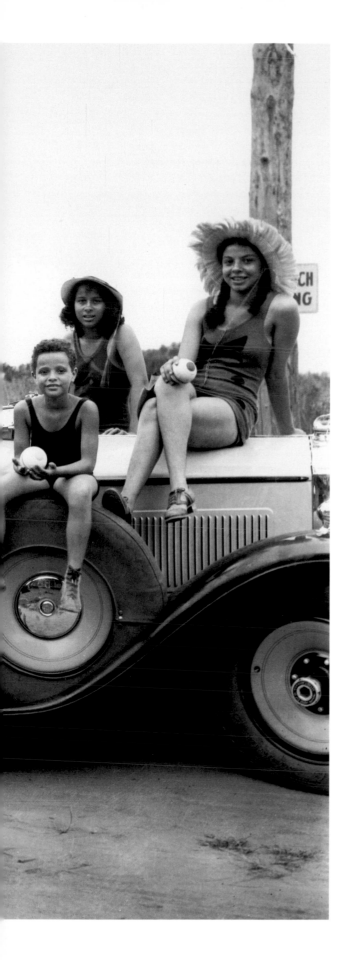

Picnic Group at Highland Beach, Maryland

Addison N. Scurlock

Gelatin silver print

ca. 1931

After completing an apprenticeship with a white photographer in Washington, D.C., the young African American artist Addison N. Scurlock began his independent career in 1904 and opened his own studio in 1911. As a respected professional in Washington's segregated black community, he made fine studio portraits of both ordinary neighbors and famous African American entertainers, artists, and intellectuals. He documented the black middle class and its activities, organizations, and lifestyles and also served as Howard University's official photographer. Sons Robert and George Scurlock helped as teenagers, then in later years joined the family business full-time. They also trained photographers for the Capitol School of Photography at the Scurlock studio. Addison died in 1964, George retired in the 1970s, and following the death of Robert in 1994, the Scurlock studio closed. Thereafter, the studio's archive of more than 20,000 photographs and 250,000 negatives was acquired by the National Museum of American History.

David E. Haberstich, National Museum of American History

After making an intensive tour across the United States in 1938, on which she gave seventy vocal recitals, opera singer Marian Anderson and her manager felt they should try booking concerts at some of the premier venues in larger American cities. Constitution Hall was a choice location in Washington, D.C. Anderson attempted to book a concert there in early 1939, but the owners of the hall, the Daughters of the American Revolution, refused to allow a performance there by an African American performer. In protest, First Lady Eleanor Roosevelt resigned from the DAR, and Secretary of the Interior Harold L. Ickes invited Anderson to perform in public at the Lincoln Memorial on April 9, 1939, on Easter Sunday morning.

Local photographer Robert Scurlock caught Anderson in this sequence of photographs: getting off a train at Union Station in Washington, arriving at the Lincoln Memorial, and performing before a record-breaking crowd of more than seventy-five thousand people. Millions of Americans listened to this historic concert at home on the radio broadcast.

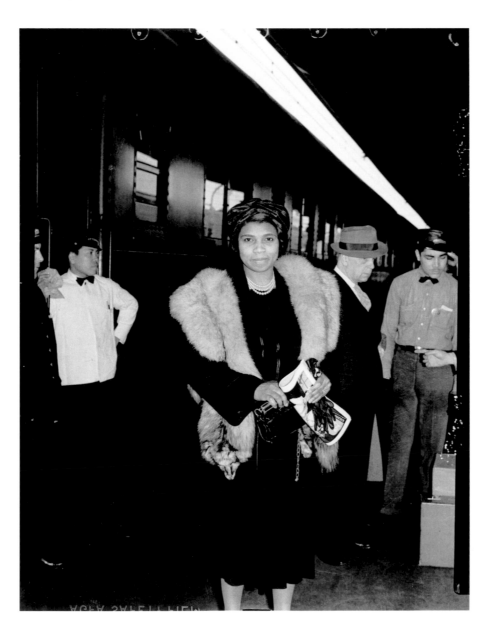

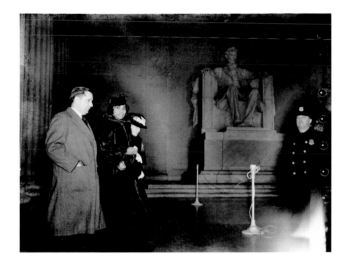

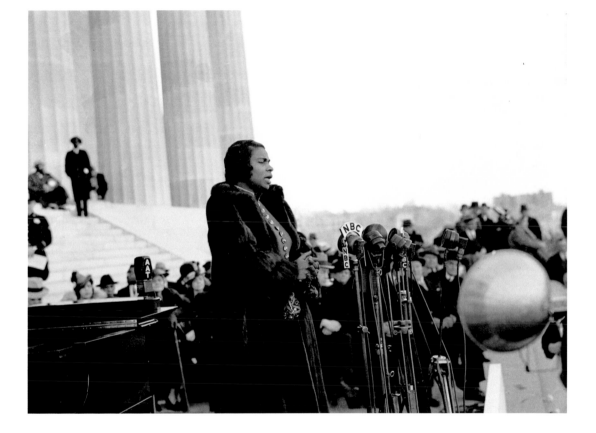

Marian Anderson Arriving at Union Station, Washington, D.C.
Marian Anderson Arriving at the Lincoln Memorial, Washington, D.C.
Marian Anderson Singing at the Lincoln Memorial, Washington, D.C.
Robert S. Scurlock
Silver gelatin negative (on cellulose acetate film)

1939

FOLLOWING SPREAD

**Concert by Marian Anderson
at the Lincoln Memorial,
Easter Sunday, April 9, 1939**
Robert S. Scurlock
Silver gelatin negative (on cellulose acetate film)

1939

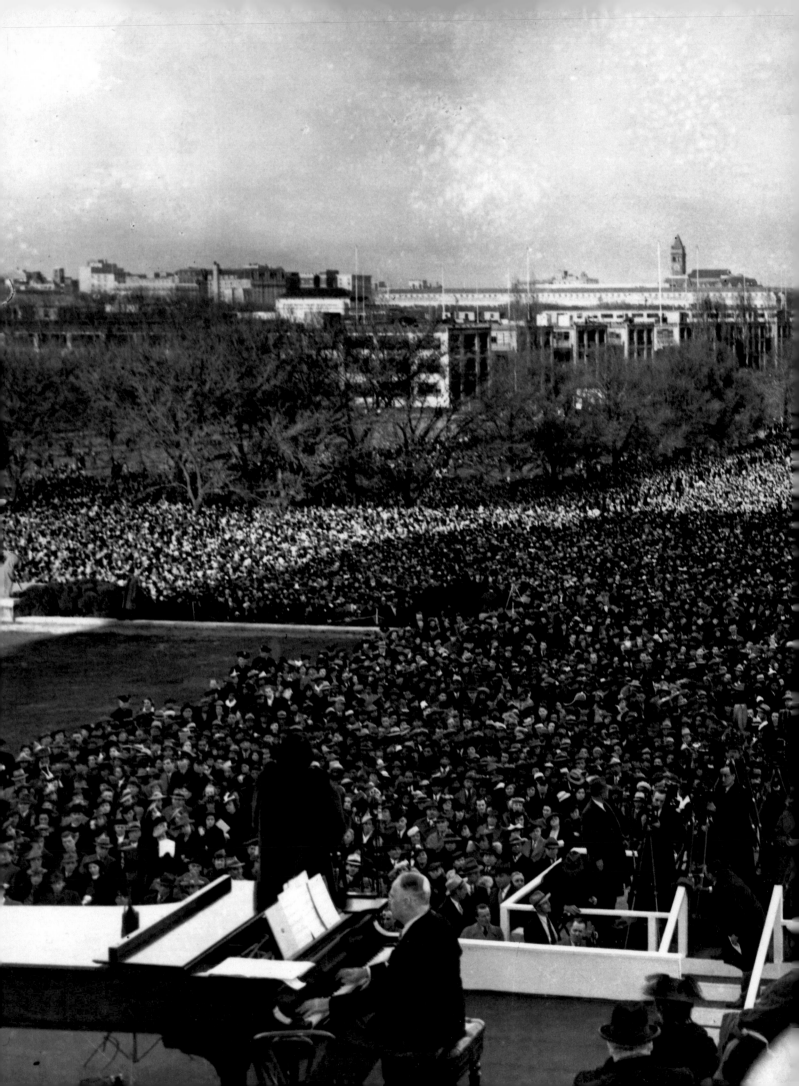

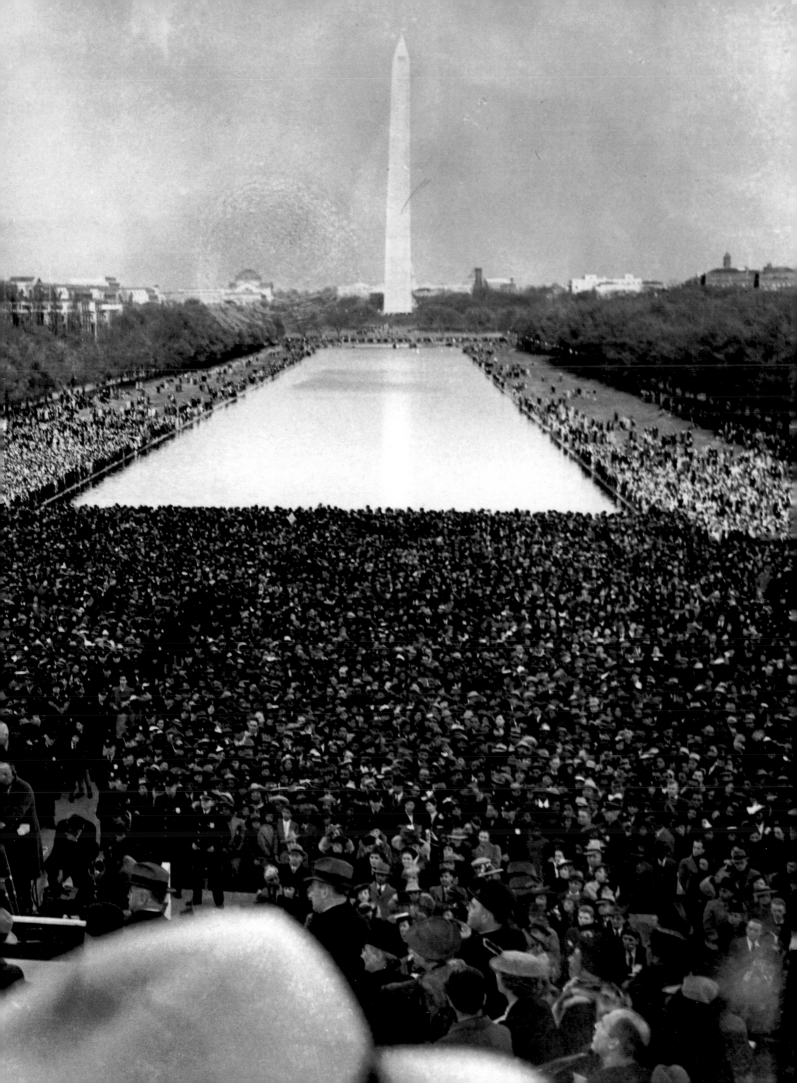

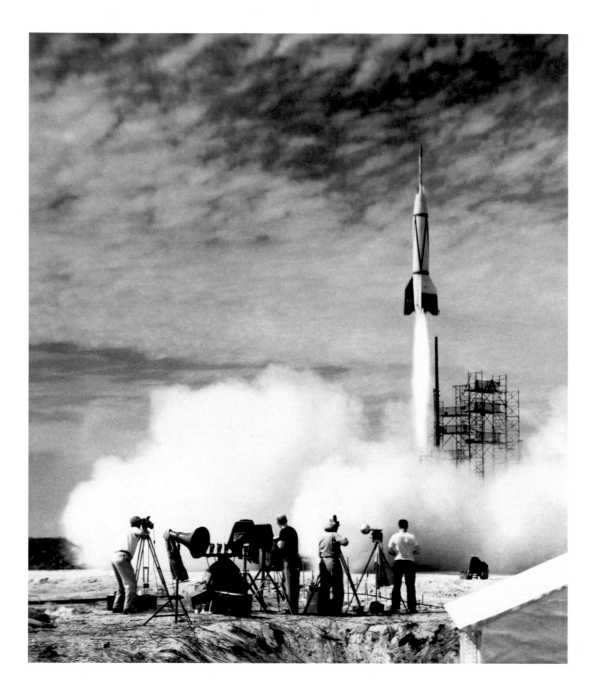

Bumper Project Launch in Florida, July 24, 1950

U.S. Air Force

Gelatin silver print

1950

SEEing
AS BELIEVING

The idea that "seeing is believing" is deeply ingrained in the American character. Idiomatically we say, "I'll believe it when I see it." On a more sophisticated level, we trust photographs as evidence in courtrooms and as records of events when we see them in newspapers and magazines. Some of the most advanced and arcane enterprises of contemporary science rely totally on photographic images to verify discoveries and confirm theories, whether the field of view is miniscule, as with the subatomic particles tracked by nuclear physicists, or immense, as with the distant galaxies revealed by radio telescopes.

Virtually nothing happens today without a camera in attendance. In 1857 a single photographer caught the moment of impending lift-off of Professor Steiner's balloon (page 28). Less than a hundred years later, a similarly amazing aeronautical first — the first rocket launch at Cape Canaveral — was recorded for posterity by scores of cameras. The spectacle of observation, in this case the camera crews assembled for the unprecedented lift-off, plays an equal role in the scene. Even for those who witness an event firsthand, photographs may later supersede memories of what actually happened. Image thus becomes reality. The raising of the American flag at Iwo Jima (first a photograph, then a sculpture), Neil Armstrong's first steps on the moon, the collapse of the World Trade Center towers: these images are embedded in our shared experience. Photographs create a reality derived from real life but one quite different from it.

The steady multiplication of visual images has changed our perception of the world in sometimes subtle but nonetheless fundamental ways. From the amateur snapshot to mass media, photographs form a common language of Western culture, and increasingly of all other cultures as well. To the extent that these pictures depend on photographic reality and not on reality itself, photography centers on the intent of the photographer and the desire of the viewer — not on questions of seeing, that is, but of believing.

Although photographic reality is thought to be a twentieth-century phenomenon, discourse between artifice and representation has long fueled interest in photography. Not surprisingly, many of the greatest debates about photography have occurred in the realm of fine art. In the nineteenth century, efforts to elevate public perceptions of photog-

raphy focused not on the medium's inherent realism but rather on emulating the conventional subjects of painting and literature, especially those that might ennoble or instruct the viewer. One of the most famous art photographers of the nineteenth century in this regard was Oscar Rejlander, who began his career as a painter. He thought nothing of cutting and pasting several negatives together to create tableaus based on morality themes.

In Rejlander's wake, Julia Margaret Cameron, Gertrude Käsebier, Rudolf Eickemeyer Jr., and other artistically minded photographers produced images intended to be seen as consciously made pictures, not as photographs. Their sort of artificial portraiture continued well into the twentieth century through popular fashion magazines, most notably, *Harper's Bazaar* and *Vogue*. Together with picture-oriented magazines such as *Time* and *Life*, these publications shaped the concept of history being a story of heroic, attractive people and their actions. They also reinforced our sense of the importance of social role, of living in a social and cultural environment that defines our very identity — a subject that has persevered to today in the work of contemporary photographers William Eggleston (page 271) and Tina Barney (pages 226 – 27).

At the turn of the twentieth century, photographers who aspired to art believed their medium's true calling was to record not facts but the impression of facts. As Arthur Wesley Dow and other artists and teachers discussed, a photograph combines two functions: one "as a record of truth, the other as a work of art." The art of photography, by this argument, is based not on the sharp and undiscriminating detail of the scientific image, in which every vein of leaf or striation of rock is recorded, but on a naturalism based on what the eye sees in a landscape modified by light and atmosphere. Such a poetic, subjective way of seeing appealed to many late Victorian photographers who worked in the far-flung reaches of the colonial empire. They forswore the cool, matter-of-fact style of earlier survey photographers for views framed less as a source of information than as a ground for contemplation. British colonial studios such as Skeen and Company produced huge numbers of photographs that, without explanatory captions, are mysterious and romantic evocations of cultures far from the din of industrial expansion. Joseph Kossuth Dixon's dramatically conceived, if clichéd and anachronistic, tableaus of "vanishing" American Indians vividly suggest how the importance of the photograph lies not only in its subject but also in the photographer's construction of its presentation.

For contemporary photographers, Dow's either/or view of photography's art status no longer is convincing. Today's artists borrow freely from all of photography's rich past. They adopt the techniques of geological survey photographers for landscapes, of stop-motion pioneers for conceptual tableaus, of amateur snap shooters for cultural

Installation View of Smithsonian Photography
Exhibition Art Section

Thomas Smillie

Cyanotype

ca. 1913

commentary, of research scientists for exploring the nature of photo-graphic information. William Wegman, whose 1988 sequence *Untitled (Gallop)* (pages 242 – 43) appears to capture the running movement of a Weimaraner, arouses laughter by mimicking Eadweard Muybridge's motion studies of a hundred years earlier. Terry Evans's photographs of specimen drawers inspire reflection on how photography has served the fields of zoology and natural science and, at the same time, has helped redefine concepts of beauty.

In part, pictures such as those by Wegman and Evans comment on other pictures. They demonstrate photography's complex ability to represent and reflect stereotypes of the visual world and also to make us aware of visual experiences that we may take for granted. While most photographers, particularly those concerned with cultural documentation, have not abandoned entirely the notion that camera images are in some sense authentic, their awareness of the camera's ability to create believable fictions has not been suppressed. This may explain why so much of today's most intriguing work is simultaneously

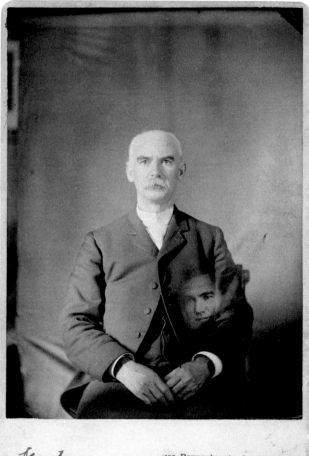

Nephew

493 Pennsylvania Avenue,
Washington, D. C.

Portrait of Thomas Smillie
Unidentified photographer
Cabinet card

ca. 1900

NATIONAL MUSEUM OF AMERICAN HISTORY
DIVISION OF INFORMATION TECHNOLOGY AND SOCIETY
PHOTOGRAPHIC HISTORY COLLECTION

true and false, authentic and artificial, objective and subjective. Photographs are no longer seen as transparent windows on the world but as intricate webs of information spun by a visual culture that encompasses not only art but also advertising, design, fashion, Hollywood movies, celebrity "fan" magazines, and the ubiquitous television set.

The efficient way that photography yokes together style and subject matter has made it an important component in selling modern life. The conjunction between art and commerce that winds through photography's history touches upon a wide range of photographic styles. Issues of art — the pursuit of a particular aesthetic standard — and advertising — the creation of desire — are usually considered antithetical, but they coexist in photographic practice. In the twentieth century the professional advertising industry employed photographs to communicate an appropriate sense of a product to consumers. Fame and celebrity became commodities in themselves and enhanced the allure of consumer goods. "Image consciousness" gained in relevance as "life style" came to replace "life" in most advertisements.

Consider the photograph of Amelia Earhart (pages 254–55). Taken in the mid-1930s, after her solo flights across the Atlantic and Pacific made her a public celebrity, the picture includes a Lockheed Electra airplane and a Cord Phaeton automobile. Is it a winsome portrait of the nation's most famous woman aviator? Is it an advertisement for the airplane? (We now know it is the one she was flying when she disappeared in 1937.) Or is it promoting the car, which by association with the airplane and its pilot is made to seem part of a glamorous world of technological innovation? The answer could be any of the above, or some combination of all three, or another possibility. Only the original use of the image might decide this with some certainty. What is clear is that the photograph was planned, posed, and arranged in great detail and that its historical poignancy was not part of its original intention.

In looking at the United States as a model democracy, the nineteenth-century French commentator Alexis de Tocqueville observed that nothing is ever quite what it seems in America. The classical, columned stone buildings he spied from the distance of his ship's deck on closer inspection turned out to be false fronts made of painted lumber. So it is with our contemporary sense of photographs: reality is read not as something on the surface of a picture but as what lies behind it. In the case of old photographs, this can be the sum of the dense accumulations of meaning the images have acquired over time. With recent pictures, it can refer to the matrix of cultural and historical assumptions that led to their making. The enticing sense of indeterminacy—that feeling of seeing not quite equaling believing—is in the end what makes photography such an intriguing and irresistible medium for our time.

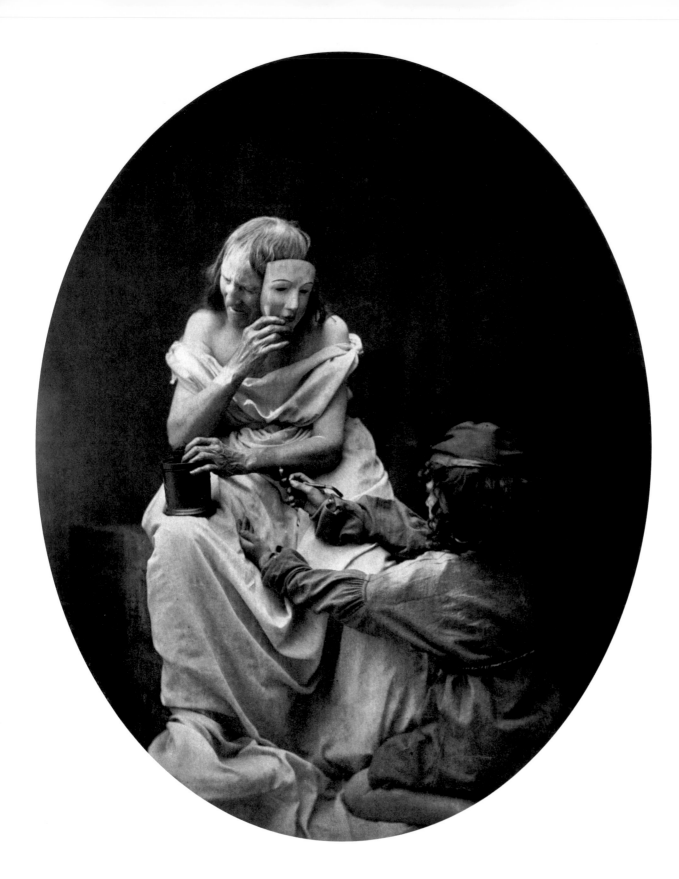

The Mask

Oscar Rejlander

Albumen print

ca. 1860

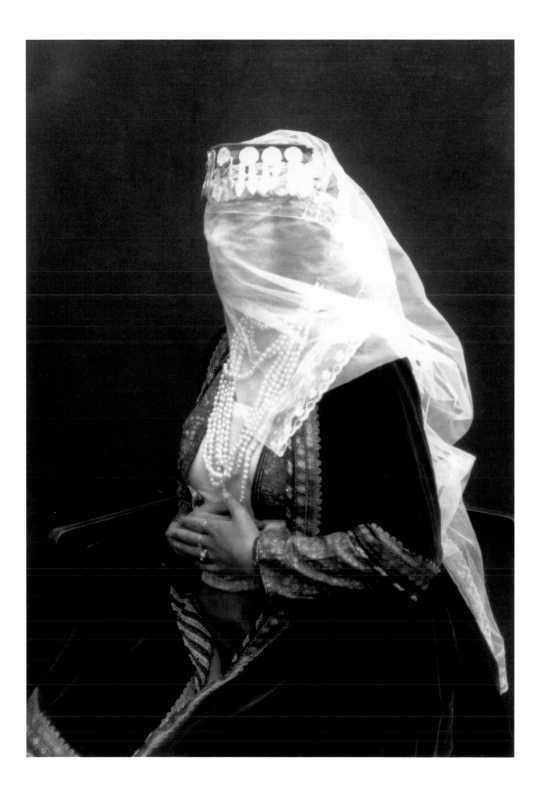

Veiled Woman with Pearls

Antoin Sevruguin

Gelatin silver print from glass photonegative

ca. 1890–1900

FREER GALLERY OF ART AND ARTHUR M. SACKLER GALLERY ARCHIVES
MYRON BEMENT SMITH COLLECTION

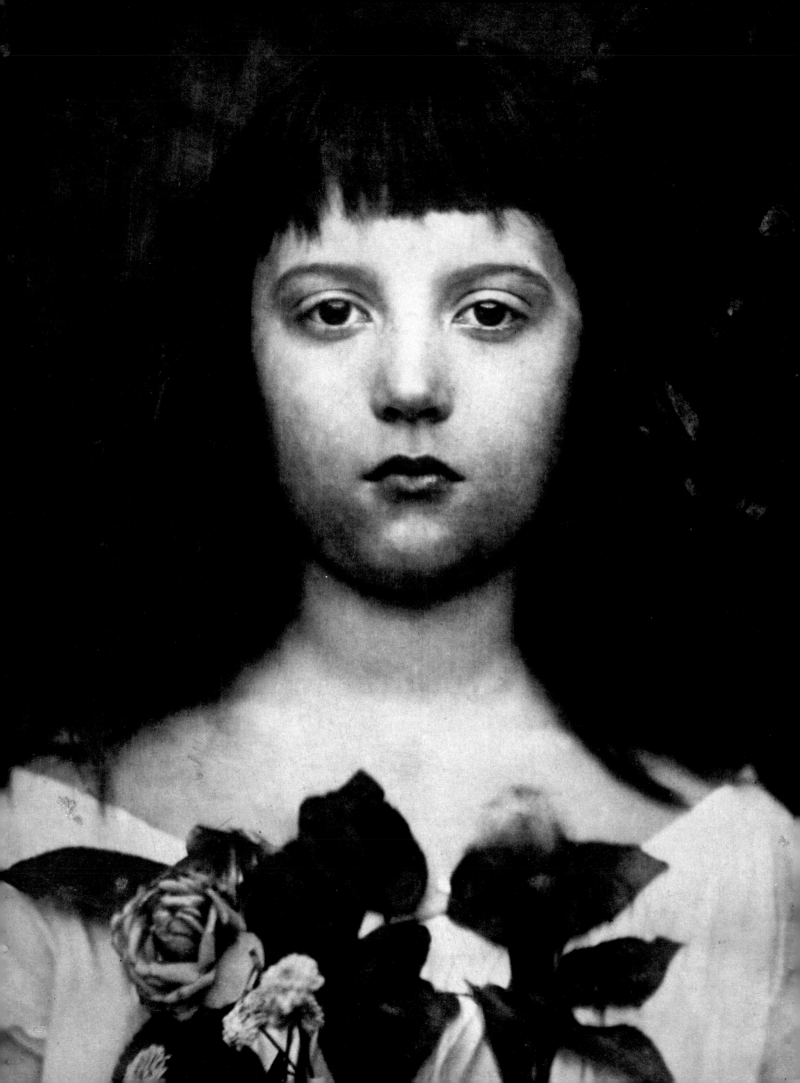

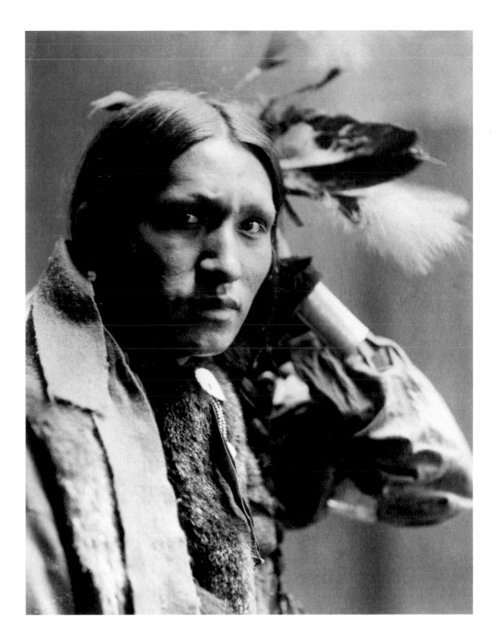

Sioux Indian
Gertrude Käsebier

Platinum print

1898

Saint John
Julia Margaret Cameron

Albumen print

ca. 1865

American photographer Gertrude Käsebier and British photographer Julia Margaret Cameron were among the first practicing women photographers to gain equal notoriety and respect in the predominately male circles of artistic photography. Käsebier came to photography later in life and after she raised her three children. She opened a studio in New York City, where some of her sitters included Alfred Stieglitz and Clarence White. In 1900 she became the first woman elected to Britain's Linked Ring Brotherhood, and she went on to found the American Photo-Secessionist movement with her fellow Pictorialist photographers Stieglitz and White. This photograph comes from a series she made in her studio of American Indians who worked and performed in Buffalo Bill's Wild West Show.

Cameron, who did not take up photography until the age of forty-nine, probably received some training from British photographers Oscar Rejlander and Lewis Carroll. Closely associated with the ideals and artists of Britain's Pre-Raphaelite movement, Cameron posed her family and friends in interpretations of literary, historical, and biblical scenes to create lush, ethereal photographs.

THE ARTIST AND THE PHOTOGRAPH

Phyllis Rosenzweig
Hirshhorn Museum and Sculpture Garden

Standing Nude (Samuel Murray)
Thomas Eakins
Platinum print

ca. 1890–92

HIRSHHORN MUSEUM AND
SCULPTURE GARDEN

Along with the Getty Museum in Los Angeles, the Metropolitan Museum of Art in New York, and the Pennsylvania Academy of the Fine Arts in Philadelphia, the Hirshhorn Museum houses one of the largest public collections of photographic work associated with Thomas Eakins. A native of Philadelphia, Eakins has long been considered one of the foremost American painters of the nineteenth century. The photographs represent an extremely varied body of work, including casual images of friends and family, portraits, posed nudes, and studies of figures in motion. Images exist as 4-by-5-inch albumen contact prints, cyanotypes, and platinum enlargements. Many seem directly related to his paintings; others are tangentially or ambiguously connected, and some are not at all. Attributing photographs to Eakins is problematic in several cases because many of his students, friends, and family members also experimented with the camera.

Early studies of the artist's career made little reference to Eakins's interest in or use of photography (perhaps because of these problems with attribution), but recent scholarship has revealed much new information about the artist's work and his use of photography in particular. New research suggests he projected photographic images directly onto the canvas — a most contemporary approach! — as a step in producing a painting.

Eakins has been categorized as a consummate realist, and to that extent it has been assumed that he himself considered a photograph to be a teaching tool rather than a work of art. Whether his interest in photography was scientific or aesthetic remains a point of speculation. Neither Eakins, who could otherwise be quite didactic about his methodology, nor his students, who otherwise were quite reverent about repeating the teachings of their "boss," left much written information about his thoughts on the uses of photography.

Wrestlers in Eakins's Studio
Thomas Eakins
Platinum print

ca. 1899

Among the photographs attributed to Eakins and his circle is a series on the human figure in motion. A rotating disk behind the shutter recorded sequential movements on a single print, unlike the sequential images popularized by Eadweard Muybridge, with whom Eakins had worked. These examples of Eakins's systematic scientific inquiry exist in the Hirshhorn collection in several mediums and sizes, and as cropped or flopped images. Together the elegantly proportioned and rhythmic compositions, with their simple forms and sequential imagery, are of great aesthetic interest. If the distinction between photography's supposed objective vision and painting's place as an expressive, subjective tool is considered almost obsolete today, it may be that the differences between science and art are permeable, flexible, and interwoven in Eakins's photographic sensibility as well.

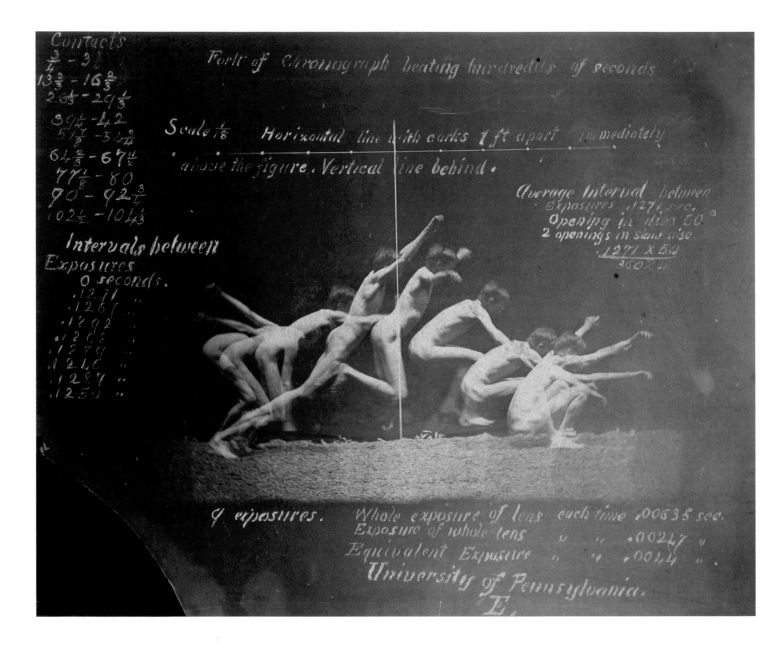

**Marey Wheel Photographs of Unidentified Model,
with Eadweard Muybridge Notations**

Thomas Eakins

Albumen print

1884

HIRSHHORN MUSEUM AND SCULPTURE GARDEN

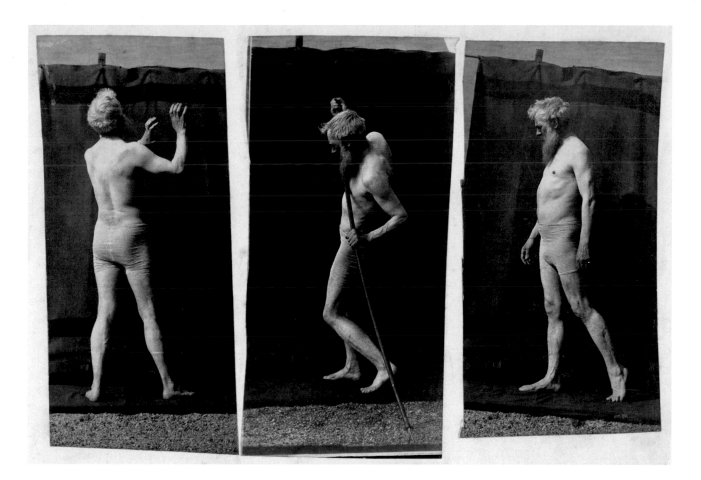

Self-Portrait

Eadweard Muybridge

Albumen print

ca. 1880s

Girl Laying in Hammock, Mt. Meigs, Alabama

Rudolf Eickemeyer Jr.

Platinum print

ca. 1900

NATIONAL MUSEUM OF AMERICAN HISTORY
DIVISION OF INFORMATION TECHNOLOGY AND SOCIETY
PHOTOGRAPHIC HISTORY COLLECTION

Evelyn Nesbit

Rudolf Eickemeyer Jr.

Platinum print

1902

NATIONAL MUSEUM OF AMERICAN HISTORY
DIVISION OF INFORMATION TECHNOLOGY AND SOCIETY
PHOTOGRAPHIC HISTORY COLLECTION

Pictorialist Rudolf Eickemeyer Jr. began photographing the South after visiting a plantation in Alabama, where he likened the freed slaves working in the fields to the French peasants portrayed in paintings by the Barbizon artist François Millet in the 1850s. He returned to Alabama several times to photograph rural scenes, and he later published books of his nostalgic images. *Down South* (1901) contained an introduction by Joel Chandler Harris, the American folklorist who created the character Uncle Remus.

Architect Stanford White hired Eickemeyer to photograph his mistress Evelyn Nesbit in 1902. Eickemeyer's poses of Nesbit became some of his most well known work, and the photographs helped Nesbit establish her career as a model and performer. This particular image of Nesbit was voted best picture in 1902 by the members of the Camera Club of New York.

In 1929, following an exhibition of his work at the Smithsonian, Eickemeyer presented one hundred of his medal-winning photographs to the Department of Photography. A year later he gave the museum a collection of his personal papers and an additional endowment of $15,000 to maintain his original gift and to add to the photography department.

Marina's Room
Tina Barney
Ektacolor Plus color print
1987
SMITHSONIAN AMERICAN
ART MUSEUM

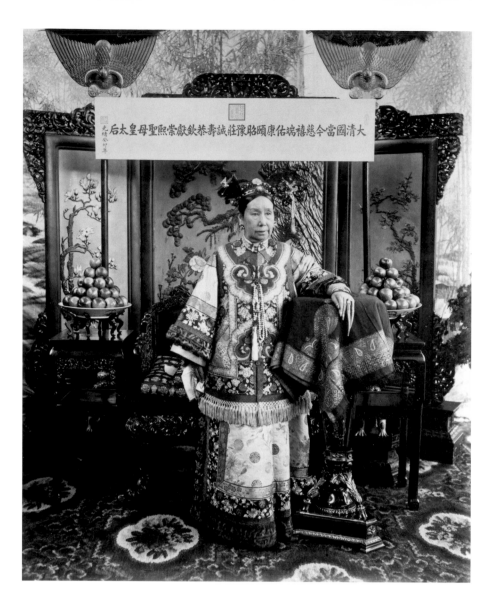

Cixi, the last empress dowager of China, reigned over the Chinese empire for more than fifty years as the consort to one emperor, mother to a second emperor, and adoptive mother to a third. During her lifetime she emerged as one of the most powerful women in Chinese history. These photographs of the empress dowager come from a rare collection of glass-plate negatives that depict Cixi participating in many activities both at the Summer Palace and in the Forbidden City. The empress staged the elaborate settings and enhanced the scenes with calligraphied descriptive scrolls and fake lotus blossoms. Xunling, son of Cixi's senior lady-in-waiting, took all the photographs.

Cixi, Empress Dowager of China,
Standing before the Imperial Throne
Xunling
Modern gelatin silver print from glass negative

ca. 1900–1905

Cixi, Empress Dowager of China,
Li Lien Ying, and a Lady-in-Waiting
aboard the Imperial Barge
Xunling
Modern gelatin silver print from glass negative

ca. 1900–1905

FREER GALLERY OF ART AND
ARTHUR M. SACKLER GALLERY ARCHIVES

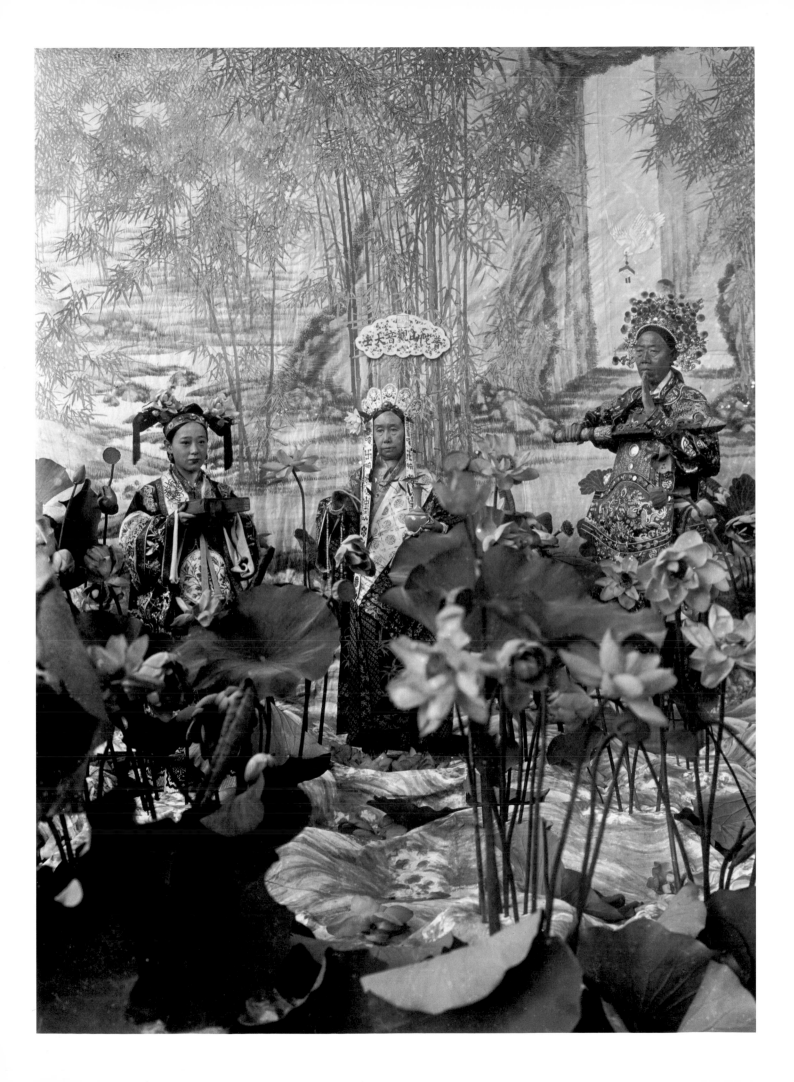

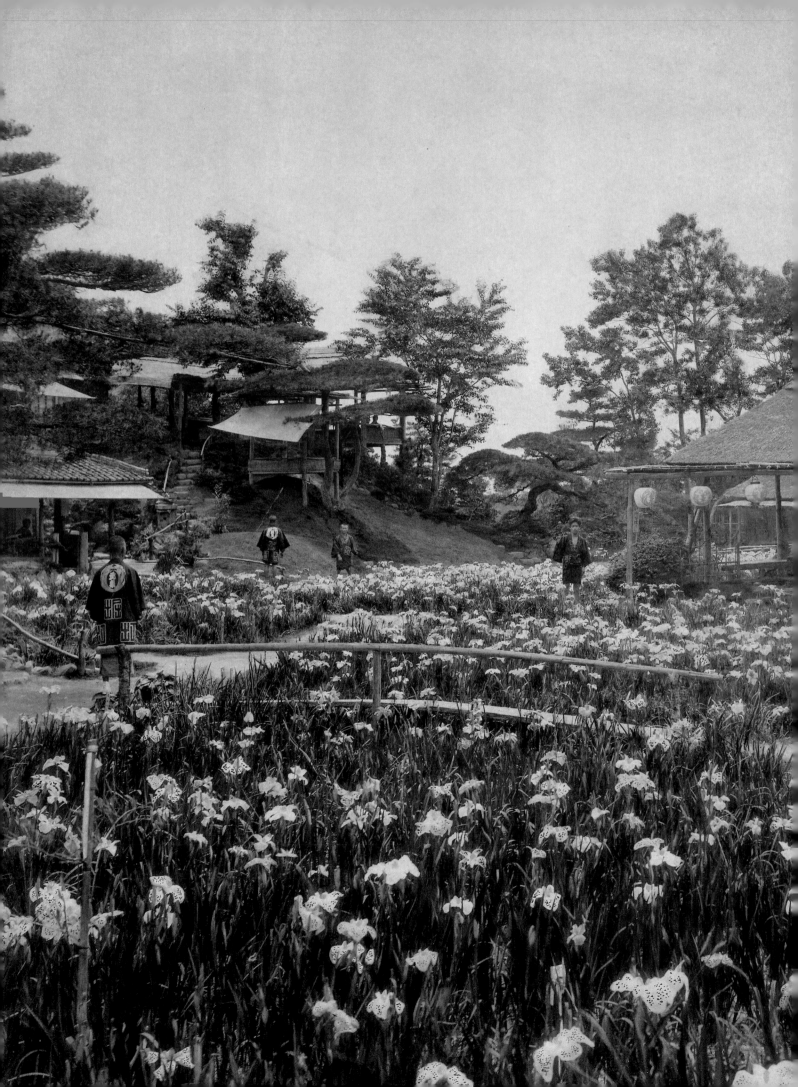

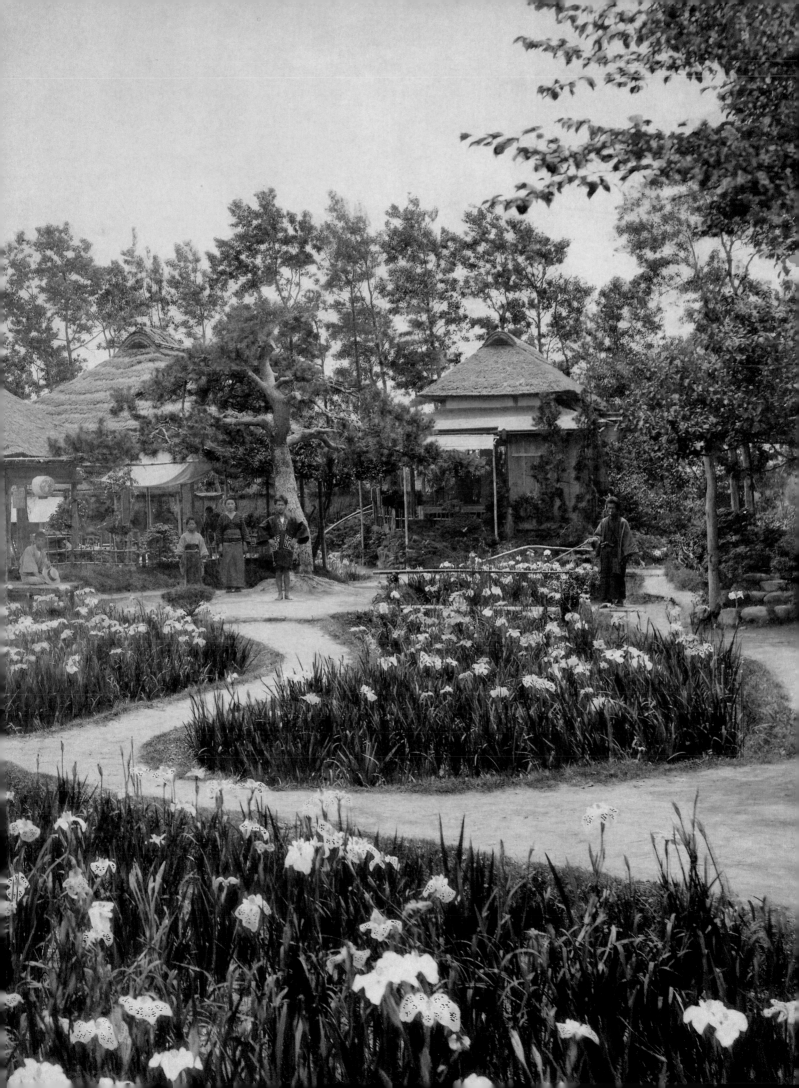

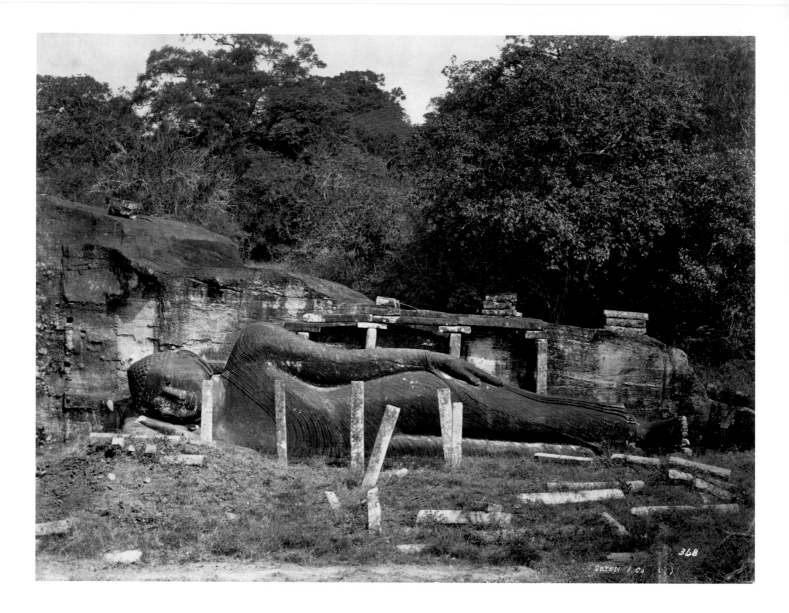

Recumbent Buddha at Gal Vihara, Polonnaruva

Skeen and Company

Albumen print

ca. 1875

FREER GALLERY OF ART AND ARTHUR M. SACKLER GALLERY ARCHIVES
CHARLES LANG FREER PAPERS

PREVIOUS SPREAD

Iris Blossoms at Horikiri, Tokyo

Kusakabe Kimbei

Hand-colored mammoth plate

ca. 1864–80

FREER GALLERY OF ART AND
ARTHUR M. SACKLER GALLERY ARCHIVES
HENRY AND NANCY ROSIN COLLECTION OF
EARLY PHOTOGRAPHY OF JAPAN

British photographer William Louis Henry Skeen moved to Sri Lanka in the 1860s and photographed that exotic island for more than forty years. During that time, Skeen documented Sri Lanka's ancient ruined cities and Buddhist landmarks, such as those depicted here. These photographs derive from albums of Sri Lankan views that Skeen and Company sold to wealthy tourists, such as Freer Gallery of Art benefactor Charles Lang Freer.

First Flight of Stone Steps towards the Summit
at the Sacred Hill of Mihintale

Skeen and Company

Albumen print

prior to 1907

Vanishing into the Mists

Joseph Kossuth Dixon

Gelatin silver print

1909

NATIONAL MUSEUM OF NATURAL HISTORY
NATIONAL ANTHROPOLOGICAL ARCHIVES

Department store magnate John Wanamaker, owner of the lucrative chain of Wanamaker stores in Philadephia, created an Education Bureau in 1906 to better serve his customers. Photographer Joseph Kossuth Dixon headed the new bureau and gave public lectures illustrated with lantern slides and motion pictures in the store's auditorium. In 1908 Rodman Wanamaker, the store owner's son, sponsored an educational outreach program and commissioned Dixon to travel on three expeditions to Montana with the purpose of making photographs and movies of the vanishing Indian tribes there. On these expeditions Dixon took thousands of photographs of the American Indians living in the valley of the Little Big Horn region, and he filmed a movie illustrating the epic poem *The Song of Hiawatha* by Henry Wadsworth Longfellow. The photographs were later published in a book called *The Vanishing Race* (1913). Both efforts were well received by the American public and resulted in commercial success for Dixon and the Wanamakers.

Face wood	Veneered on	Back bead	Glass bead	Recd. 7/17/31 Photo by	115767 Place of Picture
Apple 1927	H. Pine	Rosewood	Fl. Orange	H. F. Bucher	Washington D.C.
Pear 1927	"	Walnut	Cherry	" "	Falls Church Virginia
Peach 1929	Chestnut	Rosewood	Fl. Orange	U.S. Dept. Agri.	N. Carolina
Fl. Orange 1928	Chestnut	"	African Padauk		Florida
Cal. Orange 1929	H. Pine	Ebony	" "		California
Cherry 1927	Solid	———	———	U.S.F.S.	N. Carolina
Walnut 1931	H. Pine	———	———	" "	Georgia
Walnut burl 1914	"	Gaboon Ebony	Amaranth	" "	
Circassian Walnut Tree 1914	Ash	Rosewood	Andaman Padauk	H. F. Bucher	U.S. Capitol
Circassian Walnut Panel 1930	H Pine and 3 ply Birch	Macassar Ebony	Frame is Bullet wood veneered on Ash		
Brazil 1915 Walnut	Spruce	Gaboon Ebony	———	Pan American Union at New York 1912	Shipment received
English Oak 1928	Chestnut	"	{ The Book of the English Oak	E. N. Mason — Big Ben: Banbury Park	Essex: England.
American 1927 White Oak	Solid	———	———	F. W. Besley State Forester	Wye Mills Maryland
Live Oak 1930	Ash	-	and courtesy of Chamber of Commerce	Mr Geo W Johnson Charleston	Middleton Gardens Ashley River, S.C.
Southern 1925 Red Oak	Cypress	Ebony	Amaranth	R. A. Emmons	14th & Florida Ave Wash. D.C.
Red Oak	Solid	(Bought Frame)		H. F. Bucher	Sargent Road Wash. D.C.
Weathered Oak 1927	"	———		" " "	Rock Creek Park
Ash 1929	"	———		U.S.F.S.	Kentucky
White 1931 Ash	Chestnut	Ebony	Andaman Padauk	H. F. Bucher	U.S. Capitol
Ash burl 1928	Ash	(Rosewood Edges) in Timbers of the World		A L Howard	Hungary
Chestnut 1926	Chestnut	———		U.S.F.S.	Howard County Maryland 1914
Elm 1928	White Pine	Elm	Elm	H. F. Bucher	Judiciary Square Washington D.C.
Honey Locust 1927	" "	———		" " "	14th & Penna. Ave Washington D.C.
Black Locust	Poplar	———		" " "	16th & Florida Ave Washington D.C.

Both Locust frames are made of wood from trees grown in Washington D.C.
The Southern Red Oak frame is wood from tree shown in photo.

Handwritten Index of Trees

W. F. Bucher

Manuscript page

ca. 1932

NATIONAL MUSEUM OF AMERICAN HISTORY
DIVISION OF THE HISTORY OF TECHNOLOGY
NATURAL RESOURCES COLLECTION

PREVIOUS SPREAD

National Champion American Beech,
Ashtabula County, Ohio

Barbara Bosworth

Gelatin silver print

1990

SMITHSONIAN AMERICAN ART MUSEUM

In 1931, after contributing several specimens of wood to the wood technology section of the United States National Museum at the Smithsonian Institution, William F. Bucher offered to loan his collection of forty-nine tree photographs for an exhibition titled *Our Trees and Their Woods*. Bucher, a cabinetmaker, framed each photograph in wood from the same species depicted in the image.

In a letter to the curator at the Smithsonian, in which he described the exhibition and his collection, Bucher writes, "Most any boy … can start a collection of this kind; which will lead into many interesting avenues of research, and grow more fascinating as the hobby progresses." Upon his death in 1950, Bucher left his entire collection of tree photographs to the U.S. National Museum. Today the collection resides in the Natural Resources Collection of the National Museum of American History.

Photograph of a Blue Ash Tree

W. F. Bucher

Gelatin silver print in frame made of blue ash wood

ca. 1932

NATIONAL MUSEUM OF AMERICAN HISTORY
DIVISION OF THE HISTORY OF TECHNOLOGY
NATURAL RESOURCES COLLECTION

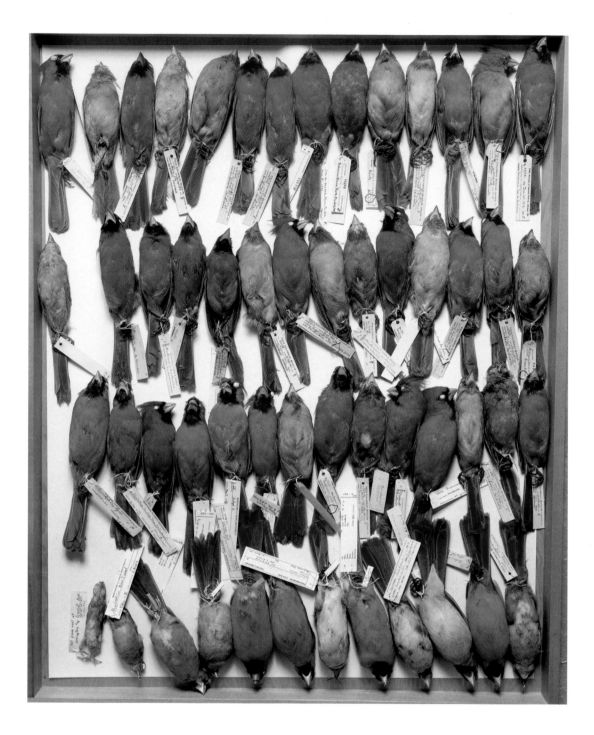

Field Museum, Drawer of Cardinals, Various Dates

Terry Evans

Iris print

2001

HIRSHHORN MUSEUM AND SCULPTURE GARDEN

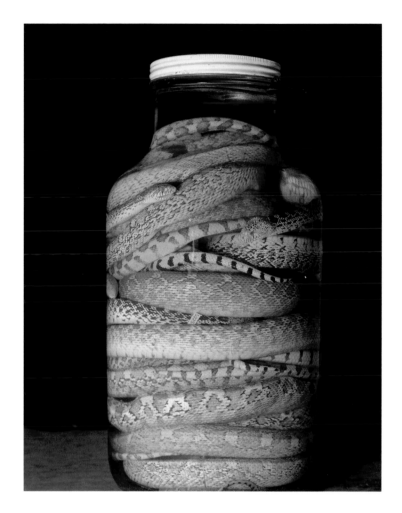

Field Museum, Bull Snakes, Various Dates

Terry Evans

Iris print

2001

HIRSHHORN MUSEUM AND SCULPTURE GARDEN

Known for her aerial landscape photographs of the Midwestern prairies, photographer Terry Evans decided to visit the natural collections of the Field Museum in Chicago to look closer at the species native to the areas where she makes her landscapes. The beauty of the botanical and animal specimens so inspired Evans that she created a photographic portfolio of the specimens themselves, taken straight from the drawers and cabinets of the museum.

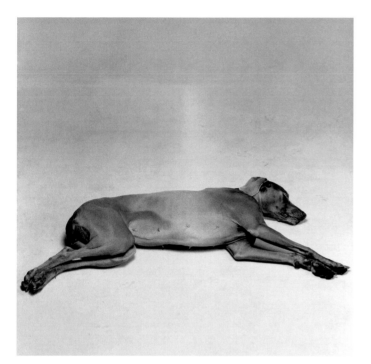
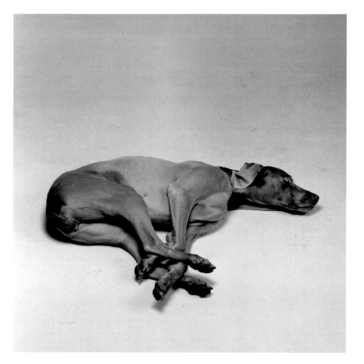

Untitled (Gallop)

William Wegman

Gelatin silver print

1988

SMITHSONIAN AMERICAN ART MUSEUM

DESIGNING MODERNISM

Merry A. Foresta
International Art Museums Division

Modern photography, like modern design, was enlisted in the early twentieth century to promote a vision of a new world organized around a different kind of beauty—one rooted in industrial materials and basic principles of shape, color, and light. The notion that all things might be controllable and explainable undoubtedly attracted many modernists—artists and scientists alike—to the subject of the machine. Trained as an electrical engineer but a photographer by avocation, Harold "Doc" Edgerton worked in an atmosphere that suggested efficiency was the ultimate aim of technology. He offered the world a new tool, one as suited to the arts as to the sciences: a high-powered, repeatable flash unit—the strobe. His "stop-motion" photography revealed unseeable things, and his photographs are as remarkable for their precision as for their sensational beauty.

Photography is most often linked to modern design as a component in marketing and sales. Just as designers attempted to "streamline" products to generate sales during the worldwide depression of the late 1920s, photographers tried to show products in a progressive, sleek, and shiny way. Photographer Josef Sudek, a leading member of the Czechoslovakian avant-garde between the world wars, is best known for his style of enigmatic reality, which is evident in his intimate cityscapes of his native Prague. Sudek also produced dramatic commercial photographs in connection with Družstevní práce, a wide-ranging collective of artists, writers, and craftsmen. His photographs of houseware designs by Ladislav Sutnar, for example, are captivatingly askew. Sudek's skill as a photographer—clear glass poses one of the most difficult photographic challenges—matches dramatic composition to innovative design. Originally made to promote modern Czech design at New York's 1939 World's Fair, Sudek's photographs were never used. Czechoslovakia was invaded by Germany the month before the fair opened.

Fan and Smoke
Harold E. Edgerton
Gelatin silver print
1934 / printed 1979–80

SMITHSONIAN AMERICAN ART MUSEUM

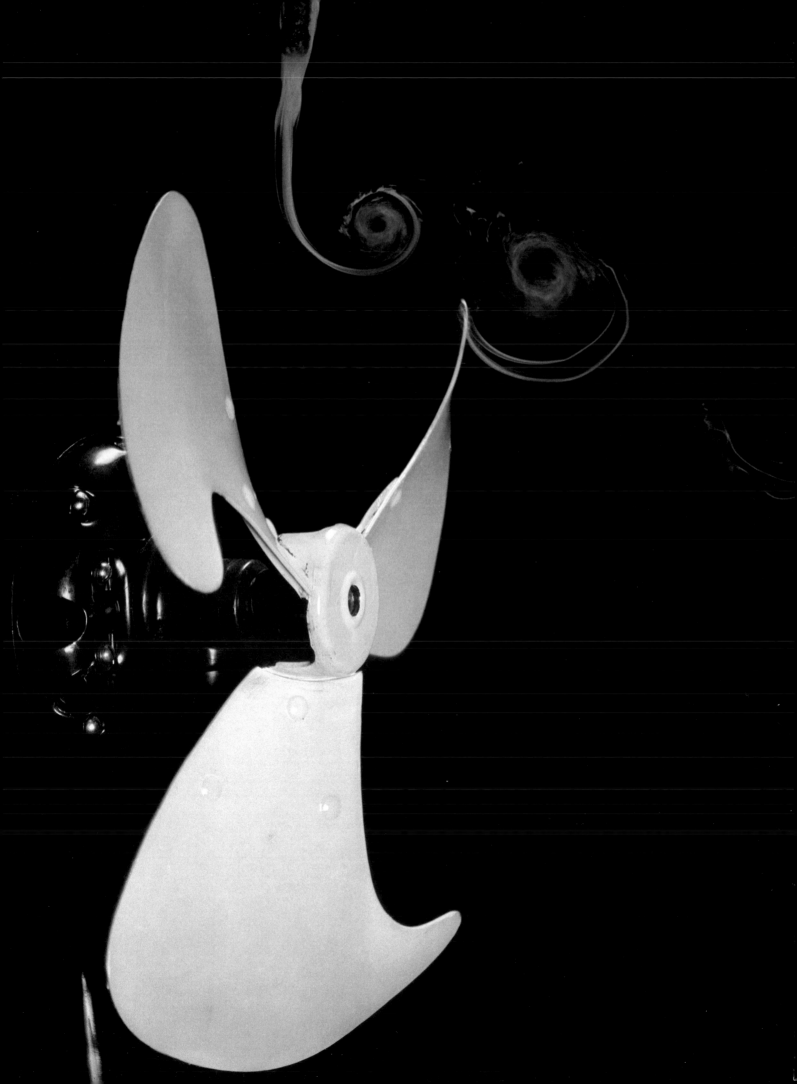

Photograph of a Model Wearing a Bracelet by
Worth and Carrying a Dog's-Head Walking Stick

Thérèse Bonney

Gelatin silver print

ca. 1929

COOPER-HEWITT, NATIONAL DESIGN MUSEUM
THÉRÈSE BONNEY COLLECTION

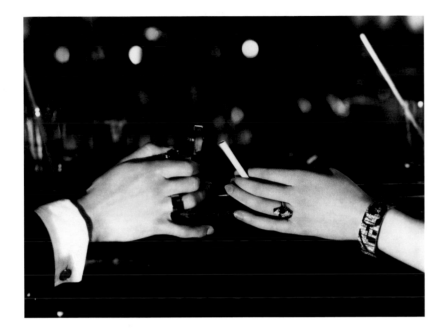

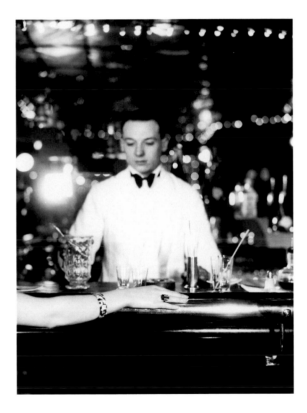

Photograph of Jewelry,
Designed by Gérard Sandoz
Thérèse Bonney
Gelatin silver print

ca. 1929

**COOPER-HEWITT, NATIONAL DESIGN MUSEUM
THÉRÈSE BONNEY COLLECTION**

Photograph of Jewelry,
Designed by Lucien LeLong,
Staged at Le Grand Écart
Thérèse Bonney
Gelatin silver print

ca. 1929

**COOPER-HEWITT, NATIONAL DESIGN MUSEUM
THÉRÈSE BONNEY COLLECTION**

Born in Syracuse, New York, in 1897, Thérèse Bonney emigrated to France in 1919. Five years later she founded the first illustrated press agency in Europe, the Bonney Service. The photographs Bonney collected, and later made herself, were used by advertising and news agencies to document and promote the latest trends in French decorative arts and fashion, and were not created for strictly artistic reasons. These photographs, which recall the work of Surrealist photographers such as Man Ray, were made in and around Paris during the 1920s and 1930s, when the Surrealist movement was at its height in France. Bonney's family presented her collection of 4,300 photographs to the Smithsonian's Cooper-Hewitt, National Design Museum.

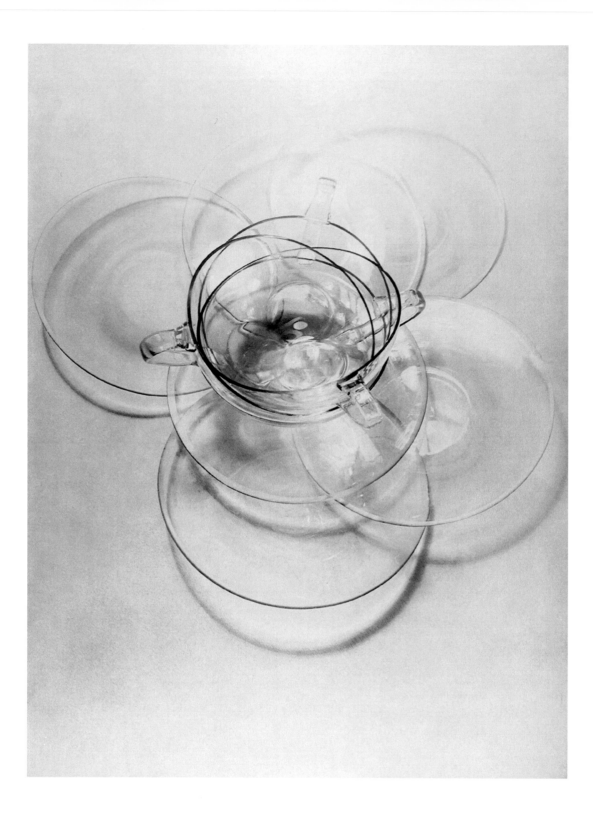

Photograph for an Advertisement: Glass Teacup
Designed by Ladislav Sutnar, Produced under the Direction of
Družstevní práce, a Czech Publishing House and Artists' Cooperative
Josef Sudek
Gelatin silver print

ca. 1931

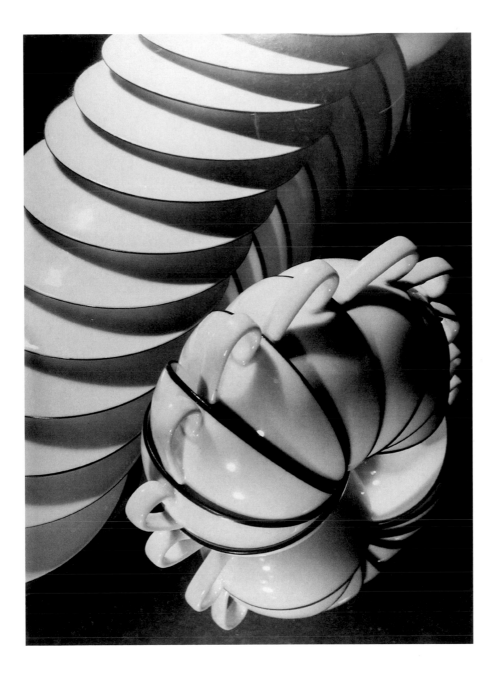

Photograph for an Advertisement: Porcelain Dinner Service Cups and
Saucers Designed by Ladislav Sutnar, Produced under the Direction of
Družstevní práce, a Czech Publishing House and Artists' Cooperative

Josef Sudek

Gelatin silver print

ca. 1931–32

Bombardiers in Training

U.S. Air Force

Gelatin silver print

ca. 1950

NATIONAL AIR AND SPACE MUSEUM ARCHIVES

A press release from the U.S. Air Force describes this unusual scene
as part of the regimen followed by bombardiers in training. "Daily
calisthenics are a 'must' on the program of bombardiers in training at
this world's largest bombardier 'college.' In this novel exercise, they use
100-pound bombs to keep arm muscles toned for instantaneous action."
Photographs such as these were made by the armed forces for publicity,
recruitment, and propaganda.

Photograph for Jones and Laughlin
Steel Corporation Advertising Campaign

Arthur d'Arazien

Ektachrome print

ca. 1965

NATIONAL MUSEUM OF AMERICAN HISTORY
DIVISION OF THE HISTORY OF TECHNOLOGY
INDUSTRY COLLECTION

The work of Arthur d'Arazien is image advertise-
ment rather than product pictures. In his "steel
mark" photos, d'Arazien used arresting images of
everyday people in industrial settings to catch the
attention of the casual magazine reader. In the
1960s the steel industry promoted the use of steel
as part of its campaign to secure protective tariffs
against the rising tide of imported products.
Cold War ideology abounds as a parade of people
toting household objects marches before the
smokestacks, a symbol of American strength, of
the Aliquippa works in Pennsylvania.

Peter Liebhold, National Museum of American History

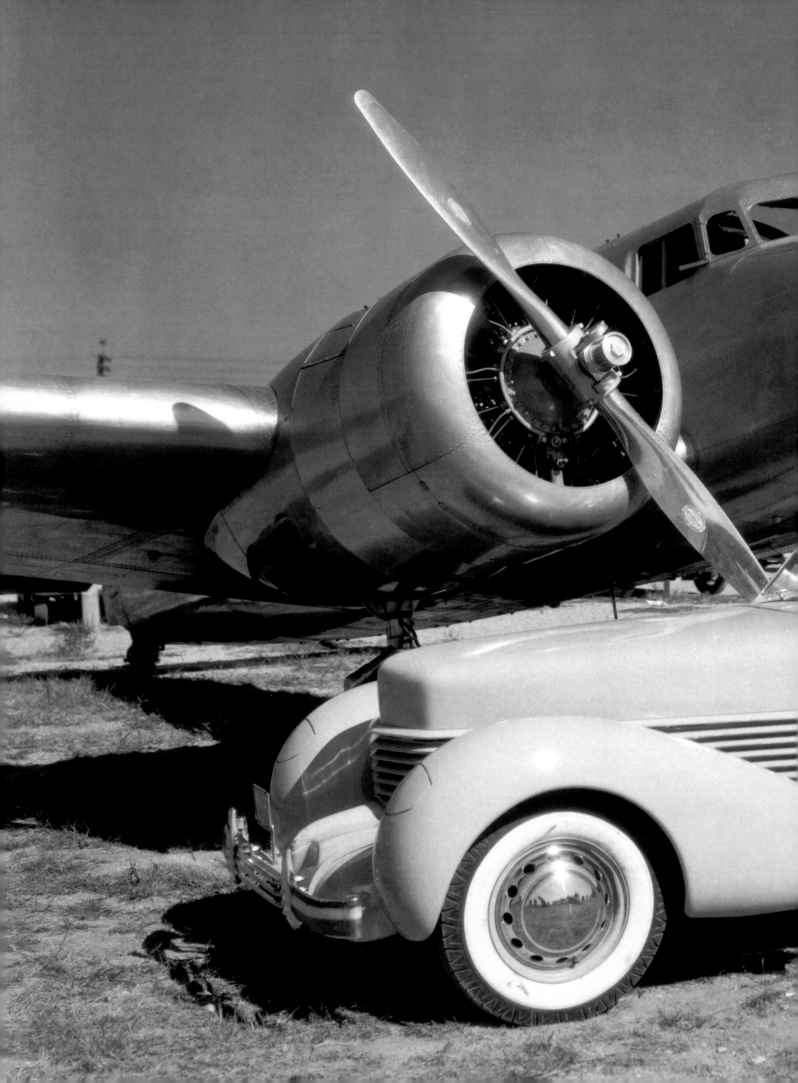

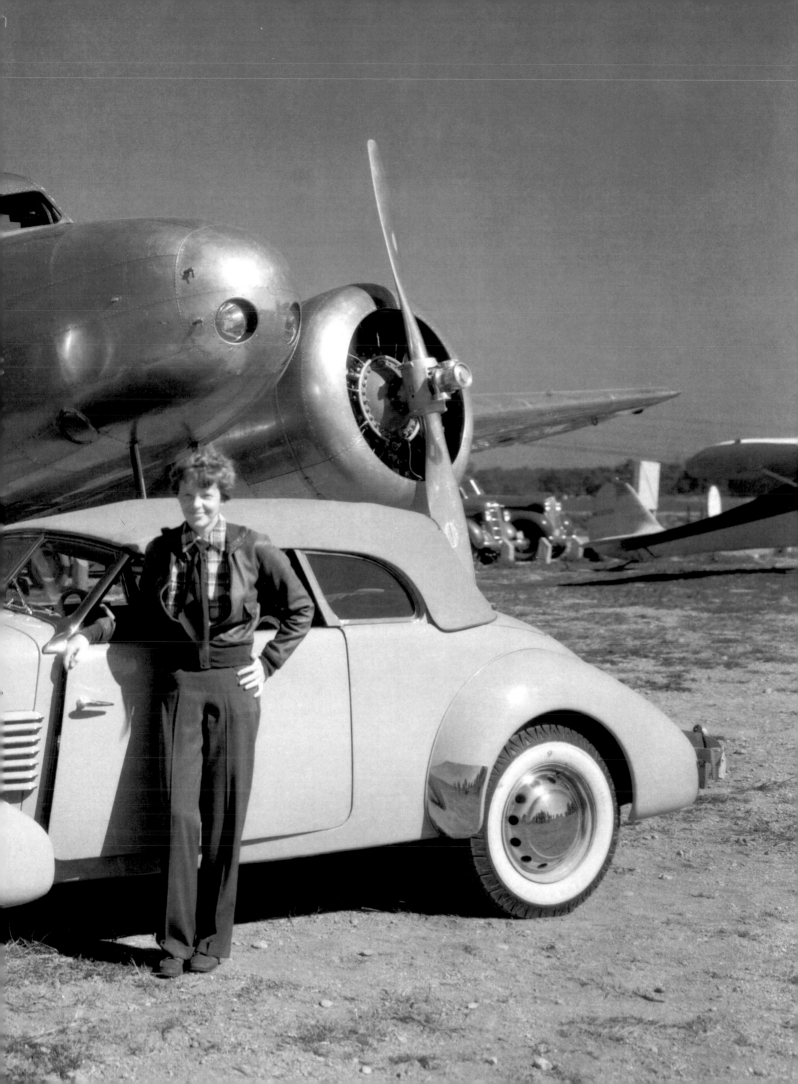

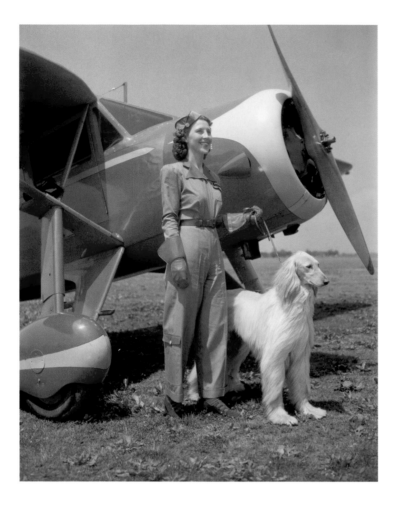

Fairchild 24 Airplane with Model and Dog
Hans Groenoff
Color transparency

ca. 1937

NATIONAL AIR AND SPACE MUSEUM ARCHIVES
HANS GROENOFF COLLECTION

Charles Lindbergh with Plane
Unidentified photographer
Gelatin silver print

ca. 1927

NATIONAL AIR AND SPACE MUSEUM ARCHIVES

PREVIOUS SPREAD

**Amelia Earhart with a Lockheed Electra
and Cord Phaeton**
Unidentified photographer
Gelatin silver print

ca. 1936

NATIONAL AIR AND SPACE MUSEUM ARCHIVES

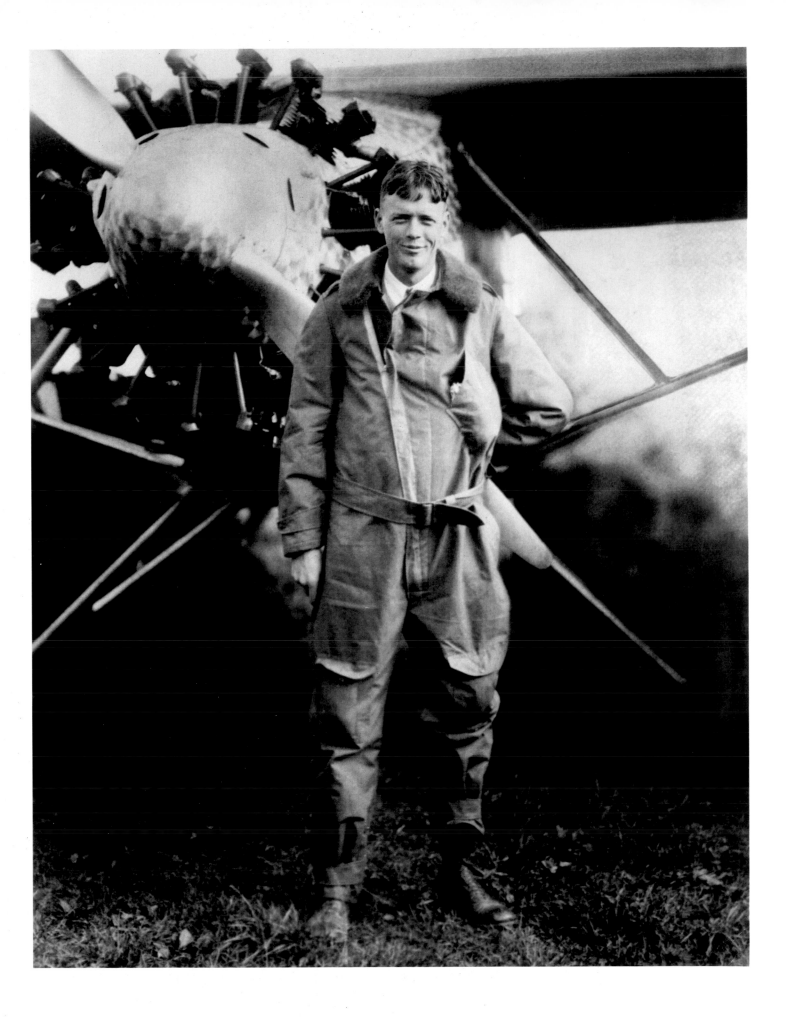

PHOTOGRAPHY AND FAME

Amy Henderson
National Portrait Gallery

In 1928, when anything seemed possible, banker Paul Mazur stood in the advertising and commercial crossroads known as Times Square and wondered at the extravagant display of attention-getting signs and blinking lights that had been generated by "a staggering machine of desire." Since the late nineteenth century, American life was illuminated by an increasingly visual culture. The rise of the entertainment industry spawned a media medley of mass-distributed magazines, recordings, and most of all, movies. In 1915 poet Vachel Lindsay wrote about the "increasingly hieroglyphic civilization" that characterized Machine Age culture. Emerging as the dominant visual symbol of modernism were media-generated "celebrities" who became virtual — if at times ephemeral — cultural icons.

Within the accelerated pace of modern life, a singular irony of celebrity status was the extent to which its success depended on photography's ability to capture and convey a personality in a defining but still image. Perhaps this was nowhere more apparent than in the "star system" that fueled the film industry after World War I. Fan magazines such as *Photoplay* appeared just before the war and flourished in its aftermath as go-betweens for fans and studios. The magazines' primary mission was to provide resonant images of the movie personalities that flickered across the silver screen. Popular desire for these images was such that, by the late 1920s, each of the major studios had created its own "portrait gallery," in which Clarence Sinclair Bull, Edward Steichen, and other highly regarded photographers used light and shade to sculpt celluloid icons. Could any flesh-and-blood creature really have been so ethereal as Greta Garbo or so Technicolor as Lucille Ball?

Beyond movies, the entertainment industry as a whole has always danced a knowing pas de deux with photography. The popularity of such musical giants as Duke Ellington was assured by his recordings and by his performances on radio and in film, but it was photography that helped broadcast a lasting impression of his character. Sports figures, too, commonly became a permanent part of our national consciousness through captured images — however odd it may be to see such action figures as the youthful boxer Muhammad Ali flash-frozen in time.

Duke Ellington

Studio Bernateau

Gelatin silver print

ca. 1960

Fanny Brice

Alfred Cheney Johnston

Platinum print

1918

Greta Garbo

Clarence Sinclair Bull

Gelatin silver print

1939

Jackie Robinson

Harry Warnecke

Color carbro print

1947

Lucille Ball

Harry Warnecke

Color carbro print

1945

The rich, saturated colors in this portrait of Lucille Ball by Harry Warnecke were created before professional photographers routinely used color film. Working with a special camera and technique that he invented himself, Warnecke created vibrant images for reproduction in the rotogravure section of the Sunday *New York Daily News*.

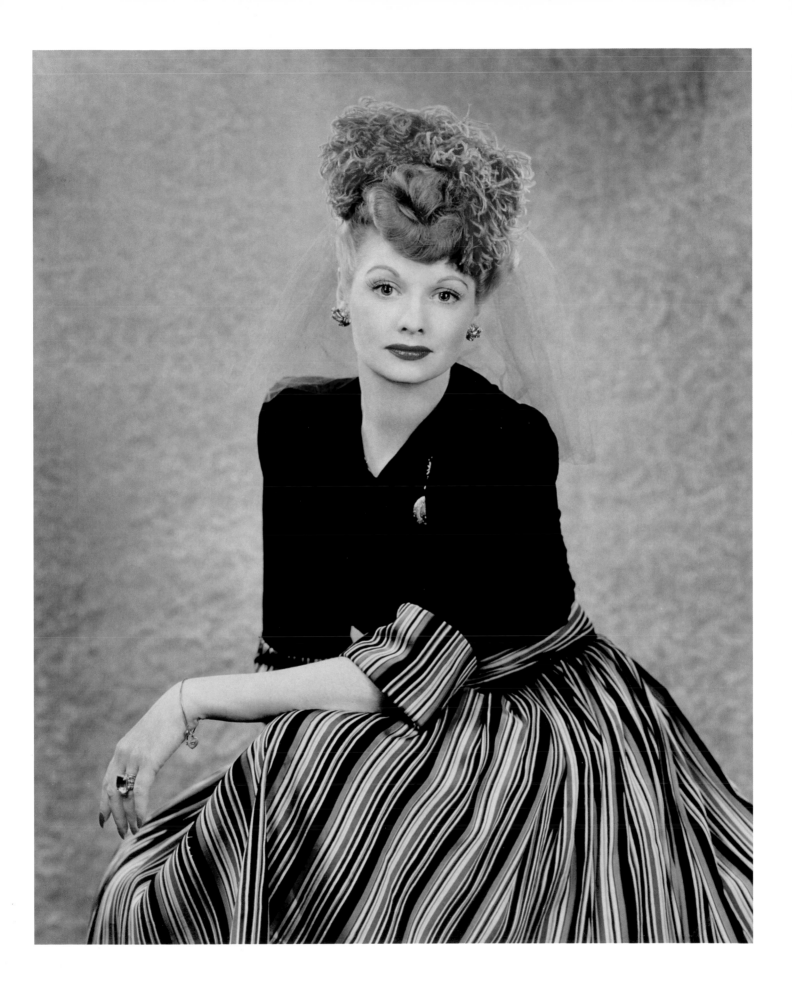

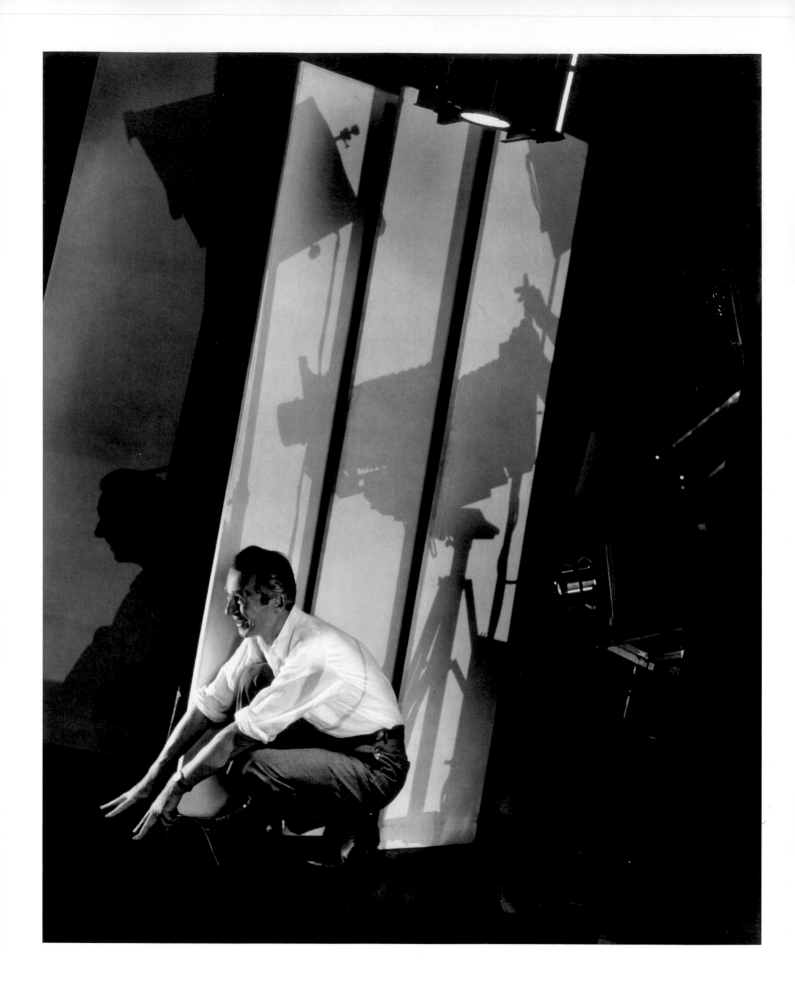

Photo Booth Self-Portrait
Ansel Adams
Gelatin silver print

ca. 1930

Self-Portrait
Edward Steichen
Gelatin silver print

1929

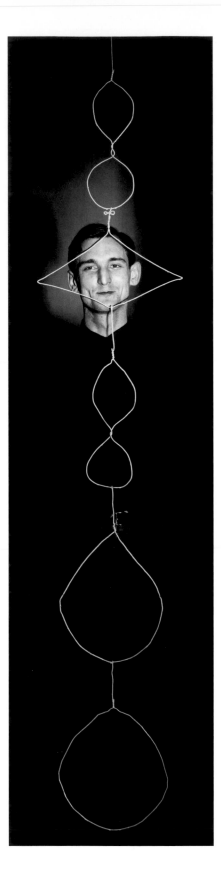

Portrait of Hugo Weber

Harry Callahan

Gelatin silver print

ca. 1950

Muhammad Ali

Gordon Parks

Gelatin silver print

ca. 1962

John F. Kennedy and Caroline Kennedy

Richard Avedon

Gelatin silver print of proof sheet

1961

NATIONAL MUSEUM OF AMERICAN HISTORY
DIVISION OF INFORMATION TECHNOLOGY AND SOCIETY
PHOTOGRAPHIC HISTORY COLLECTION

At an exclusive pre-inaugural sitting at the Kennedy compound in Florida early in 1961, Richard Avedon photographed John Fitzgerald Kennedy and his daughter Caroline, as well as Jacqueline Kennedy and young John Jr. The first photograph in the middle row of the enlarged contact sheet to the right shows Caroline holding her father's hand to her face. It appeared as one of six photographs of JFK and his family that was published in the February 1961 issue of *Harper's Bazaar* as the first in a series titled "Avedon: Observations." The collection of Avedon photographs at the National Museum of American History includes photographs, tearsheets, contact prints, and negatives.

Shannon Perich, National Museum of American History

THE CULTURE OF LANDSCAPE

Debra Diamond
Freer Gallery of Art and Arthur M. Sackler Gallery

In the past three decades, contemporary photographers have extended the genre of the pastoral and the documentary to incorporate fresh perspectives on the cultural meanings of the landscape. In the 1970s William Eggleston and Raghubir Singh were instrumental in expanding the landscape aesthetic to include color images. Eggleston exploited the surreal effects of neon lighting and the garish colors of industrial products to define new poetics of the suburban landscape. The sumptuous, albeit nightmarish, color of *Untitled (Grave)* conveys the American vernacular as an uneasy tension between pathos and banality.

Singh built upon Henri Cartier-Bresson's dictum to "capture life in the act of living" by making color the organizing principle of his photographs of India. In an image from his series on the river Ganges, an elegantly restrained palette and a classical composition transform the fleeting moment of an improbable dive into an image of lyric monumentality. In his last photographic series taken before his death in 1999, Singh shifted his focus from a directly perceived India to a landscape reflected, refracted, or seen through the windows of a car. The automobile's presence in each photograph signals an inquiry into the cultural landscape of post-independence India.

Contemporary photographers Hiroshi Sugimoto and Mark Klett share Singh's preference for serial images, but they approach place and the passage of time from radically different perspectives. If Singh emphasizes the pregnant moment and the specific place, Sugimoto, in his "Seascapes" series, withholds the visual clues that identify time and place. In austerely elegant images, Sugimoto records oceans around the world, without color and without signaling his presence, in nearly identical images that divide the picture plane into twin halves of sea and sky. The photographs convey not specific oceans but rather the idea of oceans. Klett, in his panoramic photograph of Washington, D.C., creates a cultural landscape of the nation's capital as both city and symbol by enmeshing the passage of time and the accumulation of events into the fabric of a multipart image. From a single vantage point atop the Old Post Office building, Klett photographed the city on several days over the course of three seasons, combining fourteen images within a single linear composition.

Untitled (Grave) (from the portfolio "Graceland")
William Eggleston
Dye transfer print

1983 / printed 1984

SMITHSONIAN AMERICAN ART MUSEUM

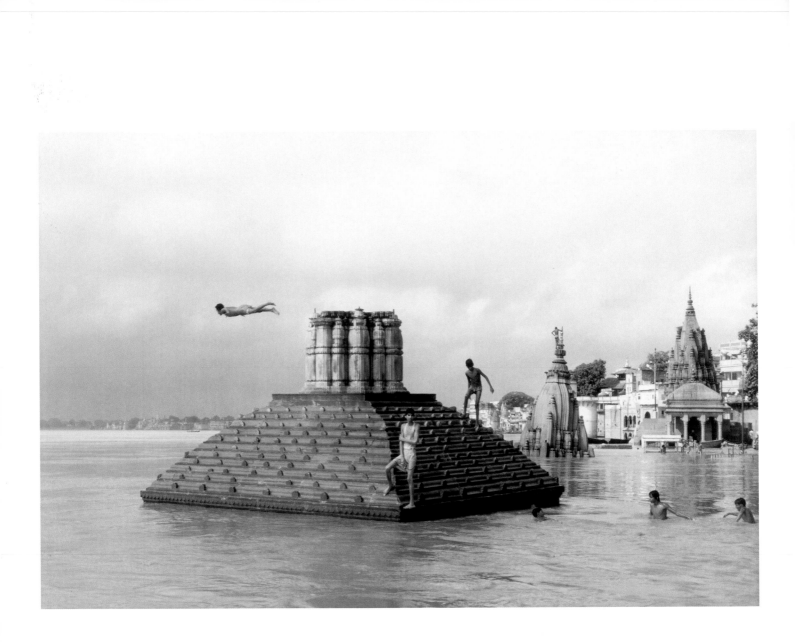

Man Diving, Ganges Floods, Benares

Raghubir Singh

Chromogenic print

1985

Grand Trunk Road, Durgapur, West Bengal
Raghubir Singh
Chromogenic print

1988

ARTHUR M. SACKLER GALLERY

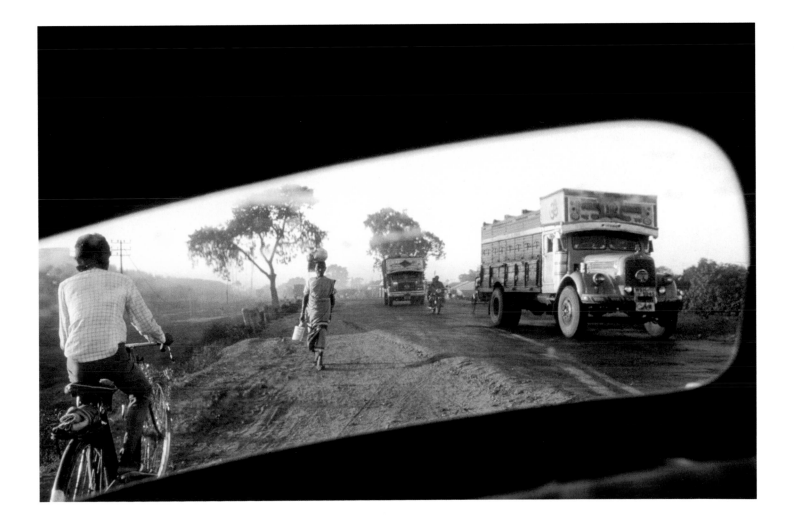

Boden Sea/Utwill

Hiroshi Sugimoto

Gelatin silver print

1993

ARTHUR M. SACKLER GALLERY

Yellow Sea/Cheju
Hiroshi Sugimoto
Gelatin silver print

1992

The sublimely tranquil seas in these photographs by Hiroshi Sugimoto appear to have frozen while the photographer went about his work. To create this series of similar but subtly different seascapes, Sugimoto travels the world over, photographing bodies of water from the land. He uses a large view camera with filters and lenses to recreate a slow film speed, similar to that used in the nineteenth century. The extremely long exposure period—over an hour—both conceptually and physically convey the sea, its light, and its calm mystery through time.

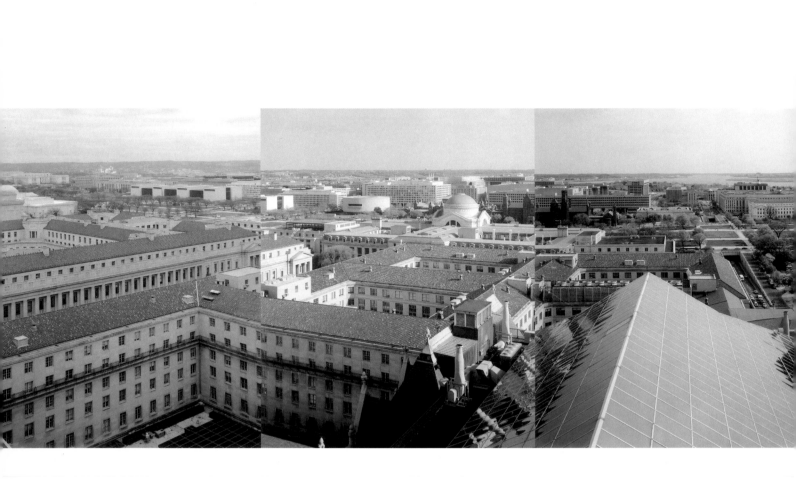

A Panorama of Washington, D.C., from the Nancy Hanks Tower,
September 1992 to April 1993, Panels 8–13
Mark Klett
Organic pigment prints

1992–93

SMITHSONIAN AMERICAN ART MUSEUM

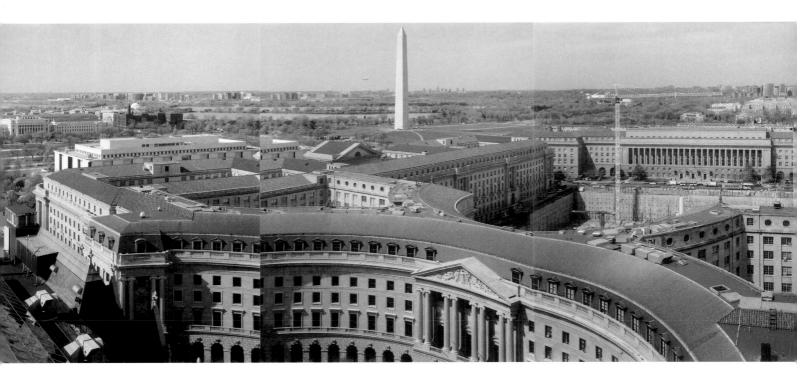

In 1992 landscape photographer Mark Klett was commissioned by the Smithsonian's National Museum of American Art to create a new panorama of Washington, D.C. A student of nineteenth-century landscape photographers such as Eadweard Muybridge, whose 360-degree panorama of San Francisco taken in 1878 served as Klett's inspiration for his own 1990 San Francisco panorama project, Klett has also traveled throughout the West to areas first documented by nineteenth-century survey photographers. His contemporary landscapes of the same locations examine the passage of time and the changes that have resulted over the years.

After studying both existing historic panoramas of the nation's capital and the late twentieth-century layout of the city, Klett chose to shoot his photographs from atop the Nancy Hanks Tower of the Old Post Office Pavilion in downtown Washington. He began photographing in September 1992 and returned to the tower the following January and April to make additional views.

The resulting fourteen-panel composition starts with four photographs from the first session in September 1992. The central four images date from January 1993 and depict the inaugural parade of President William Clinton. The last six images complete the panoramic cycle with springtime views from April 1993. The photographs successfully document a view of modern Washington, while they simultaneously capture the literal passage of time as well as ideological shifts in history and politics over the course of three seasons and two presidential administrations.

GLOSSARY

Albumen print Invented in 1850 by Louis-Desiré Blanquart-Evrard, the albumen print was the most popular photo printing technique until the 1890s. The printing paper was coated with a film of egg whites (albumen), which the photographer then sensitized with a solution containing silver nitrate. Additional toning of the photographic image was done with gold chloride to reduce fading and to stabilize the image. The addition of the gold produced the brown (sepia) highlights that are associated with albumen prints. Such prints were replaced at the end of the nineteenth century by the invention of the gelatin silver printing method.

Ambrotype James Ambrose Cutting patented the ambrotype process in the United States in 1854. An ambrotype consists of a collodion negative printed on glass and placed in front of a separate dark background. The positive image is revealed when the collodion glass negative is viewed in conjunction with the dark background. The negative and the background were stored in a protective case, similar to those used for daguerreotypes. Although the ambrotype process, like the daguerreotype process, produced only one unique image at a time, it was an improvement over the time-consuming, expensive daguerreotype method. Popular for a relatively short period of time, the ambrotype was replaced by the more cost effective ferrotype (tintype) and albumen print processes by the 1860s.

Cabinet card The cabinet card was the larger sized offshoot, measuring 6½ × 4¼", of the popular carte-de-visite photograph. Made of heavy card stock, the decorative mount frequently carried an advertisement for the photography studio that made it. The cabinet card became a common and widely collected format from the mid-1860s through the turn of the century. Like cartes-de-visite, cabinet cards were displayed in albums that often included photographs of family members as well as images of famous public figures or entertainers.

Calotype English photographer and inventor William Henry Fox Talbot patented the calotype, also known as the Talbotype, in 1841. This process allowed for the creation of multiple salted-paper prints from a single paper negative. The paper negative had to be sensitized first with a silver nitrate and potassium iodide solution, dried, and then coated with more silver nitrate and gallic acid. After being exposed, the negative was developed in gallo-nitrate of silver before being washed and fixed. This laborious process had to be completed on the same day the calotype was created or the image would fade away. Although it could make multiple images from a single negative, the calotype process was used less extensively for portraiture than the daguerreotype process because it required a longer exposure time. The rise in popularity of glass plate negatives in the 1850s made the calotype negative obsolete.

Carbon print Patented by Joseph Swann in 1864, the carbon printing process remained in common use through 1910. To create carbon tissue, a thin sheet of gelatin was infused with carbon black powder. The tissue could be exposed after it was sensitized with potassium bichromate. The gelatin hardened after it was exposed to light. Then, the tissue was developed in water, washing away the unhardened, unexposed gelatin and thus revealing the photographic image. In the water bath, the hardened tissue was transferred from its original backing onto paper to make the final print. Carbon prints lasted a long time and were among the first efforts that succeeded in stabilizing the photographic printing process.

Carbro print An offshoot of the carbon print process, the carbro process uses the same idea of exposing sensitized gelatin tissue to light. Carbro prints advanced towards creating color photographs by using tissue pigmented in three separate layers of cyan, magenta, and yellow. A vivid color photo-

graph resulted when the layers were fused together after exposure. Photographer Harry Warnecke created his own version of this process using a special camera and techniques he invented to make the vibrant carbro images that were reproduced in the rotogravure section of the Sunday *New York Daily News*. Warnecke's production process involved a complex system of mirrors that exposed three black-and-white negatives through separate color filters of red, blue, and yellow. These variously colored images were then transferred to rotogravure plates and printed in succession, one on top of the other, or were fused together on sheets of sensitized photo tissue to create a fully colored photographic print when bonded onto white paper.

Carte-de-visite In 1854 French portrait photographer Andre-Adolphe-Eugene Disderi patented the carte-de-visite, a format that enabled eight small photographs to be taken on and printed from the same glass plate negative. This allowed the photographer to produce more photographs of a sitter for less money, and as a result it popularized the collection of carte-de-visite photographs. The small photos were mounted on card stock that measured $4\frac{1}{2} \times 2\frac{1}{2}$", the same size as the calling cards that were already commonly collected among friends and acquaintances in the Victorian era. People assembled the card photos in albums made especially to hold and display them. In the cartes-de-visite albums, photographs of family members were often displayed alongside those of famous figures, which many photography studios also made available for purchase.

Collodion Made from gun cotton, collodion was used to coat glass plate negatives in the nineteenth century. Gun cotton was made by first soaking cotton in nitric and sulfuric acid, and then mixing it with alcohol, ether, and potassium iodide. This created a solution that was poured onto the glass plates to prepare them for use as light-sensitive negatives.

Contact print A fast and easy way for photographers to see the results of their work is a contact print, which is made by directly printing a negative onto photographic paper. The resulting positive image replicates the exact size and state of the negative. The physical outline of the film, showing the sprockets, is usually visible as well.

C-type print Introduced in the 1950s to print color negatives, C-type paper is coated with an emulsion that is sensitive to cyan, magenta, and yellow dyes. When exposed to color negatives, the dyes from the negatives are transferred to the gelatin-based emulsion to create a photographic image.

Cyanotype Sir John Herschel invented the cyanotype process in 1842. More commonly known as a blueprint, the cyanotype involved developing prepared paper with an iron-salt solution. The paper was treated with ferric ammonium citrate and potassium ferriyanide. A negative, or even a drawing, was then placed on top of the sensitized paper in direct sunlight. The exposed parts of the paper turned bright blue from the effects of the iron. When the image was fixed by submerging the print in water, the unexposed chemicals washed away and the blue image intensified from the iron oxidation that took place. Engineers and architects commonly used this cheap, efficient, and stable process to copy drawings. Thomas Smillie, the Smithsonian's first photographer, employed this printing method to keep track of his glass plate negatives. He made and catalogued cyanotypes of each image, then stored the corresponding glass plate negative.

Daguerreotype French inventor Louis-Jacques-Mandé Daguerre announced this first successful photographic process in 1839. His method involved coating a copper plate with silver, then sensitizing it with vapors of iodine and bromine. After a lengthy exposure, the plate was developed using heated mercury and then fixed in a sodium thiosulfate bath. The daguerreotype's delicate silvery surface was protected in a case behind glass, and each one was a unique, singular image. Daguerreotypes were made in sizes ranging from a sixteenth plate, $1\frac{3}{8} \times 1\frac{5}{8}$", to a full plate size, $6\frac{1}{2} \times 8\frac{1}{2}$". The process continued in use through the mid-1860s, when new techniques such as the ambrotype, ferrotype, and wet-collodion methods eventually replaced it.

Double exposure A double exposure occurs when a piece of photographic film is intentionally exposed twice, causing two different images to be layered onto one negative before it is developed. The resulting print depicts both images.

Dye transfer print Created by the Jos Pé Company in 1925, this early color process required differently colored filters to create three negatives. These negatives were then used to sensitize surfaces to the three primary colors of cyan, magenta, and yellow.

One at a time, the dyes from these sensitized surfaces were transferred to gelatin-coated paper to produce a full color photograph.

Ektacolor print This process uses the same technique as the C-type, only the photographs are printed on Ektacolor paper. Sensitized to a slightly different color range than C-type paper, Ektacolor paper utilizes a color process with a different tonal result. Ektachrome film, used in conjunction with Ektacolor paper, was invented by the Eastman Kodak Company in 1946.

Enlargement To create an enlargement, the original negative is projected and the image is subsequently transferred onto paper. It is then developed into a photograph that is bigger than the physical size of the negative.

Ferrotype See Tintype.

Flash A flash adds intense light, for a very brief period of time, to aid in exposing a photographic negative. The magnesium flare, created in the 1860s, is among the first examples of a flash. Flashbulbs and electronic flashes were created in the twentieth century for the same purpose.

Gelatin dry plate Dr. Richard Leach Maddox invented the gelatin dry plate process in 1871. In this method of securing a photographic image, an emulsion of heated silver and bromide was applied to glass plates to sensitize them to light. The process was applied to celluloid roll film after 1889. The dry plate process revolutionized photography because it allowed for the mass production of glass negatives and later celluloid film that could be developed any time after exposure. This simplified way to prepare and develop negatives in turn enabled amateurs to take up photography as a hobby.

Gelatin silver print This type of print is made with the gelatin dry plate process. It remains the standard, noncolor photographic process, having replaced the albumen print by the late 1890s.

Gum bichromate print In this technique, created in the 1850s but popularized by art photographers during the 1890s, paper coated with pigmented gum arabic was exposed to light through a photographic negative. Gum in the areas that received the most light hardened. When the print paper was developed in a water bath, excess gum that had not hardened washed away, revealing the photographic image. Late nineteenth-century art photographers, such as the Pictorialists, preferred this method because they could control the quality of the print. They could manipulate the moist gum with brushes to heighten the artistic effects they sought to achieve.

Hand-colored This practice of manually adding colored pigments to a monochromatic photograph was done from the beginning of photography to daguerreotypes and continues to be practiced with gelatin silver prints. Any sort of paint — watercolors, oils, or other dyes — can be applied with a brush or any other hand-held implement.

Lantern slide A lantern slide is a positive image sandwiched between glass slides that commonly measure $3\frac{1}{4} \times 3\frac{3}{4}$". The slides were used with early projectors, also called magic lanterns, to entertain and educate viewers.

Mammoth plate The nineteenth-century view cameras that were commonly used to create landscape photographs were large and unwieldy. The cameras held glass plate negatives of seemingly gigantic proportions — as large as 18×22" — to produce the wide, clear sweeping views preferred by the photographers with the U.S. Geological Survey expeditions. Not only were the cameras hard to haul, but the oversized negatives were also difficult to transport safely. Few mammoth plate photographs and negatives have survived from the 1800s.

Panorama Made from a series of photographs or a single, oversized photograph, a panorama offers a continuous view, sometimes up to a full 360 degrees, of a landscape. When a camera outfitted with a regular lens is used to make a panorama, it is attached to a tripod and pivoted to capture overlapping exposures that later can be pieced together to show the entire view. Many types of specially outfitted cameras have been invented to aid in creating a panoramic image from a single, continuous piece of exposed film.

Photogram To produce a photogram — a photographic image made without a camera — an object is placed on sensitized photographic paper, then exposed to direct light. An image of the solid parts of the object is left behind on the paper, creating the photogram.

Photogravure Karel Klic of Vienna invented this mechanical printing process in 1879. To create a

photogravure, a copper plate is dusted with resin, then coated with bichromated gelatin. A positive transparency of a photographic image is exposed to the coated copper plate, and the photographic image is subsequently etched onto the plate's surface. The plate is then inked and wiped, as is done in the standard practice of making prints. Deeper pits etched onto the plate hold more ink and produce the shadows of the photograph. Highlighted areas of the photograph are formed from shallower plate impressions. Art photographers in the early twentieth century embraced this technique, and from 1903 through 1917 Alfred Stieglitz filled his well-known periodical *Camera Work* with photogravures of works by Pictorialist photographers.

Platinum print William Willis invented the platinum printing process in 1873 and continued to refine it until 1878, when he started a company that produced commercially prepared platinum printing papers. This type of paper is sensitized with iron salts and then exposed directly to the negative. When a light reaction results and the image begins to appear, the paper is developed in a solution of potassium oxalate, which causes a chemical reaction that dissolves and transforms the iron salts into platinum. After the paper is washed in hydrochloric acid and then in water, the photographic image becomes more pronounced and is set. The platinum printing process is known for its beautiful tonal range and permanence. The process was used widely until the 1920s, when the cost of platinum rose steeply. It is still practiced today by art photographers.

Salted-paper print William Henry Fox Talbot invented this printing technique during his early photographic experimentation in the 1830s. It was refined and more commonly practiced by the 1840s. Some of the earliest known photographs on paper are salted-paper prints. In this process, printing paper was sensitized with sodium chloride, then coated with silver nitrate. This combination created silver chloride, which is sensitive to light. The printing paper was exposed over a long period in direct sunlight with usually a paper calotype negative. When the desired image intensity was reached, the paper was washed in sodium thiosulfate to halt the chemical reactions. Like albumen prints, the salted-paper print could be enhanced and made more stable with gold chloride toning. Salted-paper prints were commonly used until 1860, when albumen printing replaced the technique.

Snapshot Snapshots are informal photographs taken by amateur photographers. The ubiquity of snapshots today resulted from the development of smaller, more portable cameras and George Eastman's invention of commercial dry plate negatives in the 1880s. Kodak, Eastman's first film camera, became available to the public in 1888. What was once a complicated, technical process soon became a hobby for many average Americans.

Stereograph A popular form of parlor entertainment from the 1850s through the 1920s, the stereograph consists of two similar photographs taken from a slightly different vantage point by a specially equipped camera. The two photographs, mounted on card stock, appear as a single three-dimensional image when viewed simultaneously through a stereoscope. The lenses of the stereoscope transform the slightly shifted vantage points of the two images into a recreation of binocular vision. Viewmaster reels that children (and adults) still enjoy today are a contemporary version of the stereograph.

Tintype The tintype, more correctly though less commonly known as the ferrotype, is the offspring of the daguerreotype and ambrotype processes. Appearing in the United States in the mid-1850s, the economical tintype process remained in common use, predominantly for portraiture, until the early twentieth century. As with the ambrotype, the unique photographic image was a negative printed on a sheet of iron that had been coated with dark enamel. When the two were combined, the positive image resulted. Tintypes were sometimes stored in cases, like daguerreotypes, but more often they were placed in paper frames by the street vendors and fair photographers who commonly made them.

Wet-collodion process F. Scott Archer invented the wet-collodion plate process in 1851, and it remained in use until the early 1880s (see Collodion). This process replaced the daguerreotype and calotype photography methods due to its shorter exposure time, greater transparency of the glass negative, and better ability to yield details in the finished photograph, which were primarily albumen prints.

CONTRIBUTORS

Michelle Anne Delaney is a Museum Specialist and Collections Manager in the Photographic History Collection of the National Museum of American History. Her recent exhibitions include *The Scurlock Photographic Collection, Freeze Frame: Eadweard Muybridge's Photography of Motion*, and *Photo du Jour: A Picture-a-Day Journey in the First Year of the New Millennium*.

Debra Diamond, Assistant Curator of South and Southeast Asian Art at the Freer Gallery of Art and the Arthur M. Sackler Gallery, received her doctorate from Columbia University. A specialist in contemporary art and nineteenth-century north Indian painting, she has taught at Sarah Lawrence College, Barnard College, and the Parsons School of Design.

Paula Richardson Fleming is a Photographic Archives Specialist at the National Anthropological Archives, a division of the National Museum of Natural History. Fleming wrote *Native American Photography at the Smithsonian: The Shindler Catalogue*, which was recently published by Smithsonian Books.

Jeana K. Foley serves as Assistant Curator of Photography with the Smithsonian's International Art Museums Division. Foley has also worked in the photography department of the National Portrait Gallery and in the curatorial department at the Smithsonian American Art Museum. She has contributed to numerous Smithsonian exhibitions, including *Mathew Brady and the Image of History; American Photographs: The First Century*; and *Helios: Photography Online*.

Merry A. Foresta is Senior Curator of Photography and Program Manager for the Smithsonian photography initiative with the International Art Museums Division. Prior to *At First Sight*, Foresta organized more than fifty exhibitions on art and photography, including *Perpetual Motif: The Art of Man Ray* and *American Photographs: The First Century*.

Christraud M. Geary was Curator of the Eliot Elisofon Photographic Archives of the National Museum of African Art from 1990 to 2003. Geary has published extensively on the art and photography of Africa; her most recent book is *In and Out of Focus: Images from Central Africa, 1885–1960*.

David E. Haberstich is Head of Photographic Collections in the Archives Center, National Museum of American History, where he has organized numerous exhibitions by photographers David Plowden, Barbara Morgan, Betty Hahn and Gayle Smalley, Berenice Abbott, Elliott Erwitt, Janine Niepce, and Eikoh Hosoe, among others.

Amy Henderson, a Cultural Historian at the Smithsonian's National Portrait Gallery, specializes in American musical theater, broadcasting, and movies. She is the author of *On the Air: Pioneers of American Broadcasting*, co-author of *Red, Hot & Blue: A Smithsonian Salute to the American Musical*, and co-editor of *Exhibiting Dilemmas: Issues of Representation at the Smithsonian*.

Pamela Henson is Director of the Institutional History Division of the Smithsonian Institution Archives, where she is responsible for research on the history of the Institution and for the Oral History Program. One of her recent exhibitions is *Smithsonian Expeditions: Exploring Latin America and the Caribbean*.

Susan Jewett, Collections Manager of the Division of Fishes at the National Museum of Natural History, is widely known in ichthyological circles through her management of the Smithsonian's fish collection as well as through her field work in Venezuela, Peru, Brazil, and Cuba.

Liza Kirwin serves as Curator of Manuscripts at the Smithsonian's Archives of American Art. She received her doctorate from the University of Maryland at College Park and is working on a book based on her dissertation, "It's All True: Imagining New York's East Village Art Scene of the 1980s."

Peter Liebhold is Exhibition Curator in the Division of the History of Technology, National Museum of American History. Among his recent exhibitions are *Between a Rock and a Hard Place: A History of American Sweatshops, 1820 – Present, Images of Steel, 1860 – 1994*, and *Who's in Charge: Workers and Managers in the United States*.

Claire Orologas is the Acting Head of Education at the Freer Gallery of Art and the Arthur M. Sackler Gallery. She holds a master of arts degree in teaching and is currently a master's candidate in art history at the University of Florida in Gainesville.

Shannon Perich is a Museum Specialist in the Photographic History Collection, National Museum of American History. She is the image manager for *September 11th: Bearing Witness to History* and the project manager for the Photographic History Collection's web guide.

Phyllis Rosenzweig is Curator of Works on Paper at the Hirshhorn Museum and Sculpture Garden. She has curated numerous exhibitions on contemporary art and photography. Rosenzweig is also a specialist on the photography of artist Thomas Eakins, whose archive is housed at the Hirshhorn.

Joanna Cohan Scherer, an anthropologist, works as an Illustrations Researcher for the Handbook of North American Indians project at the National Museum of Natural History. She has helped to initiate visual anthropology, a new area of study that uses historical photographs in anthropological inquiry.

Ann M. Shumard is Curator of Photographs at the National Portrait Gallery. Her past exhibitions include *Lincoln and His Contemporaries: Photographs by Mathew Brady from the Frederick Hill Meserve Collection* and *A Durable Memento: Portraits by Augustus Washington, African American Daguerreotypist*.

Steven Turner, a Subject Specialist, works in the Smithsonian's Physical Sciences Collection at the National Museum of American History. His research interests delve into the history of physics and astronomy, and he is currently studying the history of science demonstrations.

William E. Worthington Jr. specializes in the history of mechanical and civil engineering at the National Museum of American History. One of his most recent exhibitions, *Make the Dirt Fly!*, dealt with the construction of the Panama Canal.

ILLUSTRATION CREDITS

Height precedes width in measurements

Page 6: *Blériot XI bis Airplane,* sheet: 5 5/16 × 4 1/16 in., National Air and Space Museum Archives.

Page 10: *Architect's Model,* Photographic History Collection, Division of Information Technology and Society, National Museum of American History, Behring Center.

Pages 26 and 27: Barnes, *Carnegie Cat,* 20 × 16 in., *Animal Locomotion,* 20 × 16 in., Hirshhorn Museum and Sculpture Garden, Gift of the Artist, 2002.

Page 28: *Inflation of John Steiner's Balloon,* National Air and Space Museum Archives.

Page 31: Smillie, *Morse's Daguerreotype Equipment,* sheet: 8 1/16 × 9 15/16 in., Smithsonian Institution Archives, RU 95, Box XI.

Pages 32 and 33: Talbot, *Photographic Printing Experiments, Miscellanea Photogenica,* and *Branch of Leaves,* Photographic History Collection, Division of Information Technology and Society, National Museum of American History, Behring Center.

Page 34: Henry Draper, *The Moon,* Photographic History Collection, Division of Information Technology and Society, National Museum of American History, Behring Center.

Page 35: John William Draper, *Photomicrograph of Frog Blood,* Photographic History Collection, Division of Information Technology and Society, National Museum of American History, Behring Center; photographed by Mark Gulezian.

Page 36: *Thomas Eakins and Frances Eakins,* 4 5/16 × 3 1/4 in., National Portrait Gallery.

Page 37: Fitz, *Self-Portrait,* Photographic History Collection, Division of Information Technology and Society, National Museum of American History, Behring Center.

Page 39: Washington, *John Brown,* 3 15/16 × 3 1/4 in., National Portrait Gallery, Purchased with major acquisition funds and with funds donated by Betty Adler Schermer in honor of her great-grandfather, August M. Bondi.

Page 40: Vannerson and McClees, *Tshe-Tan Wa-Ku-Wa Ma-Ni,* 5 × 6 in., National Museum of Natural History, National Anthropological Archives, NAA Photo Lot 4286: Inv. 01169600.

Nishaneanent, National Museum of the American Indian, Presented by Joseph Keppler.

Page 41: *Frederick Douglass,* 4 3/16 × 3 3/8 in., National Portrait Gallery, Gift of an anonymous donor.

Brady, *Abraham Lincoln,* 3 7/16 × 2 1/16 in., National Portrait Gallery.

Page 42: Root, *Barnum and "Tom Thumb,"* 5 1/2 × 4 1/4 in., National Portrait Gallery.

Page 43: Gurney, *Woman and Child,* plate: 3 3/8 × 2 3/4 in., Smithsonian American Art Museum, Museum purchase from the Charles Isaacs Collection made possible in part by the Luisita L. and Franz H. Denghausen Endowment.

Page 45: Bonnevide, *Young Wolof Man,* sheet: 3 9/16 × 2 1/8 in., National Museum of African Art, Eliot Elisofon Photographic Archives.

Pages 46 and 47: *Dakar—Familie Sénégalaise,* 5 1/4 × 3 9/16 in.; *Dakar—Fils d'un Chef,* 5 5/16 × 3 9/16 in.; *Dakar—Race Toucouleur,* 5 5/16 × 3 1/2 in.; *Dakar—Un Sénégalais Wolof,* 5 5/16 × 3 1/2 in.; *Dakar—Un Sénégalais,* 5 5/16 × 3 1/2 in., National Museum of African Art, Eliot Elisofon Photographic Archives.

Page 48: Greene, *Palms along the Nile,* 13 3/8 × 17 in., Smithsonian American Art Museum, Gift of Charles Isaacs in memory of Martha and Louis Isaacs.

Page 49: Frith, *Pyramids,* Photographic History Collection, Division of Information Technology and Society, National Museum of American History, Behring Center.

Pages 51–54 and 55: Bonfils, *Panorama of Damascus,* 1.) 8 11/16 × 11 3/8 in. 2.) 8 11/16 × 11 5/16 in. 3.) 8 15/16 × 11 1/4 in. 4.) 8 13/16 × 11 3/8 in. 5.) 8 7/8 × 11 5/16 in., Freer Gallery of Art and Arthur M. Sackler Gallery Archives, Henry and Nancy Rosin Collection of Early Photography of Japan, Purchase, 1997.

Page 56: Weed, *Fishing Village,* sheet: 15 5/8 × 20 5/16 in., Freer Gallery of Art and Arthur M. Sackler Gallery Archives, Henry and Nancy Rosin Collection of Early Photography of Japan, Gift and partial purchase, 1999–2001.

Page 57: Beato, *Samurai,* 8 13/16 × 10 15/16 in., Freer Gallery of Art and Arthur M. Sackler Gallery Archives, Henry and Nancy Rosin Collection of Early Photography of Japan, Gift and partial purchase, 1999–2001.

Pages 58–59: Weed, *Mirror Lake and Reflections,* sheet and image: 15 1/2 × 20 1/4 in., Smithsonian American Art Museum, Gift of Dr. and Mrs. Charles T. Isaacs.

Page 60: Talbot, *Holy Trinity Church,* Photographic History Collection, Division of Information Technology and Society, National Museum of American History, Behring Center.

Page 61: Bourne, *Gateway Hussinabad,* 12 × 9 in., National Museum of Natural History, National Anthropological Archives, NAA Photo 97: India: Inv. 04561400.

Pages 62 and 63: Kyuichi, *Empress Meiji,* 10 1/8 × 7 11/16 in., *Emperor Meiji,* 10 1/8 × 7 3/4 in., Freer Gallery of Art and Arthur M. Sackler Gallery Archives, Henry and Nancy Rosin Collection of Early Photography of Japan, Gift and partial purchase, 1999–2001.

Pages 64–65: *Wright Type A Flyer,* 6 5/8 × 9 3/16 in., National Air and Space Museum Archives.

Page 66: *Selden and Son,* Transportation Collection, Division of the History of Technology, National Museum of American History, Behring Center.

Page 67: *Pickering Wind Tricycle,* 6 3/8 × 7 1/2 in., National Air and Space Museum Archives, William J. Hammer Scientific Collection.

Page 68: *Wright Type A Flyer,* image: 3 1/4 × 4 1/4 in., National Air and Space Museum Archives.

Page 69: Detrich, *Spectators at an Air Show,* sheet: 9 11/16 ×7 3/8 in., National Air and Space Museum Archives.

Page 71: Lippmann, *Color Photograph of Solar Spectrum,* Physical Sciences Collection, Division of Science, Medicine, and Society, National Museum of American History, Behring Center; photographed by Franko Khoury.

Page 72: *Aerial Reconnaissance Photograph,* 8 1/2 × 6 1/2 in., National Air and Space Museum Archives.

Page 73: John William Draper, *Photomicrograph of Algae,* Photographic History Collection, Division of Information Technology and Society, National Museum of American History, Behring Center.

Page 74: NASA, *Mars Orbiting Camera Digital Transmission,* image: 7 7/16 × 8 15/16 in., National Air and Space Museum, Center for Earth and Planetary Studies.

Page 75: Apollo 15 Mission Orbiter Camera, *Panorama of the Moon's Surface,* 9 7/16 × 77 1/4 in., National Air and Space Museum, Center for Earth and Planetary Studies.

Page 76: NASA/CXC/MIT/F.K. Baganoff et al., *Sagittarius A,* Smithsonian Astrophysical Observatory.

Page 77: NASA/CXC/SAO, *Crab Nebula,* Smithsonian Astrophysical Observatory.

NASA/CXC/SAO, *Cassiopeia A,* Smithsonian Astrophysical Observatory.

Page 78: Draper, *Spectrograph,* Photographic History Collection, Division of Information Technology and Society, National Museum of American History, Behring Center.

Page 81: Smillie, *Installation View,* sheet: 7 5/16 × 9 5/8 in., Smithsonian Institution Archives, RU 95, Box X.

Page 82: O'Sullivan, *Historic Spanish Record of the Conquest,* sheet: 7 15/16 × 10 7/8 in., Smithsonian American Art Museum, Museum purchase from the Charles Isaacs Collection made possible in part by the Luisita L. and Franz H. Denghausen Endowment.

Pages 84 and 85: Draper, *Chicken Entrails* and *Fly's Proboscis,* Photographic History Collection, Division of Information Technology and Society, National Museum of American History, Behring Center; photographed by Mark Gulezian.

Pages 86–87: Smillie, *Stuffed Animal Installation,* sheet: 8 1/16 × 10 1/16 in., Smithsonian Institution Archives, RU 95, Box X.

Pages 88–89, 90, and 91: Billings and Matthews, *Measuring Skull Cavities,* NAA Photo Lot 78-42: negative 83-4198; *Male Ponca Skulls,* NAA Photo Lot 6A: Inv. 09713900; *Ogalalla Skulls,* NAA Photo Lot 6A: Inv. 09715300; each 6 × 6 1/2 in., National Museum of Natural History, National Anthropological Archives.

Pages 92 and 93: Bell, *Recovery after a Penetrating Gunshot Wound,* sheet and image: 8 1/2 × 6 5/8 in., *Lieutenant Goodwin, Deceased,* sheet: 7 × 8 1/2 in.; Smithsonian American Art Museum, Museum purchase from the Charles Isaacs Collection made possible in part by the Luisita L. and Franz H. Denghausen Endowment.

Page 94: Lascoumettes, *Portrait of a Fante Woman,* sheet: 3 5/8 × 2 1/8 in., National Museum of African Art, Eliot Elisofon Photographic Archives.

Bonaparte, *Va-Shesh-Na-Be and Child,* 12 × 15 in., National Museum of Natural History, National Anthropological Archives, NAA Photo Lot 80-52: Inv. 02535400.

Page 95: Stillfried, *Travelers in Winter Dress,* 10 5/16 × 8 5/16 in., Freer Gallery of Art and Arthur M. Sackler Gallery Archives, Henry and Nancy Rosin Collection of Early Photography of Japan, Gift and partial purchase, 1999–2001.

Pages 96–97: *Richard's Studio,* 7 7/16 × 9 9/16 in., Smithsonian Institution Archives, RU 95, Box 29, Folder 7.

Pages 98 and 99: Smillie, *Tasmanian Hyena* and *Komodo Dragon and Keeper,* each 8 × 10 in., National Zoo, Photo Archives.

Page 101: Jackson, *Hayden Survey Party Picnicking,* sheet: 7 15/16 × 9 15/16 in., Smithsonian Institution Archives, RU 311, Box 11, Folder 1.

Page 102: *Damaliscus Being Photographed by Kermit Roosevelt,* 5 3/8 × 3 3/16 in., Smithsonian Institution Archives, Edmund Heller Collection, RU 7179, Box 2, Folder 9.

Page 103: Cunningham, *"First Bull Elephant,"* sheet: 3 1/2 × 5 3/4 in., Smithsonian Institution Archives, Edmund Heller Collection, RU 7179, Box 2, Folder 13.

Pages 104–105: Walcott, *Dr. Walcott at Fossil Quarry,* 4 11/16 ×14 7/8 in., Smithsonian Institution Archives, RU 7004, Box 76C.

Page 106: Jackson, *Hayden Survey Party,* 4 7/16 × 7 5/8 in., Smithsonian Institution Archives, RU 7177, Box 14, Folder 13.

Page 107: *Moss and Ingersoll on Hayden Survey*, image: 7 15/16 × 5 1/2 in., Smithsonian Institution Archives, RU 311, Box 11, Folder 2.

Pages 108–109: O'Sullivan, *View of Three-Masted Sailing Ship*, 8 × 11 in., National Museum of Natural History, National Anthropological Archives, NAA Photo Lot 97: Panama: Inv. 04267900.

Page 110: Hillers, *View from Above of River in Canyon*, 13 × 10 in., National Museum of Natural History, National Anthropological Archives, NAA Photo Lot 37: Hillers: Inv. 02695500.

Page 111: Jackson, *View of Moqui Pueblos*, 4 3/8 × 7 1/2 in., Smithsonian Institution Archives, RU 95, FMC 148.

Page 113: *The Tioga*, Photographic History Collection, Division of Information Technology and Society, National Museum of American History, Behring Center.

Pages 114–15 and 117: *Construction of the Pension Building* and *Construction of the Washington, D.C., Aqueduct*, Engineering Collection, Division of the History of Technology, National Museum of American History, Behring Center; photographed by Mark Gulezian.

Page 116: *Construction on the River Seine*, Engineering Collection, Division of the History of Technology, National Museum of American History, Behring Center.

Pages 118 and 119: Smillie, *Chinese Kite Frames*, each 7 3/4 × 9 1/2 in., Smithsonian Institution Archives, RU 95, Box XI.

Pages 120 and 121: Smillie, *Airplane Models*, each 7 7/8 × 10 1/16 in., National Air and Space Museum Archives.

Pages 122 and 123: Bentley, *Snowflake Studies*, each approx. 3 × 3 1/2 in., Smithsonian Institution Archives, RU 31, Box 12, Folder 17.

Pages 124 and 125: Smillie, *Keel-billed Toucan*, 9 3/4 × 7 3/4 in.; *Cassowary*, 9 11/16 × 7 3/4 in.; *Secretary Bird*, 9 13/16 × 7 11/16 in.; *Brown Kiwi*, 9 3/4 × 7 3/4 in.; *Greater Flamingo*, 9 13/16 × 7 3/4 in.; *Greater Adjutant*, 9 11/16 × 7 3/4 in.; *Spotted Nothura*, 9 13/16 × 7 3/4 in.; *Unidentified Bird Skeleton*, 9 3/4 × 7 3/4 in.; *Rhinoceros Hornbill*, 9 13/16 × 7 3/4 in.; *Ostrich*, 9 3/4 × 7 3/4 in., National Museum of Natural History, Division of Birds.

Page 127: *Alopias vulpinus*, 8 3/4 × 12 7/16 in., National Museum of Natural History, Division of Fishes.

Pages 128 and 129: Sandra J. Raredon, *Pristigenys alta* and *Himantura signifier*, National Museum of Natural History, Division of Fishes.

Pages 130–31: Muybridge, *Mounted Cyanotypes*, Photographic History Collection, Division of Information Technology and Society, National Museum of American History, Behring Center.

Pages 132 and 133: Gilbreth, *Motion Study* and *Motion Efficiency Study*, Industry Collection, Division of the History of Technology, National Museum of American History, Behring Center.

Pages 134–35 and 136: Science Service Incorporated, *Genius Engaged in Multiple Tasks* and *Color Blindness Card Test*, each 8 × 10 in., Medical Sciences Collection, Division of Science, Medicine, and Society, National Museum of American History, Behring Center.

Page 137: U.S. Navy, *Camera Testing*, 8 × 10 in., Photographic History Collection, Division of Information Technology and Society, National Museum of American History, Behring Center.

Page 139: Sabine, *Holy Trinity Church, Reflection in Closed Space*, and *Model of Century Theatre*, Physical Sciences Collection, Division of Science, Medicine, and Society, National Museum of American History, Behring Center.

Page 140: Edgerton, *Bullet Shockwave*, from the portfolio *Seeing the Unseen: 12 Photographs by Harold Edgerton*, sheet: 14 × 11 1/16 in., image: 11 3/8 × 9 5/8 in., Smithsonian American Art Museum, Gift of the Harold and Esther Edgerton Family Foundation.

Page 141: Edgerton, *Bullet through Balloons*, 13 5/8 × 22 7/16 in., Smithsonian American Art Museum, Gift of the Harold and Esther Edgerton Family Foundation.

Page 142: Draper, *Glass Positive of the Sun* and *Glass Positive of the Moon*, Physical Sciences Collection, Division of Science, Medicine, and Society, National Museum of American History, Behring Center.

Page 143: Smillie, *Corona of the Sun*, 7 15/16 × 5 3/16 in., Smithsonian Institution Archives, RU 7005, Box 186, Folder 1.

Page 144: *Portrait of a Man Holding a Photograph*, Photographic History Collection, Division of Information Technology and Society, National Museum of American History, Behring Center.

Page 147: Smillie, *Installation View*, sheet: 7 7/16 × 9 5/8 in., Smithsonian Institution Archives, RU 95, Box X.

Page 148: Pearsall, *Walt Whitman*, 5 5/8 × 4 1/16 in., National Portrait Gallery, Gift of Charles E. Feinberg.

Pages 150 and 151: *Mail Girl, Drummer Boys*, and *African American Family*, Photographic History Collection, Division of Information Technology and Society, National Museum of American History, Behring Center; photographed by Mark Gulezian.

Page 151: *Two Women with Spoons*, Photographic History Collection, Division of Information Technology and Society, National Museum of American History, Behring Center.

Page 152: Southworth and Hawes, *A Bride and Her Bridesmaids*, 8 1/16 × 6 1/16 in., Smithsonian American Art Museum, Museum purchase made possible by Walter Beck.

Page 153: Churchill and Dennison Studios, *Group at the Sanitary Commission Fair*, 6 × 8 in. oval, Smithsonian American Art Museum, Museum purchase from the Charles Isaacs Collection made possible in part by the Luisita L. and Franz H. Denghausen Endowment.

Pages 155–58 and 159: Brady Studio, *Ute Delegation*, 6 9/16 × 12 7/16 in., National Portrait Gallery.

Page 160: Vannerson and McClees, *Pko-Ne-Gi-Zhik (Chief Hole in the Sky)*, NAA Photo Lot 4286: Inv. 01169400; *Ma-Za-O Ma-Ni (Walking in Iron)*, NAA Photo Lot 4286: Inv. 01171000; *Ta-Ka-Ko (Chief Grey Fox)*, NAA Photo Lot 4286: Inv. 01172300; *Psi-Tsha Wa-King-A (Chief Jumping Thunder)*, NAA Photo Lot 4286: Inv. 01170800; each 5 × 5 in., National Museum of Natural History, National Anthropological Archives.

Page 161: Easterly, *No-Che-Ninga-An (Chief of the Iowas)*, Photographic History Collection, Division of Information Technology and Society, National Museum of American History, Behring Center.

Page 162: Grabill, *Big Foot's Band*, 8 3/4 × 10 3/4 in., National Museum of the American Indian, General Nelson A. Miles Collection.

Page 163: *A Chief and His Followers, Burundi*, sheet: 5 1/16 × 7 1/16 in., National Museum of African Art, Eliot Elisofon Photographic Archives, Pères Blancs Collection.

Pages 164–65: Brady Studio, *Union Army Encampment*, Photographic History Collection, Division of Information Technology and Society, National Museum of American History, Behring Center.

Page 166: Brady Studio, *Sherman and His Generals*, 14 7/16 × 17 15/16 in., National Portrait Gallery.

Page 167: Swartz, *Butch Cassidy*, 6 9/16 × 12 7/16 in., National Portrait Gallery, Gift of Pinkerton's, Inc.

Page 169: Brady Studio, *Alexander Gardner*, 3 7/16 × 2 1/8 in., National Portrait Gallery.

Gutekunst, *Ulysses S. Grant*, 3 5/16 × 2 1/16 in., National Portrait Gallery, Gift of Robert L. Drapkin.

Alexander Gardner, *Lewis Powell*, 3 1/4 × 1 15/16 in., National Portrait Gallery, Gift of John Wilmerding.

Brady Studio after McPherson and Oliver, *Private Gordon*, 3 3/8 × 2 3/16 in., National Portrait Gallery.

Page 170: *Japanese Man Standing*, 3 7/16 × 2 3/16 in.; *Man with Open Parasol*, 3 7/16 × 2 1/16 in.; *Woman with a Chair and Umbrella*, 3 9/16 × 2 3/8 in.; *Actors*, 2 1/4 × 3 1/2 in.; *Woman Carrying Wood*, 3 9/16 × 2 1/16 in.; *Young Man with a Sword*, 3 1/2 × 2 3/8 in., Freer Gallery of Art and Arthur M. Sackler Gallery Archives, Henry and Nancy Rosin Collection of Early Photography of Japan, Gift and partial purchase, 1999–2001.

Page 171: Wrensted, *Pat Tyhee in Native Dress*, NAA Photo lot 92-3: item #150; *Pat Tyhee after Conversion*, NAA Photo lot 92-3: item #152, National Museum of Natural History, National Anthropological Archives, Handbook of the North American Indian, Eugene O. Leonard Collection of Photographs.

Page 172: Babbitt, *Niagara Falls*, Photographic History Collection, Division of Information Technology and Society, National Museum of American History, Behring Center.

Page 173: *Rafting Party*, sheet and image: 4 3/4 × 6 5/8 in., Smithsonian American Art Museum, Museum purchase from the Charles Isaacs Collection made possible in part by the Luisita L. and Franz H. Denghausen Endowment.

Page 174: *Four Women with a Cat* and *Man with a Bicycle*, Photographic History Collection, Division of Information Technology and Society, National Museum of American History, Behring Center; photographed by Mark Gulezian.

Vail Brothers Studio, *Carcharodon carcharias*, 2 15/16 × 7 5/8 in., *Carcharodon carcharias*, sheet: 6 1/16 × 4 1/16 in., National Museum of Natural History, Division of Fishes.

Page 175: *Sleeping Dog* and *Three Acrobats*, Photographic History Collection, Division of Information Technology and Society, National Museum of American History, Behring Center; photographed by Mark Gulezian.

Mohawk Youths, 3 1/4 × 2 1/16 in., National Museum of the American Indian.

Page 176: *Three Friends in a Field*, sheet and image: 3 3/4 × 4 3/4 in., Smithsonian American Art Museum, Museum purchase from the Charles Isaacs Collection made possible in part by the Luisita L. and Franz H. Denghausen Endowment.

Page 177: White, *Rest Hour*, sheet and image: 9 3/4 × 7 3/4 in., Smithsonian American Art Museum, Museum purchase from the Charles Isaacs Collection made possible in part by the Luisita L. and Franz H. Denghausen Endowment.

Pages 178–79: *Blackfoot Indians*, sheet: 5 3/8 × 9 3/8 in., National Museum of the American Indian, Mary Roberts Rinehart Collection.

Page 180: Sevruguin, *Group Portrait*, image: 6 3/16 × 8 in., Freer Gallery of Art and Arthur M. Sackler Gallery Archives, Myron Bement Smith Collection, Gift of Katharine Dennis Smith, 1973–1985.

Page 181: *Burundi Family*, sheet: 7 1/8 × 5 1/16 in., National Museum of African Art, Eliot Elisofon Photographic Archives, Pères Blancs Collection.

Page 183: Aikins, *Fairfield Works*, Industry Collection, Division of the History of Technology, National Museum of American History, Behring Center.

Pages 184 and 185: *Burden's Wheel*, and Keystone Stereograph View Company, *Pouring Molten Steel*, Engineering Collection, Division of the History of Technology, National Museum of American History, Behring Center.

Pages 186–87, 188, and 189: *Proper Method for Shooting Coal, Kindergarten Classroom, Work of Children's Sewing Class*, and *Creek Channel after a Slide*, Industry Collection, Division of the History of Technology, National Museum of American History, Behring Center; photographed by Mark Gulezian.

Page 191: Hine, *Waiting at the Clinic*, sheet: 9 15/16 × 7 15/16 in., Archives of American Art, Elizabeth McCausland Papers.

Pages 192–93: Abbott, *Normandie*, image: 7 1/8 × 9 5/8 in., Smithsonian American Art Museum, Gift of George McNeil.

Pages 194 and 195: Hine, *One A.M. Sunday Edition*, 5 × 7 in., and *Joys and Sorrows*, sheet: 7 7/8 × 10 in., Archives of American Art, Elizabeth McCausland Papers.

Pages 196, 197, and 198: Larrabee, *Woman and Children, Woman*, and *Soweto*, National Museum of African Art.

Pages 199 and 200–201: Elisofon, *Untitled* and *Songye ritual*, National Museum of African Art, Eliot Elisofon Photographic Archives.

Pages 202–203: Lepkoff, *Untitled (Family on Street)*, sheet: 7 1/4 × 9 3/4 in., Smithsonian American Art Museum, Museum purchase made possible by Howland Chase, James Harlan, Lucie Fery, B. Giradet, and George McClellan.

Pages 204–205: Addison Scurlock, *Picnic Group*, Archives Center, Scurlock Studio Collection, National Museum of American History, Behring Center.

Pages 206, 207, and 208–209: Robert Scurlock, *Marian Anderson Arriving at Union Station, Marian Anderson Arriving at the Lincoln Memorial, Marian Anderson Singing at the Lincoln Memorial,* and *Concert by Marian Anderson,* Archives Center, Scurlock Studio Collection, National Museum of American History, Behring Center.

Page 210: U.S. Air Force, *Bumper Project Launch,* sheet: 8 1/16 × 10 in., National Air and Space Museum Archives.

Page 213: Smillie, *Installation View,* sheet: 7 5/8 × 9 11/16 in., Smithsonian Institution Archives, RU 95, Box XIII.

Pages 214 and 216: *Portrait of Thomas Smillie,* and Rejlander, *The Mask,* Photographic History Collection, Division of Information Technology and Society, National Museum of American History, Behring Center.

Page 217: Sevruguin, *Veiled Woman with Pearls,* image: 4 1/2 × 3 1/16 in., Freer Gallery of Art and Arthur M. Sackler Gallery Archives, Myron Bement Smith Collection, Gift of Katharine Dennis Smith, 1973–1985.

Pages 218 and 219: Cameron, *Saint John,* and Käsebier, *Indian,* Photographic History Collection, Division of Information Technology and Society, National Museum of American History, Behring Center.

Pages 220, 221, and 222: Eakins, *Standing Nude,* 3 15/16 × 2 1/16 in., *Wrestlers,* 3 1/2 × 6 in. irreg., and *Marey Wheel Photographs,* 9 1/8 × 11 1/4 in., Hirshhorn Museum and Sculpture Garden, Transferred from the Hirshhorn Museum and Sculpture Garden Archives, 1983.

Page 223: Muybridge, *Self-Portrait,* 1.) 4 5/16 × 1 15/16 in., 2.) 4 3/8 × 2 13/16 in., 3.) 4 1/8 × 2 1/8 in., Archives of American Art, Thomas Anschutz Papers.

Pages 224 and 225: Eickemeyer, *Girl Laying in Hammock* and *Evelyn Nesbit,* Photographic History Collection, Division of Information Technology and Society, National Museum of American History, Behring Center.

Pages 226–27: Barney, *Marina's Room,* sheet: 48 × 60 in., Smithsonian American Art Museum, Museum purchase, copyright 1987, Tina Barney, Courtesy Janet Borden, Inc.

Pages 228 and 229: Xunling, *Cixi Standing before the Imperial Throne,* image: 9 × 7 3/8 in., and *Cixi aboard the Imperial Barge,* image: 9 3/16 × 7 1/16 in., Freer Gallery of Art and Arthur M. Sackler Gallery Archives, Cixi, Empress Dowager of China, 1835–1908, Photographs, Purchase.

Pages 230–31: Kimbei, *Iris Blossoms,* sheet: 16 5/16 × 21 1/4 in., Freer Gallery of Art and Arthur M. Sackler Gallery Archives, Henry and Nancy Rosin Collection of Early Photography of Japan, Gift and partial purchase, 1999–2001.

Pages 232 and 233: Skeen and Company, *Recumbent Buddha,* sheet: 8 5/16 × 10 7/8 in., and *First Flight of Stone Steps,* sheet: 10 7/8 × 8 1/4 in., from the album "Photographs of the Ruined Cities of Ceylon, Anuradhapura & Pollanarua," Freer Gallery of Art and Arthur M. Sackler Gallery Archives, Charles Lang Freer Papers, Gift of the Estate of Charles Lang Freer.

Pages 234–35: Dixon, *Vanishing into the Mists,* 21 × 29 in., National Museum of Natural History, National Anthropological Archives, NAA Photo Lot 64: Inv. 02517300.

Pages 236–37: Bosworth, *National Champion American Beech,* image: 7 5/8 × 9 11/16 in., Smithsonian American Art Museum, Gift of the Consolidated Natural Gas Company Foundation.

Page 238: Bucher, *Handwritten Index of Trees,* 10 × 8 in., and *Blue Ash Tree,* Natural Resources Collection, Division of the History of Technology, National Museum of American History, Behring Center.

Page 239: Bucher, *Blue Ash Tree,* Natural Resources Collection, Division of the History of Technology, National Museum of American History, Behring Center; photographed by Franko Khoury.

Pages 240 and 241: Evans, *Field Museum, Drawer of Cardinals, Various Dates,* and *Field Museum, Bullsnakes, Various Dates,* each 24 × 20 in., Hirshhorn Museum and Sculpture Garden, Gift of the Artist, 2002.

Pages 242–43: Wegman, *Untitled (Gallop),* 25 × 45 3/16 in., Smithsonian American Art Museum, Museum purchase.

Page 245: Edgerton, *Fan and Smoke,* sheet: 23 7/8 × 20 in., Smithsonian American Art Museum, Gift of Charles F. and Robin L. Turner.

Pages 246 and 247: Bonney, *Photograph of Model Wearing a Bracelet; Photograph of Jewelry, Designed by Gérard Sandoz;* and *Photograph of Jewelry, Designed by Lucien LeLong,* Cooper-Hewitt, National Design Museum, Thérèse Bonney Collection.

Pages 248 and 249: Sudek, *Photograph for an Advertisement: Glass Teacup,* and *Photograph for an Advertisement: Porcelain Dinner Service Cups and Saucers,* Cooper-Hewitt, National Design Museum, Sutnar Archive.

Pages 250–51: U.S. Air Force, *Bombardiers in Training,* sheet: 7 15/16 × 10 in., National Air and Space Museum Archives.

Pages 252–53: d'Arazien, *Photograph for Jones and Laughlin Steel Corporation,* Industry Collection, Division of the History of Technology, National Museum of American History, Behring Center.

Pages 254–55: *Amelia Earhart with Lockheed Electra and Cord Phaeton,* 7 15/16 × 10 in., National Air and Space Museum Archives.

Page 256: Groenoff, *Fairchild 24 Airplane,* 4 7/8 × 3 7/8 in., National Air and Space Museum Archives, Hans Groenoff Collection.

Page 257: *Charles Lindbergh with Plane,* sheet: 10 × 8 in., National Air and Space Museum Archives.

Page 259: Studio Bernateau, *Duke Ellington,* 10 × 8 in., Archives Center, Ruth Ellington Collection, National Museum of American History, Behring Center.

Page 260: Johnston, *Fanny Brice,* 12 13/16 × 10 in., National Portrait Gallery.

Page 261: Bull, *Greta Garbo,* 12 7/16 × 9 7/16 in., National Portrait Gallery.

Page 262: Warnecke, *Jackie Robinson,* 10 1/2 × 7 11/16 in., National Portrait Gallery, © Daily News, LP.

Page 263: Warnecke, *Lucille Ball,* 16 1/8 × 13 1/16 in., National Portrait Gallery, Gift of Elsie M. Warnecke, © Daily News, LP.

Page 264: Steichen, *Self-Portrait,* 9 1/2 × 7 9/16 in., National Portrait Gallery, Acquired in memory of Agnes and Eugene Meyer through the generosity of Katharine Graham and the New York Community Trust, The Island Fund, © Joanna T. Steichen.

Page 265: Adams, *Photo Booth Self-Portrait,* image: 2 9/16 × 2 1/16 in., Archives of American Art, Katharine Kuh Papers.

Page 266: Callahan, *Portrait of Hugo Weber,* sheet: 9 5/16 × 2 3/8 in., mount: 9 5/8 × 7 7/8 in., Archives of American Art, Hugo Weber Papers.

Page 267: Parks, *Muhammad Ali,* 13 3/8 × 9 in., Smithsonian American Art Museum, Museum purchase through the Horace W. Goldsmith Foundation, copyright 1966, Gordon Parks.

Pages 268 and 269: Avedon, *John F. Kennedy and Caroline Kennedy,* Photographic History Collection, Division of Information Technology and Society, National Museum of American History, Behring Center; photographed by Mark Gulezian.

Pages 270–71: Eggleston, *Untitled (Grave),* image: 20 1/16 × 23 15/16 in., Smithsonian American Art Museum, Gift of Amy Loeserman Klein.

Page 272: Singh, *Man Diving,* Arthur M. Sackler Gallery, Gift of the Artist, Copyright © 1987 Raghubir Singh/Succession, Raghubir Singh.

Page 273: Singh, *Grand Trunk Road,* Arthur M. Sackler Gallery, Gift of the Estate of Raghubir Singh, © 2002 Succession, Raghubir Singh.

Pages 274 and 275: Hiroshi, *Boden Sea/Utwill,* sheet: 19 1/4 × 23 3/4 in., and *Yellow Sea/Cheju,* sheet: 19 3/16 × 23 11/16 in., Arthur M. Sackler Gallery.

Pages 276–77: Klett, *A Panorama of Washington, D.C.,* each: 29 1/4 × 23 3/8 in., Smithsonian American Art Museum, Museum purchase, copyright 1992–1993, Mark Klett.

INDEX

Page numbers in boldface refer to photographs